VICTORIAN PHOTOGRAPHY, LITERATURE, AND THE INVENTION OF MODERN MEMORY

PHOTOGRAPHY, HISTORY: HISTORY, PHOTOGRAPHY

Series Editors: Elizabeth Edwards, Jennifer Tucker, Patricia Hayes

ISSN: 2398-3892

This field-defining series explores the inseparable relationship between photography and history. Bringing together perspectives from a broad disciplinary base, it investigates what wider histories of, for example, wars, social movements, regionality, or nationhood look like when photography and its social and cultural force are brought into the centre of analysis.

Photography, Humanitarianism, Empire, Jane Lydon
Victorian Photography, Literature, and the Invention of Modern Memory: Already the Past, Jennifer Green-Lewis
Photography and Cultural Heritage in the Age of Nationalisms: Europe's Eastern Borderlands (1867–1945), Ewa Manikowska
Photography and the Cultural History of the Postwar European City, Tom Allbeson
Photography and Bearing Witness in the Balkan Conflict, 1988–2015, Paul Lowe
Photographing Tutankhamun: Archaeology, Ancient Egypt, and the Archive, Christina Rigg

VICTORIAN PHOTOGRAPHY, LITERATURE, AND THE INVENTION OF MODERN MEMORY

ALREADY THE PAST

Jennifer Green-Lewis

The George Washington University

BLOOMSBURY VISUAL ARTS
LONDON · NEW YORK · OXFORD · NEW DELHI · SYDNEY

BLOOMSBURY VISUAL ARTS
Bloomsbury Publishing Plc
50 Bedford Square, London, WC1B 3DP, UK
1385 Broadway, New York, NY 10018, USA

BLOOMSBURY, BLOOMSBURY VISUAL ARTS and the Diana logo are trademarks of
Bloomsbury Publishing Plc

First published in Great Britain 2017
Paperback Edition published 2020

Cover design: Sharon Mah
Cover image © Alfred Stieglitz Collection, 1933

A catalogue record for this book is available from the British Library.

A catalogue record for this book is available from the Library of Congress.

ISBN: HB: 978-1-4742-6308-5
 PB: 978-1-3501-4306-7
 ePDF: 978-1-4742-6309-2
 eBook: 978-1-4742-6310-8

Series: Photography, History: History, Photography

Typeset by Integra Software Services Pvt. Ltd.
Printed and bound in India

To find out more about our authors and books visit www.bloomsbury.com
and sign up for our newsletters.

For Craig

CONTENTS

LIST OF FIGURES

ACKNOWLEDGMENTS

My background in Victorian literature may explain some of my assumptions about what photography is doing when it shows up in a novel or a poem, but it also means that my debt to historians of photography with different disciplinary perspectives and deeper technical knowledge is particularly acute. Elizabeth Edwards has inspired me for years with the range and detail of her research and writing, and my first thanks are to her. I am also grateful to the co-editors of this series, Patricia Hayes and Jennifer Tucker, whose work demonstrates a similar commitment to redefining the boundaries of photographic history.

For help securing images and permissions, I thank Jaclyn Burns at the J. Paul Getty museum, Nathalie Naudi at CNAM, Paris, Linda Briscoe Myers at the Gernsheim collection, Dr. Laura McCullough of the Royal Holloway, Sophia Brothers at the Science and Society Picture Library, Karin Schnell of the Bayerisches National Museum, Ashley Dumazer at Getty Images, and Jovita Callueng at the British Library. At Bloomsbury, I am grateful to Davida Holmes, Molly Beck, and Ariadne Godwin, who got the book started, and to Frances Arnold, Nick Bellorini, and Manikandan Kuppan, who saw it through its final stages.

Some material first saw light in *English Language Notes* (2006: 44.2; 2013: 51.1) and *Nineteenth-century Contexts* (2001: 22). Part of Chapter 4 appears in *The Oxford Handbook of the Victorian Novel* (edited by Lisa Rodensky, 2013) and is reprinted here by permission of Oxford University Press. An earlier version of Chapter 6 was first published in *Victorian Afterlife: Contemporary Culture Rewrites the Nineteenth Century* (edited by John Kucich and Dianne Sadoff, 2000). It appears here in much revised form by permission of the University of Minnesota Press.

At the George Washington University, my home institution, Robert McRuer generously helped me secure leave from teaching, Maria Frawley and Kavita

Daiya provided unflagging support, and Tom Mallon kept me amused. I am grateful to each of them. I also thank Lori Brister for years of friendship and stellar teaching assistance, and Lea Skene for her research skills. On the subject of research, recent work by Jordan Bear, Geoffrey Belknap, Owen Clayton, Robin Kelsey, Gil Pasternak, and Kaya Silverman all caused me to re-visit, shore up, and even throw out some of my arguments. I'm grateful to the anonymous reader at Bloomsbury who alerted me to several books and articles published after the first draft of my manuscript was done, and thus enabled me to fold in additional insights at the last minute. Lindsay Smith's many books have been both model and companion since I first began work on *Framing the Victorians* back in the 1980s, and more recently I've benefitted from the very different approaches of Nancy Armstrong, Geoffrey Batchen, Helen Groth, and Daniel Novak, among others.

I would also like to thank those with whom I've shared years of conversations on literature, photography, and life in general: Isobel Armstrong, Allyson Booth, Harriet Scott Chessman, Dare Clubb, John Elder, Scott Elledge, Elizabeth Fowler, Anne Keller, Victor Luftig, Jim Maddox, Lucy Maddox, Leah Painter Roberts, Margery Sabin, Jonathan Strong, Marion Wells, and Bryan Wolf. A semester at sea gave me (literal) distance on the project as well as the chance to discuss it with new colleagues in a supportive community: thanks to all who sailed with the MV World Odyssey, spring 2016. I also raise a glass to my many beloved colleagues at the Bread Loaf School of English at Middlebury College. I am privileged to have spent so many summers in your fine company.

Finally, the home team: Thanks to Phoebe, Max, and Oliver Lewis, who instruct me daily in the curious and resourceful ways of digital natives. Phoebe in particular was generous with her insights into the technology of postmodern nostalgia. I thank my many nieces and nephews for making and exchanging all those images of time passing that in years to come—if we can ever find them—will be a memoir for our ever-expanding family. I particularly thank my nephew Oliver Crane, who reliably makes family events occasions for absorbing discussion of things that really matter. Thanks to Dawn and Dexter Lewis for steady and wise grand-parenting, and as always, thanks to my husband and fellow traveler, Craig Lewis. He is a diligent finder and loving curator of old photographs, and this book is for him.

AFTERLIGHT

Instagram: a little burial ground of a word for something that no one gets any more: the telegram.

The first telegram I ever received came in 1979. It was from my mother, for whom a telegram was a logical choice when she wished to send exam results to a daughter who was out of reach in London, living in a flat where there was no phone. The telegram probably took a day to reach me, and I found it on the mat with the rest of that day's mail, because by 1979 there was nothing so retro as a uniformed telegraph boy to hand it to me. My exam results came in the form of some letters and one word. I understood the lack of extended commentary: telegrams cost money, and you paid by the letter.

Unlike Instagram, there wasn't much that was "instant" about the telegram, though a telegram was relatively more instant than a letter through the post would have been. By 1986, when my second and, as it turned out, last telegram arrived, function had been almost entirely replaced with symbol, and the telegram itself *was* the message—a romantic gesture. Somewhere I still have it, which is probably more than one will ever be able to say about Instagram, let alone Snapchat (whose images are intended to disappear from your phone within seconds of their arrival).

But where *Snapchat* sounds hard and modern, a ping-pong of images, back and forth, the word *Instagram* suggests something arriving by means of old-fashioned conveyance. The "tele" has disappeared from the word, the distance of its Greek fragment replaced by "insta," a foreshortened "instant"; but the "gram" remains, a faint reminder of the telegram and the parent telegraph apparatus that generated it. *Instagram* is a word, like *photograph*, that identifies writing as an integral part of its being; unlike Snapchat, it promises a whole message, not a half exchange.

There are no more telegrams—the world's last was sent in India in July 2013—and the word that served in one capacity for a hundred and seventy years resonates differently now. When I first read about its demise, it occurred to me that perhaps one day the market for nostalgia might bring back the telegram, at which point its original *raison d'etre*, speed, would be so far emptied out of its function as to render its modern incarnation supremely ready for the irony of postmodern performance. That day is of course already here. When I googled "telegram," up came a website that offered to send a "retro-telegram" for me: "Telegramstop," it's called. "Send a traditional, classic telegram the easy way."

Traditional and classic it obviously is not. You type in your message online, bearing in mind that you now write your telegram not for speed but for posterity. The message should therefore be, you are instructed, "Something memorable that your friends and family will keep forever." You then preview your telegram (and add a photograph if you like). Finally, the website will mail it for you—in paper form. And send you a digital copy (Figure 1).

"Telegramstop" represents a marketable desire to create a meaningful past that can be gifted to the future, and to that extent, it has as much in common with Victorian photographic practices as with postmodern digital ones. It derives its appeal from an imagined future that will be much like this one in valuing its past; it identifies the present as a future source of meaning and the future as a site of backward looking. What's for sale is anticipated retrospection. Instagram works a little differently, both in terms of what it "sells" and in its relationship to the past, and some of that has to do with its digital, nonmaterial status. By using the term "nonmaterial" in conjunction

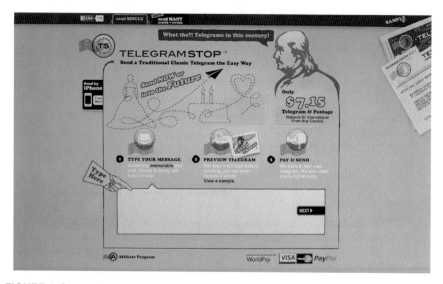

FIGURE 1 Screenshot: *www.Telegramstop.*

with "digital," I am, of course, obscuring the material reality of screens and pixel counts, as well as other factors in our daily experience of images, such as the shifting shape and weight of an iPhone. There is undeniably a physical component to the making and viewing of digital images; so far, at least, they don't just emerge from our thoughts onto our screens. There are human fingers at the computer board, as well as on the phone. Digital photography, one might argue, is just differently materialized.

But there is disagreement as to whether this justifies the claim that there is a continuum between Victorian photographic practices and contemporary ones, or whether digital photography really marks a break, rather than an evolution, from past practices. Fred Ritchin's pointedly titled book *After Photography* suggests, unsurprisingly, that the digital comprises "a markedly different environment than the analog."[1] While Ritchin acknowledges digital's common ground with analog, including the "slew of strategies" that define the history of photographic production, he nonetheless believes that what we are currently experiencing "is no less than a revolution."[2] He argues, moreover, that the language we have chosen to describe contemporary technologies has obscured their departure from former realities by implying a benign history at odds with the real harm such technologies may bring about: "We are given terms from nature and from the utilitarian everyday—apple, mouse, web, blackberry, windows, lap top, desk top, word, personal assistant, fire fox—to describe an environment that has, as of yet, no taste, no smell, and where touch is reduced to clicking and typing and sight is continually framed by yet another rectangle."[3] According to Ritchin, digital photography is no more like analog photography than a car is like a horseless carriage or, presumably, a computer "notepad" like a paper and pen. In emphasizing function over form through our nomenclature, we efface important differences between radically different objects and, as Ritchin puts it, we "minimize the manifold ways in which [those objects] long ago transcended [their] beginnings."[4]

Others see photography's history in more genuinely evolutionary terms, and digital photography as part of that history. This view stresses continuity (of function) rather than rupture (of form). Martyn Jolly, for example, argues that the "so-called 'digital revolution' … has not fundamentally destroyed, but … only intensified the trends and qualities already fundamentally inherent in the medium."[5] Jolly's argument is shaped by his view that the filing cabinet

[1] Fred Ritchin, *After Photography* (New York: Norton, 2009), 20.
[2] Ibid.
[3] Ibid., 15.
[4] Ibid., 20.
[5] Martyn Jolly, "Has the Digital Revolution Changed Documentary Photography?" *State Library of New South Wales Magazine*, May 2013.

was "the most important artifact for photography" in the twentieth century; we can understand today's conversations about the mindboggling number of images uploaded to the Internet every minute as reflecting the same archival preoccupation. Photography, Jolly writes, "was always more than just a particular technology, it was an historical convention, a social practice, an entrenched media industry, a personal relationship, and a psychological space. Shifting from film to memory cards and darkrooms to Photoshop wasn't going to change that."[6]

The title of this book is a bit of a giveaway concerning my own position, as is my continually stated belief that "the Victorians" is the best answer to Nancy Van House's question, "Why has the transition to digital been so easy?"[7] Many of the networks, spaces, and practices Jolly references have been with us since the mid-nineteenth century, when a burgeoning print culture ensured photography's proliferation not just in terms of numbers but in *kinds* of images. I will suggest that what we see today is a continued migration of photographic form in response to market forces and technological developments—on balance, perhaps, more of an evolution than a revolution, and either way something set in motion by the Victorians. But I will also argue that the shifting of photographic forms is a response to something older than the nineteenth century that will likely outlast the twenty-first: the ongoing human desire for narration.

Narrative desire, a desire to make sense of life by giving it shape, is not merely a wish to tell one's own story. It includes interest in other stories, real and imagined, and it is a contributing factor to the current market in old photographs, those found at real estate auctions or thrift stores or advertised on eBay. The monetary value of such objects is increasing, while new photographs, by contrast, pour freely every day through the virtual mail slots of our various electronic devices, mostly still attached to their stories of origin, each one different, and yet also each in its very ordinariness the same.

Presumably because of that sameness and what we have come to call "image fatigue," a variety of phone apps have become popular as ways to edit and differentiate photographs from each other. The compellingly named *Afterlight*, for example, offers a range of aesthetic interventions that are comparable to photographic manipulation in its earliest days, comparable in that such interventions occur *after* the photograph has been made (just as I wrote these pages after I had finished writing the rest of this book). While such postscripts are nothing new, their modern forms invite reflection on the specific preoccupations of our own time. What are we to make, for example, of the nostalgia filter, an app that instantly endows photographs with age in the form of a color overlay? What about the filter titled *1977*, presumably to indicate that it produces the temporal

[6]Ibid.
[7]Nancy Van House, "Personal Photography, Digital Technologies and the Uses of the Visual," *Visual Studies* 26.2 (June 2011), 125–34, 125.

atmosphere of 1977—or the imagined atmosphere of that year, since its most enthusiastic consumers were born after that date?[8] What of *1977&8221*, which frames its images in the square white border of the Polaroid? What explains the popularity of "Pic Grunger," an app that gives images the effect of scuffing and creasing, to convey the material life of an object that has travelled through time? Why should the desired look of the present be the past?

These questions are not really about photography at all, but are more precisely understood as questions that photography currently poses about history, identity, and the passage of time. Indeed, a history of photography might be mapped by the kinds of questions that photography has raised. Those questions have always concerned life as much as they have art; they remain broad, philosophical ruminations about what it means to be human at a particular point in history, and they might be explored within any of the disciplines with which photography, in all its formal and technological variation, engages. Twenty-first-century work on the history of photography reflects an emerging sense of the need for wider conversation, conversation that attends to the technical realities of photography, including the limitations, innovations, and commercial pressures of specific historical moments and photographic "networks," a development obviously consistent with the contemporary social practice of photography. Certainly, much recent work has been defined by what Geoffrey Batchen describes as "a shift of analytical emphasis from the producers of photographs to their owners," a shift that offers, Batchen suggests, a new way of thinking about the history of photography in terms of its reception. The results of that shift have resulted in an increased focus on process and method as photography is increasingly perceived as "a dynamic mode of apprehension rather than a series of static pictures."[9]

Readers familiar with the theory of reader response popularized in the 1980s by Stanley Fish will find the parallels striking. Just as Batchen's viewpoint suggests an understanding of "photography" as verb rather than noun—a doing rather than a being—Fish insists that a written text *is* what it *does*. We understand what we read as we read it, and as we read our understanding, and, according to Fish, our production of the text, evolves.[10] Meaning thus

[8]According to Gil Bartholeyns, most users of digital nostalgia are themselves digital natives and are therefore too young to actually remember the 1970s, a reminder that one doesn't actually have to have lived through something to be nostalgic for it. "The Instant Past: Nostalgia and Digital Retro Photography," in *Media and Nostalgia: Yearning for the Past, Present and Future*, ed. Katharina Niemeyer (London and New York: Palgrave Macmillan, 2014), 51–69, 54.

[9]Geoffrey Batchen, "Snapshots: Art History and the Ethnographic Turn," *Photographies* 1.2 (2008), 121–42, 127.

[10]See Stanley Fish, *Surprised by Sin: The Reader in Paradise Lost* (Cambridge, MA: Harvard University Press, 1967); and "Interpreting the Variorum" (1976), in *Is There a Text in This Class? The Authority of Interpretive Communities* (Cambridge, MA: Harvard University Press, 1980), 147–74.

understood is dynamic, but it is also vulnerable to the individual contingencies of one's history as a reader and as a member of a community.

Fish is best known for his attention to those "interpretive communities," contexts within which readers read, and which determine the kinds of readings they are likely to produce and understand. The emergence of cultural studies in recent decades has to some degree resulted in the naturalization of that idea; few would argue today that how we read isn't to some degree determined by the various constraints of our historical and geographical realities. Moreover, an increased interest in interpretive communities is reflected in a broader sense of what "doing history" might entail. As Modris Eksteins puts it, "The history of modern culture ought ... to be as much a history of response as of challenge, an account of the reader as of the novel, of the viewer as of the film, of the spectator as of the actor."[11]

But Fish's work in the 1980s had other consequences for literary scholars, particularly where the study of photography was concerned. The intensified interest in reading practices at that time contributed to a more frequent use of the language of reading when looking at pictures as well as words. People used to writing about words began writing about pictures as "visual texts," implicitly de-emphasizing the distinction between words and images. In the case of Victorian studies this has had mixed results, since, as Owen Clayton argues, to write meaningfully about nineteenth-century literature's relationship with photography, "it is necessary to be not only a literary scholar but also, to some extent, a historian of photography. This is because of the significant differences that existed between photographic methods during the Victorian period—differences that find no equal in the twentieth century."[12] There has unquestionably been a tendency in photo-literary studies to overlook the technological differences of the medium in favor of some broader thing called "photography" that in actuality was experienced very differently by different people in different contexts and at different times. In 1997, Patrick Maynard noted that "almost all writing about photography ... tends to begin with the alleged nature of the product rather than with its production and use,"[13] as though the hurdle of determining "what it is" had at that point still to be attempted before any work on "what it does" might be underway. In my own work, admittedly, I have found it challenging to keep the "nature of the product" at bay. But the last two decades of scholarship have marked significant changes

[11]Modris Eksteins, *Rites of Spring: The Great War and the Birth of the Modern Age* (Boston and New York: Houghton Mifflin, 1989), xiv–xv.
[12]Owen Clayton, "Barthes for Barthes' Sake? Victorian Literature and Photography beyond Poststructuralism," *Literature Compass* 12.4 (2016), 245–57, 245.
[13]Patrick Maynard, *The Engine of Visualization: Thinking through Photography* (Ithaca, NY: Cornell University Press, 1997), 9.

in that regard. The "ethnographic turn" that Batchen identifies in twenty-first-century photographic studies, the shift in interest away from individual artist-figures and canonical works in favor of photographs characterized by availability and ordinariness, is contributing to a new photographic historiography. In its focus on the different networks within which photography is embedded, much of the new history offers alternative ways of thinking about how photography's meaning has been produced by those different contexts. What photography *does* rather than what it *is* has become the driving question, and it's a question that I ask in this book as well.

<p style="text-align:center">***</p>

What Gil Bartholeyns calls the "backward looking aesthetic" of postmodernism was fully on display in Victorian culture, and what Bartholeyns says is suggestive with regard to the nineteenth as well as the twenty-first century: "The backward looking aesthetic appears to be a way of cordoning off the time we find so hard to inhabit ... of mounting a defense against the feeling that time passes quickly, leaving no trace. The outcome, the feeling of nostalgia, connects the present to the past."[14] While Bartholeyns is right that it is hard to "inhabit" the present, it is far from clear whether desire for the past is the result of that difficulty, or its source. The free-floating nostalgia of contemporary culture has, he points out, no referent: "It is not based on anything that came before." He concludes, therefore, that it is deliberately produced "in a bid to render the present more poignant."[15] But perhaps it is simpler than that: the present *is* poignant, and to those whose conscious experience of time passing is almost entirely through photographs, nostalgia is simply the modern condition, the daily sense that real life happens elsewhere—and that by the time we see it, it is the past. When, in *To the Lighthouse*, Virginia Woolf makes Mrs. Ramsay pause as she leaves her dinner table, and look back at the scene of her family and their guests with the self-consciousness of a photographer, the reader understands that Woolf marks the moment for significance. She cuts it off from the temporal flow of events so that we can return to it as a static image (as indeed I will, later); in framing that moment like a photograph, she endows it with nostalgia. Barthes once described a photograph as a pointing finger, a way of saying "Look."[16] Today's nostalgia filter also says, "look," but it adds, albeit redundantly, "Time passing!" By the time you look at this photograph, the filter says, you're like Mrs. Ramsay in the doorway after her dinner party, looking back. It's already the past.

[14]Bartholeyns, 67.
[15]Ibid., 60.
[16]Roland Barthes, *Camera Lucida: Reflections on Photography*, trans. Richard Howard (New York: Hill and Wang, 1981), 5.

The immense popularity of nostalgia filters deserves more attention than it has received, but part of the problem is that the field changes so quickly. When I mentioned to a friend that I was going to write about Instagram, he cautioned against using the present tense: "Be sure to use the past," he said, "because whatever you're talking about is already over." Well, yes and no. Instagram will have doubtless changed or become extinct by the time you read this, but its popularity, like that of other digital platforms for the dissemination of images, points toward a remarkably consistent desire among human beings for *collaborative* recall. As much as it may be driven by the urge to make pictures and tell stories, Instagram also represents the desire to share them: "looking together," as Woolf wrote of the Ramsays' dinner guests, "united them."[17] The very fact that the number of followers and likers is part of the Instagram exchange suggests that the coming-into-being of the image in this way is a matter of mutual consent and appreciation, as though the texture that time once conferred on the material photograph is instead now produced across space through the taps of distant fingers on faraway phone screens. The more an image is "liked," the more it matters. Its authenticity—its mattering—is conferred by consensus.

Barthes's experience of photographic nostalgia was so intense that in *Camera Lucida* he could not bring himself to show readers a particularly beloved photograph of his mother as a child. The power of this photograph lay in the apparently minimal intervention between subject and object; in the image Barthes found a "treasury of rays," precious because they were produced by light in that moment glancing off "her hair, her skin, her dress, her gaze."[18] Nostalgia filters, by contrast, are postscripts, add-ons, writing after, or over, the light, and whatever emotion they elicit is likely to be shared in the public sphere. In this, contemporary social media recalls the mid-Victorian belief in the importance of community and the utilitarian; indeed, the conceptually suggestive vocabulary of networks and connections that defines the twenty-first century echoes throughout Victorian philosophy and literature. Think of *Middlemarch* or *Bleak House*, for example, novels that display a keen interest in the idea of a "social web" in which all are implicated.[19]

Contribution to a community's sense of itself, a sense predicated on the writing and transmittal of personal memories as well as public history, occurs

[17]Virginia Woolf, *To the Lighthouse*, 1927 (New York and London: Harcourt Brace Jovanovich, 1981), 97.

[18]Barthes would likely not have been a fan of the nostalgia filter. "I am not very fond of Color," he writes, "What matters to me is not the photograph's 'life' … but the certainty that the photographed body touches me with its own rays and not with a superadded light." Barthes, *Camera Lucida*, 81–82.

[19]Think also of Mrs. Grundy as presiding over Instagram etiquette, a code of manners that regulates posting behavior. The re-posting of a photograph, for example, must be labeled as such, with the term "regram," while being a "ghost follower" (an inactive spectator) may be frowned upon, since it marks a failure to participate in the circulation of the image.

in different ways. Today, photographs are crucial in social networking, but written feedback remains an expected part of the exchange, and photographs in any form still invite language. Digital photography has permitted language to assume new functions: contemporary use of the hash tag, for example, as a way of labeling an image, also writes it into the network, so that it connects to other tangentially related images.[20] This too suggests similarities with Victorian photography; the previously mentioned "migration" of photography from the material to the digital may be better understood as a reformulation of how we define and recognize materiality. Today, words connect *and* network images while simultaneously describing them. Meanwhile, the word "network" has extended its purchase from noun to verb, just as the practice of photography— making, sharing, viewing—has arguably superseded the photograph itself in terms of importance. Indeed, the source of a photograph (where it was taken, and by whom) is frequently and deliberately *dis*-connected or made secondary to the thematic significance of the image—how it functions, or is intended to function, in the network into which it has been inserted. Shared via Instagram, a picture of a sunny field, for example, becomes "loving that sunshine," an observation about what the image means to its poster that refers neither to sunshine nor field but to its creative, responsive subject.

We recall the past in those very terms in which we have most frequently looked back, and our language bears the marks of that kind of looking. It produces, in other words, its own nostalgia filters, linguistic traces of photography that for the most part go unremarked because their way of looking is naturalized. The consequences of that naturalization are hard to determine, in part because it is how we remember now, and, as I will argue in this book, we learned it from the Victorians.

[20]I understood the hash tag as a concept only when it was described to me as "a sort of internet Rolodex for images with that hash tag attached." The original object of the Rolodex was necessary for my understanding of the function of the hash tag, whereas the Rolodex, for the digital native, is presumably a sort of object hash tag.

Introduction

"Stars from the Empty Sky"

Oliver Wendell Holmes—Boston physician, poet, essayist, father of the famous future jurist, and keen amateur photographer—was once developing a wet collodion negative when he was struck for a moment by an existential doubt. "What if," he wondered, as he poured chemicals onto the glass plate, "there were no picture there?"[1]

For today's reader, "What if there were no picture there?" has metaphysical potential as a question. Like photography itself in its earliest days, it's the stuff of science fiction. What if your camera, and everyone else's, suddenly stopped working? What if, starting from now, all visual access to the past were suddenly denied? What if the past suddenly withdrew every photographic trace of itself from frames, screens, all images still and moving? What if photography's door to our recorded pasts, our childhoods, our long-dead grandparents, suddenly closed? In other words, what if the past became for us what it was for every person who ever lived before 1839?

Fortunately for the comfort of his *Atlantic Monthly* readers in 1863, who were about twenty-four years on the other side of the historical divide officially marked by the invention of photography and were thus, I will argue, closer to us in the way they remembered the past than they were to their own grandparents, Holmes was freed from such ruminations by an emerging image. There was indeed a picture there, and he describes it as though he is witnessing the dawning of a new world:

> Stop! What is that change of color beginning at this edge, and spreading as a blush spreads over a girl's cheek? It is a border, like that round the picture, and then dawns the outline of a head, and now the eyes come out from the blank as stars from the empty sky.[2]

[1] Oliver Wendell Holmes, "Doings of the Sunbeam," in *Soundings from the Atlantic*, ed. Oliver Wendell Holmes (Boston: Ticknor & Fields, 1864), 228–81, 242.
[2] Ibid., 242.

This particular photograph is a portrait, and Holmes treats its appearance like a creation myth, inspired by the idea that the outline of a head is like the sun rising, that eyes show up in the previously empty sky like stars.[3] Moreover, although "while we look it seems to fade again, as if it would disappear," Holmes assures us to "Have no fear of that; it is only deepening its shadows."[4] The image is not fading away; on the contrary, it is becoming solid. It is getting weightier, closer with every shade to the heaviness of the reality of which it is now a part. We might even say that from Holmes's point of view the collodion is reversing the direction of life: what was past is returning from the dead.

For Holmes this is a biblical moment, clearly profound enough to carry the mythical language he chooses to describe it. For him, the darkroom is a "shadowy realm where Cocytus flows in black nitrate of silver and Acheron stagnates in the pool of hyposulphate," where "invisible ghosts, trooping down from the world of day, cross a Styx of dissolved sulphate of iron, and appear before the Rhadamanthus of that lurid Hades,"[5] there, presumably, to be fixed rather than judged. Holmes pours on "the Stygian stream"[6]—the "proto-sulphate of iron"—and out of the blank sky a face appears; just as, some years earlier, a leg, and the suggestion of a top hat, broke through the wake of vanishing history as an unknown man having his boots blacked on Paris's Boulevard du Temple had his image captured on a silver-plated sheet of copper, and, thanks to Daguerre, became an unwitting survivor of the nineteenth century, whose curious afterlife thus far has included being a staple in every photographic history, the subject of much musing on the passage of time, and the illustration for at least one article in *PMLA*[7] (Figure I.1).

If asked about the invention of photography, most people would reasonably point to the early nineteenth century as the time when so-called "light writing" first appeared. But light has always written itself onto the world. Throughout the ages, incarnations of the camera obscura threw temporary images of the outside world on surfaces that did not retain them. Eighteenth-century drawing-room walls, fifteenth-century sheets of paper, tenth-century scrims of fabric, the cool

[3]Holmes writes this essay in order to "take the reader into the sanctuary of the art" and to describe the various stages of making a photograph (236); it is not clear whether his description is specific or composite. It's also not clear whether the portrait he photographs is, in fact, another photograph or a painting.
[4]Ibid., 243.
[5]Ibid., 241.
[6]Ibid., 242.
[7]See Lynn R. Wilkinson, "Le Cousin Pons and the Invention of Ideology," *PMLA* 107.2 (1992): 274–89. See also Samuel Morse's comments regarding this image which was among those shown him by Daguerre during a trip to Paris in 1839:

Objects moving are not impressed. The Boulevard, so constantly filled with a moving throng of pedestrians and carriages was perfectly solitary, except an individual who was having his boots brushed. His feet were compelled, of course, to be stationary for some time, one being on the box of the boot black, and the other on the ground. Consequently his boots and legs were well defined, but he is without body or head, because these were in motion.

Beaumont Newhall, ed. *The History of Photography* (New York: Museum of Modern Art, 1982), 16.

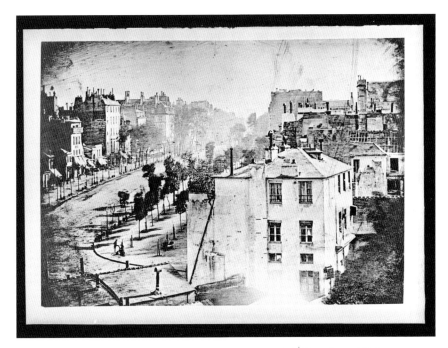

FIGURE I.1 Louis Jacques Mandé Daguerre, *Boulevard du Temple*, c. 1838.
© Bayerisches National Museum, Munich (inventory no. R 6312.1-8, photo no. D5163).
Photo: Marianne Stöckmann.

stone interiors of grottos and caves—all functioned as sites of spectatorship, spaces of varying sizes throughout human history into which light pictures of the outside were invited but could not be made to stay. And there were also natural spaces where there were no human beings at all but where prismatic images nonetheless danced, as presumably they still dance, on the dark insides of hollow trees or abandoned buildings or rock crevices. In the third decade of the nineteenth century, however, the history of light writing took a sharp and formally significant turn. Thanks to the development of chemical processes of different kinds, camera-produced images no longer vanished but could be fixed. They could merge with, and evolve into, more temporally stable material objects. The things that Victorian photographs showed were thus thrown into a different relationship with time, while their original subjects moved onward in chronological terms.

It is hardly surprising that to many Victorian imaginations, every boot and face that took photographic form, every leaf, star, and roofline that appeared out of the blank sky of pewter, glass, or paper, subsequently appeared to offer itself as metaphor for memory. Those metaphors shaped the reception of photography in the nineteenth century, since in many cases before people actually saw photographs, they read about them. Their first experience of photography was in words, although, as Marcy Dinius notes, "we have lost sight of this mediation and its significance to how we

see photography even today."[8] More than images merely slotted into a text, when photographs entered the language of newspapers and novels they bled into discourse; they shaped and infiltrated the very thing that attempted to define and describe them. They left traces of themselves.

Technologies that bring about conceptual shifts in our relationship to time and space accomplish those shifts in various ways, and an increase in our vocabulary is necessarily one of them. That new vocabulary can seem startlingly rapid in its adoption; the speed with which language changes arguably reflects the intensity of social desire to accommodate the new reality. Moreover, language is dynamic as well as descriptive, and while new words and phrases are usually necessary to name new objects and experiences, they also actively, if unobtrusively, mediate the world that generated them. At a certain point, the metaphors subsume the reality; as Wallace Stevens so memorably put it, "what we said of it/became a part of what it is."[9]

In this book I will be drawing on different kinds of writing, just as I will reference different technologies and different interpretive communities, but I will be making a special case for self-consciously aesthetic prose as part of photography's historiography. Paul Fussell's study of the ways in which English literature shaped British understanding of the First World War still provides a useful model for thinking about how works that are endowed with particular value by their respective communities offer interpretive frames for new realities.[10] In the case of the First World War, the literary frame (Shakespeare, Housman, the *Oxford Book of English Verse*) was to prove inadequate; nonetheless, Fussell drew meaningful conclusions about the imaginative work of poems and plays based on his understanding of a prewar reading community that was defined by common educational requirements and cultural expectations. In this book I discuss canonical literature of the Victorian period with a similar understanding of the canon's limitations and usefulness. I like Robin Kelsey's description of canons as "conversations around which a culture can define itself."[11] Canonical works arguably teach us more about such conversations than they do anything else, however, a point that I will make more extensively in the last chapter. They are repositories and resources for a national identity, prosthetic memories for cultures increasingly dependent on their relationship to the past. While Lindsay Smith has demonstrated Victorian poetry's engagement with photography,[12] I will suggest that novels are an especially privileged site for examining authorial preoccupations

[8]Marcy Dinius, *The Camera and the Press: American Visual and Print Culture in the Age of the Daguerreotype* (Philadelphia, PA: University of Pennsylvania Press, 2012), 2.

[9]Wallace Stevens, "A Postcard from the Volcano," in *Collected Poems* (New York: Vintage, 1990), 158.

[10]Paul Fussell, *The Great War and Modern Memory* (Oxford, New York and London: Oxford University Press, 1975).

[11]Robin Kelsey, *Photography and the Art of Chance* (Cambridge, MA: The Belknap Press of Harvard University Press, 2015).

[12]Lindsay Smith, *Victorian Photography, Painting, and Poetry: The Enigma of Visibility in Ruskin, Morris, and the Pre-Raphaelites* (Cambridge: Cambridge University Press, 1995). See also Andrew D. Miller, *Poetry, Photography, Ekphrasis* (Liverpool: Liverpool University Press, 2015).

with temporality and recollection. Nicholas Dames has argued that memory was under reconstruction during the nineteenth century and that the instability of concepts associated with remembering helped foster a literary nostalgia that ultimately worked to obscure truths novels couldn't comfortably accommodate.[13] For Dames, the Victorian novel offers a prehistory to the modern memory that is on display in early-twentieth-century literature, a literature distinguished by its preoccupation with remembering. I will argue, however, that the authorial evasions, creations, and refusals of memory that Dames documents in Victorian novels may be somewhat differently illuminated if we consider the extent to which their authors had to engage with new technologies that relocated the site of memory's production from human beings to machines. Throughout the nineteenth century, the work of remembering was changing in its demands. Victorian literature, and in particular Victorian novels—works whose very shape and existence, as Dames shows, depended upon the active engagement of their readers' memories—helped define the meaning of the past at the same time that photography provided a variety of new ways to view it.

Memory itself is not, of course, and despite the title of this book, an *invention*, but nor is it clear whether photography is best described as an invention, either; in fact, recent thinking on the subject argues otherwise. Kaja Silverman proposes that photography is the natural collaboration of nature with an image-making process, and should therefore be understood as the world's own coming-into-being of another version of itself. In Silverman's account, the world reveals itself to us through a kind of generative agency that brings forth, in different guises and at different times, aspects of its own being that might be more accurately described as having been discovered than invented.[14] Silverman's work marks a departure from traditional accounts of photography's history, but it is by no means alone in rethinking the boundaries traditionally maintained between photography's history and prehistory.[15] Tanya Sheehan and Andrés Mario Sevigón have called attention to another significant boundary shift by publishing a collection of essays affirming the view that "the historiography of photography no longer belongs exclusively, or even chiefly, to the discipline of art history."[16] There's plenty of evidence of this, and plenty of reminders recently, too, that for most of the period under consideration in this book, "photography" was an umbrella term, no more specific than the word "art." Much contemporary work in photographic history now reflects the view that a stable,

[13]Nicholas Dames, *Amnesiac Selves: Nostalgia, Forgetting and British Fiction, 1810–1870* (Oxford and New York: Oxford University Press, 2001).

[14]Kaja Silverman, *The Miracle of Analogy, or The History of Photography, Part 1* (Stanford, CA: Stanford University Press, 2015).

[15]See especially Batchen, *Burning with Desire: The Conception of Photography* (Boston: MIT Press, 1999); Jonathan Crary, *Techniques of the Observer: On Vision and Modernity in the Nineteenth Century* (Boston: MIT Press, 1992).

[16]Tanya Sheehan and Andrés Mario Zervigón, eds. *Photography and Its Origins* (New York: Routledge, 2015), 4.

unified photography has never existed. Owen Clayton, for example, foregrounds the many different recording and production technologies of the nineteenth century by using the word "photographies."[17] Unlike John Tagg, who used the term to acknowledge the many uses to which photography might be put,[18] Clayton employs it as a necessary reminder of early photography's formal and technical variability before its "work of consolidation was complete"[19]—before, that is, something more uniform was understood by the word *photography*.

It is because of that variability, the range of practice, technology, and readership of photographs from 1839 until the early twentieth century, that close reading of literary texts is crucial to photography's new historiography. Literature's engagement with photography occurs in the imagination, and it is in the imagination that the symbolic power of photography resides. Whatever "work of consolidation" had to be done, literature was one of the sites on which that work can be said to have been carried out. The Victorian novel's frequent vagueness regarding the specifics of photographic practice, moreover, suggests that the technical variations of photography were of lesser significance to many authors than the imaginative fact of its existence; the figurative language of self-consciously crafted prose arguably conveys more powerfully than any other historical document what it was like to live, as many Victorians did, first in a world without photographs, and then in a world with them. The human significance of photography cannot be fully charted without attending to the role that it has played in our dreams.

It is precisely because Holmes's essays on photography are informed by his dreams that the essays are suggestive regarding photography's role in the development of "modern memory." I use that term deliberately in this book to describe a concept of pastness peculiar to the photographic age, but in fact the age of photography was (and still is) an age of technological innovations, any one of which might challenge an individual's thinking about her relationship to the passage of time. Stephen Kern has described the extraordinary range of events and inventions in the late nineteenth and early twentieth centuries that forced, he argues, a dramatic shift in the conceptualization of time, from the railway to the gramophone to the movie camera.[20] Photography had a particularly active role in the shift Kern describes, owing not only to the variety of its forms and the many modes of its delivery and consumption but also to its increasing use in the writing of history. By the 1890s, photographic record societies had begun to document local and national histories that contributed to a

[17]Owen Clayton, *Literature and Photography in Transition, 1850–1915* (London and New York: Palgrave Macmillan, 2015), 2.

[18]John Tagg, *The Burden of Representation: Essays on Photographies and Histories* (Amherst: University of Massachusetts Press, 1988).

[19]Clayton, *Literature and Photography*, 3.

[20]Stephen Kern, *The Culture of Time and Space, 1880–1918* (Cambridge, MA: Harvard University Press, 1983).

sense of public memory,[21] a documentation that Elizabeth Edwards has extensively explored.[22] Private memory also took photographic form, a development carefully nurtured throughout the decades when Kodak dominated the market. According to Gil Pasternak, Kodak "helped to make photographs synonymous with biography by establishing a public discourse that framed the camera as an autonomous, one-eyed witness, and portrayed the occasion of picture taking as a routine activity in the photographable spectrum of lived experience."[23] Pasternak suggests that that routine activity had to be taught, or at least that Kodak didn't take it for granted that the link between photography and life narrative was obvious. Nonetheless, it stuck.[24]

The centrality of photographs to memory practices of all kinds today is striking. We make and share them daily, as in other eras we might have written letters and journals; we use them to connect with others and to mark our passage through time. Nonetheless, photography has been kept at bay in much work on memory, presumably for reasons like those cited by Susannah Radstone and Bill Schwarz: "a focus on 'mediated' memory," they write, "on the role of media in transmitting memory beyond the individual—risks misconstruing the media, in all their complex forms, histories, genres, and technologies, simply as 'memory.' This blurs the distinction, not only between individual memory and public discourses, but also between specific processes of production, distribution, and reception."[25] The popular conflation of memory with photography, in other words, runs the risk of vagueness as well as the intellectual cherry-picking with which interdisciplinary study may be charged, while a similar collapse of difference between history and memory makes for a complex triangulation in which no one thread can be independently pursued. Eliding important differences among the three may cause us to overlook or miss the specific, historic realities of material consumption. Writing about memory, Radstone and Schwarz argue, is not the same as writing about photography.

As true as that is in theory, and as important as historical realities are, in practice it is close to impossible nowadays to read some Victorian works on memory without thinking about the relevance of their ideas to the postmodern function of photography. When, for example, Henri Bergson argues that "Matter ... is an aggregate of 'images,'" his words, written in 1896, describe the stuff of twenty-first-century lives, the way in which that stuff is constructed, produced, and shared on a daily basis. And when Bergson writes that what he means by the word *image* is "a certain existence which

[21]Ibid., 39.

[22]Elizabeth Edwards, *The Camera as Historian: Amateur Photographers and Historical Imagination, 1885–1918* (Durham and London: Duke University Press, 2012).

[23]Gil Pasternak, "Taking Snapshots, Living the Picture: The Kodak Company's Making of Photographic Biography," *Life Writing* 12.4 (2015), 431–46, 443.

[24]Ibid.; see also Nancy Martha West, *Kodak and the Lens of Nostalgia* (Charlottesville: University Press of Virginia, 2000).

[25]Susannah Radstone and Bill Schwarz, eds. *Memory: Histories, Theories, Debates* (New York: Fordham University Press, 2010), 6–7.

is more than that which the idealist calls a *representation*, but less than that which the realist calls a *thing*,"[26] and when he locates memory at "the intersection of mind and matter,"[27] he articulates our experience of contemporary digital photography. What makes Bergson's work particularly appealing is its commonsense approach to relations between perception and memory, for while on the one hand he regards them as fundamentally different, he is also willing, on the other hand, to grant that our lived experience of them suggests otherwise. As Keith Ansell-Pearson puts it, "in actuality memory [for Bergson] is inseparable from perception; it imports the past into the present and contracts into a single intuition many moments of duration."[28] When we read Bergson today, it feels as if another facet of his work is for the first time coming into view; like a gradual revelation of its potential, his text, unfixed, continues to develop and acquire new resonance in our own time.

Where memory theorists *have* engaged with photography, they have on the whole been careful to avoid conflating the two. Siegfried Kracauer, writing between the wars, kept images in memory distinct from images produced by the camera because, he argued, the photograph's point of reference is not, in fact, a memory but rather a likeness that no longer exists:

> Memories are retained because of their significance for that person. Thus they are organized according to a principle that is essentially different from the organizing principle of photography. Photography grasps what is given as a spatial (or temporal) continuum; memory-images retain what is given only insofar as it has significance. Since what is significant is not reducible to either merely spatial or merely temporal terms, memory- images are at odds with photographic representation. From the latter's perspective, memory-images appear to be fragments but only because photography does not encompass the meaning to which they refer and in relation to which they cease to be fragments. Similarly, from the perspective of memory, photography appears as a jumble that consists partly of garbage.[29]

By taking the moment out of time, Kracauer suggested, a photograph appears to make time the subject of its picture; the photograph itself bears no meaningful relation to its original subject. For Kracauer, like many born into the nineteenth century, memory was endangered by photography in that the latter appeared to supplant or efface the work of the former.

[26]Henri Bergson, *Matter and Memory*, 5th ed. (1908), trans. Nancy Margaret Paul and W. Scott Palmer (Digireads.com, 2010), 5.
[27]Ibid., 7.
[28]Keith Ansell-Pearson, "Bergson on Memory," in *Memory: Histories, Theories, Debates*, eds. Susannah Radstone and Bill Schwartz (New York: Fordham University Press, 2010), 61–66.
[29]Siegfried Kracauer, "Photography," trans. Thomas Levin, 1927. *Critical Inquiry* 19 (3) (Spring 1993), 421–36, 425–26.

Walter Benjamin also famously returned several times in his work to the relationship between memory and photography. Esther Leslie argues, indeed, that to Benjamin it seemed "as if in modernity memory cannot be thought [of] without recourse to the technologies that usurp its role as archivist."[30] Yet it is not in such frequently cited works as "A Short History of Photography" (1931) or "The Work of Art in the Age of Mechanical Reproduction" (1936) that photography left its traces on Benjamin's writing, so much as in his memoirs, which are not really about photography at all. As Benjamin looks back in "A Berlin Chronicle" (1932) and *Berlin Childhood around 1900* (1938), he notes, as Leslie puts it, that "the material form of memories is of equal significance to the act of reminiscence."[31] It's hard to imagine a more succinct statement of our postmodern experience with photography, but it's also arguable that what keeps Benjamin, and Kracauer, and Barthes central to the canon of photographic theory, and still relevant to current work on photography, is what makes Holmes's writings important: they attend to photography's human significance. They are interested less in what photography is, and more in what it *does*.

Later on I'll suggest that photography provided Benjamin with a method for personal recollection that was a legacy of his nineteenth-century childhood. His memoirs are not about photography, but having been crafted in the age of photography, they are necessarily *of* photography. His memoirs are more suggestive in this regard than his theories, about which I have little to say here. Indeed, as is likely already evident, I am more interested in expressive, figurative, and creative writing than in theory, and I will make no attempt to discuss the ontological shortcomings of photography as metaphor for memory. In relative terms, metaphors are about as revealing as they are useful to the societies that generate them, and for that reason alone they should be taken seriously.

<p style="text-align:center">* * *</p>

For sheer joy in the moment at which the boot emerges, the face takes shape, and the past becomes a modern memory, there's not much prose that measures up to Holmes's three essays on photography, each published in the *Atlantic*.[32] After several years of buying, viewing, and making photographs himself, Holmes wrote that he was "more than ever impressed with the vast accession of happiness which has come to mankind through this art, which has spread itself as widely as civilization."[33] That

[30]Esther Leslie, "Siegfriend Kracauer and Walter Benjamin," in Radstone and Schwarz (123–35), 127.
[31]Ibid.
[32]"The Stereoscope and the Stereograph," *Atlantic Monthly* 3 (1859), 738–48; "Sun-Painting and Sun-Sculpture; with a Stereoscopic Trip across the Atlantic," *Atlantic Monthly* 8 (1861), 13–29; "Doings of the Sunbeam," *Atlantic Monthly* 12 (1863), 1–15. All reproduced in Holmes, *Soundings from the Atlantic* (Boston: 1864), 124–281. Page references in this book are to the *Soundings* edition.
[33]Holmes, "Sunbeam," 233.

faint echo of Stendhal—"La beauté n'est que la promesse du bonheur"[34]—is here given a twist, made more generous. Where beauty in Stendhal is the *promise* of happiness, with a deferred or eternally anticipated point of arrival, in Holmes the beauty and "vast" happiness of photography are conflated, both already achieved and always still to come.

Holmes was enthralled with making photographs. The rituals of preparation at that time were many, and each had to be done carefully by the light of a "feeble yellow flame from a gas-light."[35] Carefully and methodically, he charted the various stages, beginning with the camera itself that, along with its chosen subject, waited in position in the bright natural light of the adjacent studio. Having described the process of readying the glass plate with the "thin syrup-like fluid" of iodized collodion, Holmes writes of "inclining the plate gently from side to side, so that it may spread evenly over the surface."[36] Next the plate must be positioned "on a flat double hook of gutta-percha" before it is lowered into its "nitrate-of-silver bath."[37] Next the now porcelain-white "milky tablet" must be sheathed in its "shield" in "utter darkness" so that "the charm" might not be broken. Having carried the shield out of the darkroom and over to the camera, and lowered it, carefully, into the groove that will now hold the "sensitive plate,"[38] Holmes finally arrives at the "tremulous moment" of lifting the brass cap off the lens.[39] This is no mere mechanical procedure, but rather something intuitive, even somatic; indeed, unless readers are unfortunate enough to count themselves among the "naturally unrhythmical" who must use a watch, Holmes writes that they should now begin to "count seconds ... by the pulsations in our souls."[40]

Although Holmes cannot be quoting Walter Pater here, since Pater has not yet penned his famous lines at the end of the *History of the Renaissance* about "getting as many pulsations as possible into the given time,"[41] Holmes surely would have included photography among the pulsations that make for a full and vivid life. Aesthetic pleasure of the Paterian variety, extravagantly, life-affirmingly sensual, is everywhere in Holmes's writings on photography, and his profound excitement in the technology and its ramifications is intended to be contagious. In his first essay on the subject (1859), he finds photography's triumph "audacious, remote, improbable, incredible."[42] Holmes does not fear overstatement; he proclaims that photography ushers in "a new epoch in the history of human progress."[43] And yet, he notes, so quickly has it been

[34]Stendhal, *De L'Amour* (Paris: Gallimard, 1822).
[35]Holmes, "Sunbeam," 237.
[36]Ibid., 238.
[37]Ibid., 239.
[38]Ibid., 240.
[39]Ibid., 241.
[40]Ibid.
[41]Walter Pater, *Studies in the History of the Renaissance* (London: Macmillan, 1873), 212.
[42]Holmes, "The Stereoscope," 127.
[43]Ibid., 165.

embraced by nineteenth-century culture, so easily has it taken its place among the ordinary, that even by 1859, a mere twenty years after news of Daguerre's work was made public, photography "has become … an everyday matter with us, [so] that we forget its miraculous nature, as we forget that of the sun itself."[44] Two years later, he bemoaned the fact that "there is a strange indifference to [the stereograph], even up to the present moment, among many persons of cultivation and taste. They do not seem to have waked up to the significance of the miracle which the Lord of Light is working for them."[45] The purpose of his three essays was to wake up those many persons, and to alert them to the new world that was photography.

If some members of the general public, even those of "cultivation and taste," seemed lacking in excitement, or at least imaginatively "indifferent" to its broader significance, it may have been because, as noted earlier, Holmes and his readers lived in an age of scientific and technological wonders. As one observer in 1839 put it, "We live at a singular epoch—steam has increased five-fold the number of our labourers. The railroads double that fugitive capital called life—gas replaces the sun—innumerable are the experiments to travel through the air."[46] Photography had to compete for mental attention with other breakthroughs of the day such as the railroad-car, the telegraph, and chloroform. For Holmes, photography won hands down: in his writings, he is adamant that it is a far greater accomplishment than any other invention, one whose implications simply could not be grasped at that particular historical moment. The imaginary future uses of the railway, or of anesthesia, roll out easily, he wrote, before the mid-nineteenth-century mind. Their possibilities are marvelous, certainly, but they are also obvious. In the case of photography, however, Holmes believed that foreseeing all of its potential future uses and understanding how it was likely to change the world called for a far greater imagination than had so far been applied to it. As he put it, coining the metaphor which secured forever his association with the history of photography and his inclusion in most anthologies of early writings on photography, "this other invention of *the mirror with a memory*, and especially that application of it which has given us the wonders of the stereoscope, is not so easily, completely, universally recognized in all the immensity of its applications and suggestions."[47]

What was it that made photography different from other inventions? Why might its "applications and suggestions" be harder to grasp? Was it, as the translator's preface to Daguerre's *History and Practice of Photogenic Drawing* (1839) suggests, that "the photogenic discoveries … unfolded a 'new order of possibilities'"?[48] Holmes does not

[44]Ibid., 127.
[45]Holmes, "Sun-Painting," 177.
[46]"La Daguerreotype." *The Court Magazine* (October 1839), 436–39, 439.
[47]Holmes, "The Stereoscope," 129.
[48]L. J. M. Daguerre, "Preface," in *History and Practice of Photogenic Drawing, with the new Method of Dioramic Painting*, trans. J. S. Memes, 3rd ed. (London: Smith, Elder & Edinburgh: Adam Black, 1839), vi.

say, though he may have sensed a larger, perceptual shift that was already underway as part of the nineteenth century's transition to an image-rich culture. Such a shift in consciousness is easier to describe with hindsight than anticipation, and Holmes, for all his intuition about photography's potential, does not venture an argument about the possibility that it might already have begun to change the way that people thought, and particularly the way they thought about the past.

Experience of photography had become an "everyday matter" as a result of the wider and burgeoning image culture of the mid- to- late nineteenth century. By 1859, the American public, like the British, were consuming their daily news in increasingly illustrated form. Holmes's account of photographs and photography does not even mention the vast majority of mechanically produced images encountered daily by his readers—the variety of sketches, woodcuts, engravings, and other images that jostled for space with photographs. Victorian "photographies" were in a constant state of evolution and proliferation. Moreover, the *ephemerality* of the vast majority of images with which readers increasingly engaged and the association of those images with modernity were in some ways at odds with Holmes's message of photography's triumph over mutability and its transcendence of time, since the commercial reproduction of all kinds of images was beginning to usher in an age of visual obsolescence and insignificance. What Holmes took for indifference in the American public may have been evidence of an increased visual fluency with a variety of representational modes—of already having, paradoxically, a modern photographic sensibility.

While his essays on photography describe his interest in a very specific version of it, then, Holmes also tries to spark his readers' *imaginations*. His first piece, "The Stereoscope and the Stereograph" (1859), is today the best known and most frequently anthologized of the three, not only thanks to its use of that phrase "mirror with a memory" but also because of another rather striking extended metaphor. "Democritus of Abdera," Holmes writes, "believed and taught that all bodies were continually throwing off certain images like themselves, which subtle emanations, striking on our bodily organs, gave rise to our sensations … Forms, effigies, membranes, or films, are the nearest representatives of the terms applied to these effluences. They are perpetually shed from the surfaces of solids, as bark is shed by trees."[49] The triumph of nineteenth-century photography was to *fix* those emanations, which would otherwise become, in Holmes's rhetoric, "the most fleeting of our illusions, that which the apostle and the philosopher and the poet have alike used as the type of instability and unreality."[50]

Photography furthered the achievement of hard-surface images by allowing the films, emanations, or fleeting illusions to be fixed on paper and thus more easily shared. But the greatest achievement of all, according to Holmes, remained photography's

[49]Holmes, "The Stereoscope," 124–25.
[50]Ibid., 126.

separation of form from matter, a separation he describes as a divorce of appearance from reality, in which "Every conceivable object of Nature and Art will soon scale off its surface for us."[51] Anticipating the sharp rise in late-nineteenth-century exhibition culture and colonial record, as well as the more distant postcolonial photographic safari of the twentieth century, he enlarges upon the idea: "Men will hunt all curious, beautiful, grand objects, as they hunt the cattle in South America, for their *skins*, and leave the carcasses as of little worth."[52] Everything will be photographed; everything will be a subject for the camera; everything will thereby be saved.

Holmes clearly liked this concept of a world constantly shedding its surface, so much so that he returned to it a couple of years later in the next *Atlantic* essay, "Sun-painting and Sun-sculpture" (1861), to extend the skinning metaphor with a story of the flaying of the shepherd Marsyas by Apollo. By flaying, he coyly suggests, the story really means that Apollo "took a *photograph*, a sun-picture" of Marsyas, first having "fixed him in position against an iron rest."[53] And the widespread skinning of the moment goes on: "We are now flaying our friends and submitting to be flayed ourselves, every few years or months or days, by the aid of the trenchant sunbeam which performed the process for Marsyas."[54] People, Holmes adds, are not the only ones subject to the flaying process:

> The monuments of Art and the face of Nature herself are treated in the same way. We lift an impalpable scale from the surface of the Pyramids. We slip off from the dome of St. Peter's that other imponderable dome which fitted it so closely that it betrays every scratch on the original. We skim off a thin, dry cuticle from the rapids of Niagara, and lay it on our unmoistened paper without breaking a bubble or losing a speck of foam.[55]

Photography here is dry surface, lifted from the world's body: it is scale, skin, cuticle, an "imponderable" instance of the photographic subject.

As a poet and essayist, as well as a physician, Holmes was evidently very aware of the need for some new language to diagnose as well as describe the earliest phases of photography's history, and it's interesting to see him casting about for ways of understanding it that reference the human body. It's also clear that he wants to forge a link that connects ancient beliefs (the shedding of forms, as their originals move through the world) with philosophical preoccupations of his own day ("instability and unreality"), as well as with the distant future in which the curious, the beautiful, and the grand will be hunted for their form rather than their matter. Holmes sees photography as addressing an ancient desire to envision those forms of moments

[51]Ibid., 161–62.
[52]Ibid., 162.
[53]Holmes, "Sun-Painting," 166.
[54]Ibid., 167.
[55]Ibid., 167–68.

that otherwise "perish instantly."[56] After 1839, the daguerreotype, like Talbot's paper calotype of 1841, provided one of the modern forms in which time's "emanations" might be fixed and held, but only its form was modern. Desire to fix the moment was as old as humanity itself, and it was a desire that connected the nineteenth century, as Holmes saw it, to all of human history. But desire to fix the moment also connected the nineteenth century to *future* ages, and photography, Holmes felt, must also be understood as taking Victorian readers to a new world entirely, connecting them to a future in which their historical moment was to have a new kind of legacy. The Victorian ability to fix the image thus marks a genuine divide. Notwithstanding the many ways in which readers were, over the preceding centuries, readied for its images,[57] the refinement of processes such that the image could be first fixed, and subsequently reproduced, separated the pre-photographic world from what was to come.

Holmes was not alone in his conviction that photography liberated us all from time and space and was thus "the greatest of human triumphs over earthly conditions."[58] Indeed, Barthes's twentieth-century realization that through photographs he could look "at eyes that looked at the Emperor"[59] is not just a postmodern revelation but a response many Victorians would have appreciated. In 1891, when G. Alfred Townsend wrote up his interview of the photographer Mathew Brady for *The New York World*, he used language one might expect to find in Barthes's *Camera Lucida*: "like a ray of light still traveling toward the vision from some past world or star, Matthew B. Brady [*sic*] is at the camera still and if he lives eight years longer, will reach the twentieth century and the age of seventy-five."[60] Brady, whose own beam moves ever forward from the distant days of the civil war, connects its history to the modern world, his photographs serving as a kind of repository for national memory, a public place to affirm coherence and identity. It is precisely this imagined connection with the past that inspires Townsend to quote Brady at length on his recollections of photographing the illustrious and infamous dead:

> "I have taken Edwin Forrest's wife when she was a beautiful woman; Mrs. Sickles and her mother; Harriet Lane; Mrs. Polk. Yes, old Booth, the father of Edwin, I have posed, and his son, John Wilkes, who killed the President. I remember when I took Mr. Lincoln, in 1859, he had no beard ... I took Stanton during the Sickles trial and Philip Barton Key while alive. I had John Quincy Adams to sit for his daguerreotype and the

[56]Holmes, "The Stereoscope," 126.
[57]See Crary, *Techniques*.
[58]Holmes, "The Stereoscope," 165.
[59]Roland Barthes, *Camera Lucida*, 3.
[60]George Alfred Townsend, "Interview with Mathew Brady," *The New York World* (1891), in Goldberg, *Photography in Print: Writings from 1816 to the Present* (Albuquerque: University of New Mexico Press, 1988), 200.

full line of Presidents after that. I took Jefferson Davis when he was a senator and Gen. Taylor's son-in-law. Mrs. Alexander Hamilton was ninety-three when she sat for me."[61]

You may know some of the photographs that Brady mentions here; it may even be that your mental picture of, say, John Wilkes Booth is a memory of having seen Brady's original photograph, since Brady's work has, in our own time, created a virtual reference library for a shared visual history. Your image—is it a memory?— of Booth is, arguably, not just a picture of its subject but a kind of likeness that is historically specific, having been crafted, marketed, and consumed by people living in the nineteenth century.

And what about that feeling of familiarity that you have on coming across that photograph—your personal image of John Wilkes Booth—in a different context? It is worth noting here that the term *déjà vu* first came into use at the turn of the twentieth century at the time when much that was in the world had, thanks to photographs, already been seen. Déjà vu, which links memory with vision, and recollection with looking rather than retrieving, describes an experience that may have existed throughout human history, but for which, it seems, no term was needed until, according to the *Oxford Dictionary*, about 1903. In other words, what that word describes is not only a human sensation but also a definitively modern one, one that can plausibly be considered symptomatic of life in a photographic age.

As a category of image, photographs of people are by far the most interesting to the general population, especially when those people are not famous, but personally known. "Many care little for the wonders of the world brought before their eyes by the stereoscope," notes Holmes; "all love to see the faces of their friends."[62] Holmes, of course, is still right. Notwithstanding our lasting interest in Brady's photographs of Lincoln and John Quincy Adams, it is in its retrieval of the *personal* past, and the people in it, that photography exercises its greatest fascination. One result of that fact is that, while Victorian photographs undeniably helped forge national and civic identities, the vast majority of photographs made in the nineteenth century actually mattered to very few. They were photographs of personal pasts, photographs that spoke about the sentimental and social lives of their subjects—and still would, if it were possible to retrieve the life stories of which they are a part. In our time, most Victorian photographs have become untethered from the human narratives that produced them and once lent them significance; their relationship to the past has become a matter for the imagination. Found photographs are poignant precisely *because* they are un-tappable memories. They are lost, having somehow come apart from the person who once cared enough to preserve them. Perhaps when we treat those untethered memories carefully, it is in part because we hope someone will one day be as tender with our own.

[61]Ibid., 204.
[62]Holmes, "Sunbeam," 255.

The metaphoric conflation in that last sentence (photograph = memory) is an invention of the nineteenth century, and, as noted earlier, it has commercial roots. Daguerreotypes and calotypes were from their earliest days marketed to an interested public as material memories, and when we make and use photographs, we engage in a practice imagined and invented by the Victorians. We can say much the same about the novel, too, another art form that flourished during the nineteenth century and influenced later cultural practices. To claim that Dickens, or any other Victorian novelist, is "photographic," or "cinematic," is to miss the more interesting (and logical) possibility that film is actually Dickensian. Dickens appeals to a love of character and story; his novels are visual and spectacular and foster a taste for pictures of all kinds, including moving ones. In the same vein, a contemporary writer whose style is considered "photographic" is not necessarily either modern or postmodern. A "photographic prose style"—whatever we understand by that term—engages, consciously or not, with nineteenth-century representational practices.

Those practices included the viewing and making of paintings as well as photographs, of course, and it's important to note from the outset that much of what we might identify in literature as photographically inspired could refer equally to paintings. To identify something as distinctly photographic may seem to imply that it is distinctly not painterly, but in fact many of the passages I point to in this book are probably both. I say probably, because it is simply impossible to say that a scene in literature recalls only photography and not painting; such a claim would make no sense. From the 1840s onward, painting necessarily spoke more self-consciously about its own painterly project. A painting was a painting by someone's choice, and not a photograph. Victorian photography was in continual conversation with other representational practices, including painting, on which in the early days it frequently modeled itself. Photography was thus, to some extent, often "about" painting, but photography and painting are not the same, and as the nineteenth century moved on, the differences between them became more pronounced. Things that the Victorians might earlier have identified as reminding them of painting increasingly reminded them of those things with which they more frequently came in contact: photographs.

<p style="text-align:center">***</p>

In Part One of this book I consider Victorian photographs as products of an age in which many people's thoughts about both time and memory began to shift. My focus is largely on the rhetoric used in early accounts of photography, and how that rhetoric affirmed and secured photography's relationship to memory practices specific to the nineteenth century. In Part Two, I make my primary source of examples the case studies with which I am most familiar—namely, novels. My focus on literature is largely formal, by which I mean that I am interested in stylistics rather more than I am concerned to identify places where photographs as objects show up in the text. Just as remembering in life was increasingly shaped, arranged, and conceptualized

by photography, so remembering in literature was similarly influenced. Evidence of that influence exists in literary texts from the nineteenth to the twentieth century and beyond; indeed, I will suggest that, in a variety of different efforts to represent and engage with the past, the structuring principle of photography never disappeared into a "was," but instead became a part of what the past *is*.

My questions in this book, then, are simple, although they are not easily answered: How did the Victorian culture of photography change how people organized and narrated past experiences? To what extent was the so-called "memory crisis" of the nineteenth century a response to the invention of photography, or is photography more helpfully understood as an expression of that crisis? Might an answer to that question help us understand our own mnemonic practices? More frequently than clear answers, and perhaps more significantly, I have found plenty of evidence that versions of these questions were on people's minds from the earliest days of photography. Signs are everywhere: in the minutiae of British and American trade journals, as well as periodicals intended for the amateur photographer; in private and published correspondence, particularly during the first decades of photography's practice; in transatlantic cultural reflection, such as that by Holmes and other essayists, published as monographs or as lifestyle pieces in popular magazines; and above all in literary representations of time's passage which, I will argue, during the nineteenth and early twentieth centuries were increasingly rendered in pointedly visual terms.

Those representations, markers of their authors' engagement with cultural developments, are the foundation of this study, which explores photography's role not just in memory and literature but also in historical imagination.[63] As a term, "historical imagination" suggests an interaction with the past that is more creative, inclusive, and kinetic than the term "historical consciousness," and for that reason seems to me more apt. Imagination, moreover, is the primary substance of the novel, no matter how much it may profess to show its readers the way things are. It should be clear, however, that the imagination under consideration in this book belongs not only to the Victorians, who introduced photography to history, but also to us, photography's twenty-first-century collaborators. Just as photography became a part of the Victorian sense of the past, so we continue to fold that sense of the past into our own.

* * *

Let's return to the Boston studio. Several pages ago, we left Oliver Wendell Holmes in 1863, in the act of removing the lens from his camera to take a photograph. Now he's almost done. Using his soul's "pulsations," he has counted "only as far as thirty,

[63]"Historical imagination" is a term Elizabeth Edwards uses to describe the way in which self-consciously historical British photographers allowed citizens to engage with or dream about a national past. See *The Camera as Historian*, 2012.

when we cover the lens again with the cap."[64] Having "taken" the picture, Holmes has witnessed the first part of the miracle that he believes defines modernity: form, he claims, has been separated from substance. Though there is as yet no visible change to the glass plate, he writes that "a ghost" is now "imprisoned" in it,[65] and "a latent soul" is waiting to be brought forth.[66] The invisible picture now exists in its own prehistory.

Although postwar theorists of the twentieth century will teach us to associate photography with death, Holmes's nineteenth-century metaphor suggests a birth. But it is the birth of a ghost, the release from time's prison of someone, or thing, that, in the limited terms of human experience, no longer exists. In that Victorian paradox lie the beginnings of modern memory.

[64]Holmes, "Sunbeam," 241.
[65]Ibid.
[66]Ibid., 242.

The Photograph in Time

Photography in the Age of Oblivion

On January 6, 1839, the Paris newspaper *Gazette de France* had a terrific scoop with the story of "an important discovery made by M. Daguerre, the celebrated painter of the Diorama." Although the journalist responsible could hardly have imagined just how important that discovery was going to be, nor how often his piece on it would be quoted in the decades and centuries to come, he had plenty of enthusiasm for his subject:

> This discovery seems like a prodigy. It disconcerts all the theories of science in light and optics, and, if borne out, promises to make a revolution in the arts of design.
>
> M. Daguerre has discovered a method to fix the images which are represented at the back of a camera obscura; so that these images are not the temporary reflection of object, but their fixed and durable impress, which may be removed from the presence of those objects like a picture or an engraving.
>
> Let our readers fancy the fidelity of the image of nature figured by the camera obscura, and add to it an action of the solar rays which fixes this image, with all its gradations of lights, shadows, and middle tints, and they will have an idea of the beautiful designs, with a sight of which M. Daguerre has gratified our curiosity. M. Daguerre cannot act on paper; he requires a plate of polished metal. It was on copper that we saw several points of the Boulevards, Pont Marie, and the environs, and many other spots, given with a truth which Nature alone can give to her works. M. Daguerre shews you the plain plate of copper: he places it, in your presence, in his apparatus, and, in three minutes, if there is a bright summer sun, and a few more, if autumn or winter weaken the power of its beams, he takes out the metal and shews it to you, covered with a charming design representing the object towards which the apparatus was turned. Nothing remains but a short mechanical operation—of washing, I believe—and the

design, which has been obtained in so few moments, remains unalterably fixed, so that the hottest sun cannot destroy it.[1]

No matter that the daguerreotype was fragile, idiosyncratic, or that as yet its image could not be reproduced. For this writer, as for the hundreds of other excited people who in July reportedly "swarmed" Paris's Palais de l'Institut to hear how Daguerre had made his "miraculous pictures,"[2] the point of the process, and the primary reason for interest in its story, had to do with one thing: the "charming designs" were "durable … unalterably fixed." The long-desired ability to preserve images cast by light through a lens figuratively signaled the end of mutability and the beginning of a world in which there would be no passing away, or, more precisely, no unmarked passing. Small wonder that it captured the imagination. "The new art," London's *Literary Gazette* observed, "has been discovered to fix these wonderful images, which have hitherto passed away volatile—evanescent as a dream—to stop them at our will … and render them permanent before our eyes."[3]

As it turned out, the process of permanently fixing the image needed some refinement. One of the first authors of a book-length history on photography wrote a mere four years later: "Since the publication of the photogenic processes, every one, and Mr. Daguerre among the first, acknowledged that something yet remained to be done, to give to these marvelous images that degree of perfection, which it is now possible to obtain: I mean the fixing of the impressions."[4] In early 1839, Daguerre's method of producing pictures on copper sheets with silver iodine remained secret as he negotiated a purchase price with the government for its release,[5] while in England, Sir John Herschel worked on finding a chemical that might fix images on sensitized paper. He soon discovered, as his notes record, that "hyposulphite of soda … Succeeds perfectly."[6] With Herschel's permission, his friend Henry Fox Talbot described the discovery of "hypo" in a letter published by the French Academy of Sciences, and Daguerre adapted the technique for his own use.

Talbot's own accounts of the distinctly different process of "photogenic drawing" return obsessively to the theme of permanence. Images made some thirty years earlier by his predecessors in science, Sir Humphry Davy and Thomas Wedgwood, could be examined only briefly and in the dark, lest they vanish altogether. In Talbot's early work with sensitized paper he had anxiously anticipated similar losses:

[1] Hippolyte Gaucharaud, "The Daguerotype" [sic]. *Gazette de France* (January 6, 1839); translated and republished by London's *Literary Gazette* (January 12, 1839), 28.
[2] "The Daguerre Secret," *Literary Gazette* (July 13, 1839), 538–39.
[3] "French Discovery—Pencil of Nature," *Literary Gazette* (February 2, 1839), 74.
[4] N. P. Lerebours, *A Treatise on Photography*, trans. J. Egerton (London: 1843), 53.
[5] Eventually, according to Newhall, "a proposal was made to Daguerre and Isidore Niépce [son of Nicéphore, Daguerre's partner, who had died in 1833]: as recompense for granting the state the right to publish the inventions, they would be awarded generous annuities for life." Newhall, *History*, 23.
[6] Newhall, *History*, 21.

I expected that a kind of image … would be produced, resembling to a certain degree the object from which it was derived. I expected, however, also, that it would be necessary to preserve such images in a portfolio and to view them only by candlelight; because if by daylight, the same natural process which formed the images would destroy them, by blackening the rest of the paper.[7]

Talbot's initial results were indeed temporary. "The first attempts which I made became indistinct in process of time," he recalled, with the result that "I thought that perhaps *all* these images would *ultimately* be found to fade away."[8] Throughout the 1830s, correspondence between Talbot and his family and friends is punctuated with disappointments that the charming "specimens" of his work had not lasted as their recipients had hoped. "Thank you very much for sending me such beautiful shadows," wrote his sister-in-law Laura Mundy in 1834; "the little drawing I think quite lovely … I had no idea the art could be carried to such perfection—I had grieved over the gradual disappearance of those you gave me in the summer & am delighted to have these to supply their place in my book."[9] After Herschel's discovery of hypo's utility, however, the "little drawings" ceased fading away, and Talbot's triumph in his paper process was, he felt, secure:

The most transitory of things, a shadow, the proverbial emblem of all that is fleeting and momentary, may be fettered by the spells of our "*natural magic*," and may be fixed for ever in the position which it seemed only destined for a single instant to occupy … we may receive on paper the fleeting shadow, arrest it there and in the space of a single minute fix it there so firmly as to be no more capable of change.[10]

The desire to fix life and render it "no more capable of change" drives every representational and memorializing act; it isn't limited to the history of photography and its well-known cast of characters, and nor does it originate in the nineteenth century.[11] Yet that desire seems to have been particularly acute when Victorian photography was emerging into the general consciousness. Only a few years before Daguerre's announcement, and around the same time that Talbot was experimenting with simple wooden box cameras in the grounds of his home, Lacock Abbey, the geologist Charles Lyell foresaw the peculiar urgency of the Victorian will to stasis and predicted the fatigue of the modern imagination in the effort required to grasp

[7]W. H. Fox Talbot, "Some Account of the Art of Photogenic Drawing, or, The Process by Which Natural Objects May Be Made to Delineate Themselves without the Aid of the Artist's Pencil." 1839. Reprinted in *Photography: Essays & Images: Illustrated Readings in the History of Photography*, ed. Beaumont Newhall (New York: Museum of Modern Art, 1980), 23–31, 23.
[8]Ibid., 24.
[9]Laura Mundy to W. H. Fox Talbot, December 12, 1834.
[10]Talbot, "Some Account," in Newhall, *Essays and Images*, 25.
[11]See Silverman, *The Miracle of Analogy*; Batchen, *Burning with Desire*.

new developments in science, most notably those having to do with the discovery of what John McPhee calls "deep time."[12] By the 1830s, memory no longer defined the limits of history but was eclipsed by the conceptual void of oblivion, into which the present must fall as fast as the world moved toward the future. Human history was dwarfed by the incomprehensible magnitude of prehistory, and the modern world seemed to be moving faster, with the result that things tumbled "with increasing rapidity," as Pierre Nora has written, "into an irretrievable past."[13] It was, Lyell thought, too exhausting for the public to comprehend the vastness of time and space against which humankind was now known to have scarcely measured, impossible for anyone, indeed, "to conceive the immensity of time required for the annihilation of whole continents." He was right in anticipating a desire for relief from such demands, a longing for rest at a time when "no resting-place was assigned in the remotest distance."[14]

Swarming hordes in Paris notwithstanding, a search through popular British periodicals of January 1839 for public response to Daguerre's announcement— headline news, one might have thought—is actually rather disappointing. Of equal or greater interest that month in London, to judge by coverage, were the "startling facts" of the "incalculable antiquity of our planet."[15] Those facts were not new to 1839, but they were, both before and during the first six decades of the nineteenth century, in a process of what seemed like continual and dramatic adjustment. In the face of those facts, and by comparison with their imaginative demands, the invention of the daguerreotype may initially have shrunk in significance. Between 1654, when Bishop Ussher declared the world to have begun in 4004 BC, and 1862, when the physicist Lord Kelvin argued that "it probably was not more than a hundred million years old and was possibly not more than twenty million," the age of the Earth seemed to balloon and shrink like a pair of lungs. In the 1770s, Comte de Buffon set it at "at least 168,000 years old"—about 163,451 years older, therefore, than it had been a hundred years before; and in 1859, some twenty years after Daguerre's announcement and three years prior to Lord Kelvin's margin of error of eighty million years, Darwin inflated prehistory fourfold by estimating one particular area of the globe at "over 300 million years."[16]

When anxiety concerning origins is traced in the Victorian period, it frequently winds up not with Darwin, however, nor even with Lyell, but rather earlier, on James Hutton's desk, as he concluded his dissertation in 1785 with the now famous claim

[12]Stephen Jay Gould, *Time's Arrow, Time's Cycle: Myth and Metaphor in the Discovery of Geological Time* (Cambridge: Harvard University Press, 1987), 1–8.
[13]Pierre Nora, "General Introduction: Between Memory and History," *Realms of Memory: The Construction of the French Past*, eds. Lawrence Kritzman, and Pierre Nora, trans. Arthur Goldhammer, vol. 1 (New York: Columbia University Press, 1996), 1.
[14]Charles Lyell, *Principles of Geology*, 1830, vol. 1 (Chicago: University of Chicago Press, 1990), 63.
[15]"Murchison's Silurian System," *Quarterly Review* 64 (1839), 102–20, 103.
[16]Stephen Kern, *The Culture of Time and Space*, 37.

that the age of the Earth is in fact indeterminable: "we cannot estimate the duration of what we see at present, nor calculate the period at which it had begun; so that, with respect to human observation, this world has neither a beginning nor an end."[17] Hutton seems to perch in the Victorian imagination like a lonely figure in the crow's nest at the top of the world's ship, his telescope trained to oblivion: "no vestige of a beginning," he calls down, "—no prospect of an end."[18] His conclusions offered small comfort, since to imagine a world with neither ending nor beginning was to trade in an old-fashioned fear of apocalypse for a modern-day haunting by a new specter: the absence of signifying bounds. As Stephen Kern notes, "While geologists and biologists tried to work out patterns of development through those vast stretches of time, the history of man came to appear increasingly as a parenthesis of infinitesimal brevity."[19] For many Victorians, confronted with what Stephen Jay Gould calls "an almost incomprehensible immensity, with human habitation restricted to a millimicrosecond at the very end,"[20] the stasis of photography's absolute present may have promised a kind of imaginative respite. "Oblivion's veil may shroud the past," observed a poem of 1839, concluding that, therefore, "The happiest time is now."[21] In the decades that followed, thanks to the various new processes of photography, the happiest time—the "now"—appeared for the first time in human history to be retrievable through being "fixed" and subsequently reborn in object form as a visual aid to memory.

For memory, it seemed, was in need of assistance. It is no exaggeration to say that there was a crisis of memory in the nineteenth century, a heightened fear of forgetting, stimulated both by the mental demands of a new concept of human history and by the emergence on to the plate of the mind of too many things to remember. Not only was the history of the world now reckoned in millions of years, years in which human memory played no part, but, thanks to the telescope and the microscope, an unimagined variety of plant and animal life was also entering the range of human vision, the discovery of which created the necessity of cataloging it all.

Such work—identifying, naming, recording—had all the ingredients for imperial greatness. It was daunting, perhaps impossible; it was eccentric and heroic. Far-flung efforts, such as Herschel's account of his years charting South African stars from the base of Table Mountain, 1834–8, received glowing acclaim as much for the

[17]James Hutton, *System of the Earth*, 1785, ed. George White (CO: Hafner, 1970), 28. A general preoccupation with origins is all over the pages of *The Literary Gazette* of March 2, 1839, in which several columns, devoted to an explanation of the various personalities involved in photography's early history, and claims to intellectual ownership of the daguerreotype, sit opposite an account of recent proceedings at the Royal Society, where Mr. Lubbock had just read members the conclusion to a paper by "Mr. Darwin," "On the Gradual Uprising of the Earth in Certain Places" (136).
[18]*Theory of the Earth*, 1788. Ibid., 128. Hutton presented *Theory of the Earth* as a paper in 1785 (the year in which the dissertation abstract of *System* was also heard), but it wasn't published until 1788.
[19]Kern, *The Culture of Time and Space*, 38.
[20]Gould, *Time's Arrow, Time's Cycle*, 2.
[21]Samuel Lover, "The Happiest Time Is Now," *Literary Gazette* (April 13, 1839), 225.

sheer bravado of the project as for the results he achieved. The ensuing book, with its promising subtitle (*being the completion of a telescopic survey of the whole surface of the visible heavens*), published in 1847,[22] was lauded largely for its testament of Herschel's "great and sustained labour." The image of an exhausted, persistent, and multitalented Herschel at his telescope under an African sky seems to have excited the imagination of his readers as much as reading about the stars, and the *Quarterly Review* was reverential in its assessment:

> Here we have the actual record of sleepless nights, and abundant proof of the toil of busy days; we have before us the clear-sighted patient observer stationed on his little gallery at the tube of his telescope, whence he so 'oft outwatched the Bear,' struggling against fatigue and sleep; we have the mechanist of his own observatory, the optician and constructor of his own mirrors; the artist of his own illustrations; the computer who co-ordinated and reduced all the multifarious results of the campaign; and lastly, the philosopher who with consummate address has unfolded in clear and unambiguous terms the conclusions deducible from the whole.[23]

The magnitude of Herschel's project, his many roles (observer, computer, mechanist, artist, philosopher), and the scale of the task (not to mention his having moved a large household to South Africa, including "his lady and a numerous family of young children")[24] delighted his peers; on his return to England he received a baronetcy for his efforts.

Readers of publications such as the *Quarterly Review* and the *Literary Gazette* (the latter being one of London's two "principal scientific newspapers," at the time, according to Talbot, the other the *Athenaeum*)[25] were invited every week to "marvel" at such feats of scientific record as Herschel's star-counting, or at the "indefatigable spider collector" who had collected "1800 species of the genus Musca in the single Department of the Yonne." As one reviewer of several new geographical studies observed, if the public would only read about the results of such far-flung exploration and accounting, all the "unexpected results derived from minute inquest into the subdivisions of the organic world—the fungi, the algae, the heaths, the lichens, the mollusks of different seas and depths, the zoophytes, infusoria, &c.," it would surely

[22]Sir John Frederick Herschel, *Results of Astronomical Observations Made during the Years 1834, 5, 6, 7, 8, at the Cape of Good Hope; Being the Completion of a Telescopic Survey of the Whole Surface of the Visible Heavens, Commenced in 1825 ...* (London: 1847). See also Herschel's *Outlines of Astronomy* (London: 1849).

[23]"Sir John Herschel's *Astronomical Observations at the Cape of Good Hope,*" *Quarterly Review* 85 (1847), 1–31, 30.

[24]Ibid., 3.

[25]Talbot, letter to John Herschel, Tuesday, January 29, 1839. Presumably Talbot commended those publications to Herschel in good part because, as he writes in the same letter, the editors "have both taken up with zeal (much more than I could have expected) the subject of my discovery of Photogenic Drawing."

begin to recognize "the value of these insulated labours, and to applaud the happy diligence to which we owe such exact and abundant knowledge."[26]

While abundance of new knowledge contributed to the perception that memory must be in crisis, the exactitude of much work in the natural sciences, and its revelation of unimaginable detail in the universe, produced a religious enthusiasm for the proliferation of facts as well as for the new precision with which such facts might be apprehended. In 1842, the *Quarterly Review* ran a Swiftian essay on the classificatory systems of major libraries that offered a nightmare vision of the task of cataloging the hundreds of thousands of books now lining the shelves of European libraries. Paris's Bibliothèque du Roi, it noted, had 650,000 volumes; "Munich, 500,000 … Copenhagen, 400,000; St. Petersburg, 400,000; Berlin, 320,000; Vienna, 300,000; The British Museum, 270,000."[27] Lest readers be unimpressed with these figures, they were given visual assistance: "the printed books in the British Museum Library *occupy ten miles of shelf.*"[28] No matter how good a classificatory system might be, the writer argued, it was bound to fail in face of the daunting number of publications produced every year, not to mention the various minor problems caused by the uncontrollable burgeoning of words themselves in the very catalogs that sought to contain them: "Lord Byron's 'Giaour,'" for example, "is spelt in sixteen different ways; Mahomet, or Mahammud, in perhaps as many."[29] Merely imagining a solution to this problem led the writer into a frenzy as he tried to describe a catalog that might

embrace in one alphabet the works of the Fathers of the Church, and the 2870 tracts of the Religious Tract Society—the writers of old Greece and Rome, and the effusions of Mr. Colburn's novelists—Plato, and the works of the Socialists and Chartists—if all the flocci-nauci-nihili-pilifications of the present day are to be as elaborately and distinctively enumerated, in all their editions, as the works of the gigantic intellects of former epochs—if a book, of which 500 copies were printed, and which has been catalogued perhaps 600 hundred times, is to be described yet once more—if all the 365 editions of Mavor's Spelling-Book are to be duly set forth in order—if all this is to be done … Every year it would become more incomplete, not only by the regular annual production of thousands of new volumes, but also by the constant additions of books of an older date.[30]

The vaguely hysterical note on which the essay ends conveys more than mere concern at the period's abundance of volumes, copies, and editions, but indeed a real fear that any cataloging system, overburdened by this extraordinary explosion of things to be learned, must inevitably fail.

[26]"Physical Geography," *Quarterly Review* 85 (1848), 305–40, 305.
[27]"Librorum Impressorum," *Quarterly Review* 72 (1842), 1–25, 2–3.
[28]Ibid., 4.
[29]Ibid.
[30]Ibid., 24.

Conflated with the perceived overabundance of information was the sense that the proliferation of print might make memory redundant. "We have books to tell us everything," lamented James Copner in his 1891 *Hints on Memory*. "A vast amount of what we want to recollect we may find in books. Thus, to a great and increasing extent, we use our books instead of our memories."[31] Richard Terdiman's claim that one of the most "powerful perceptions" during the nineteenth century "was of a massive disruption of traditional forms of memory"[32] is born out time and again in publications such as Copner's. The intuition that memory must fail, or that its previous methods were under assault, was caused at least partly by the mental burdens, recognized earlier by Lyell, of imagining the world not merely in time (the past now being bigger than before) but also in space (the parts of the world conceptually now both smaller and more numerous). In this ever-expanding universe, the effort to record it had all the magnificent pathos of a doomed expedition; despite its supposed grandeur and heroism, human accomplishment may have seemed to those who thought about such things to have become as disturbingly inconsequential as the unfixed, flickering images of a camera obscura.

Small wonder, then, that it was the details otherwise destined to be forgotten that were celebrated by many Victorian writers on photography, and that early viewers of daguerreotypes noted frequently and with delight how "not one of the beauties [of detail] was lost."[33] If the Victorians failed to remember—which, as a result of the burgeoning of natural sciences, the expanding miles of shelves of books, in some sense they must—the photograph failed to forget. Every last detail was, it seemed, retrievable through the camera, whereby "even a shadow, the emblem of all that is most fleeting in this world, is fettered by the spell of the invention, and remains perfect and permanent."[34] No longer destined to be forgotten, the "fettered" shadow became a sign, instead, of something seen and *remembered*.

A CULTURE OF MEMORY

Human beings have no place in the study of Earth's history. Minute in the scale of things, of little significance beside the thousands of stars to be counted, of no more import than the millions of animalcula ground under the heel of the fossil hunter on the beach, they are no grand evolutionary conclusion, but rather, as Lyell informed his readers, "mere sojourners on the surface of the planet,

[31]James Copner, *Hints on Memory* (London: 1891), 51–52.
[32]Richard Terdiman, *Present Past: Modernity and the Memory Crisis* (Ithaca, NY: Cornell University Press, 1993), 5.
[33]"Daguerrotype" [*sic*]. *Literary Gazette* (July 13, 1839), 444.
[34]"Royal Society," *Literary Gazette* (February 2, 1839), 75. This report from a meeting of the Royal Society clearly paraphrases from the first reading of Talbot's paper, later published privately by him as "Some Account of the Art of Photogenic Drawing, or, The Process by Which Natural Objects May Be Made to Delineate Themselves without the Aid of the Artist's Pencil" (Newhall, *Essays and Images*, 23–31).

chained to a mere point in space, enduring but for a moment of time."[35] Study of the Earth's development necessarily begins with their exclusion, along with "all those artificial lines and names with which man has covered the Earth for political demarcation or other social purposes."[36] In place of the divine or human powers previously assumed to be the driving force of history, the Victorians had to assimilate an evolutionary theory that emphasized instead, as Gillian Beer puts it, "the thronging powerlessness of the individual organisms who were the medium of change."[37] The ostentatious designs of so many Victorian monuments are, in this light, not the egoistic absurdities they are often presumed to be, but instead moving gestures against exclusion from the vaster part of the world's history. The grandiose memorials of the nineteenth century may speak less of ego than of obligation, the moral duty that in their own time necessitated and defined the work of remembering. When Herschel returned with his family to England from South Africa, it was only to be expected that a granite column be erected at the base of Table Mountain. It marked the site of Herschel's vanished labors and gave shape to the years he spent watching the night-sky.

For remembering was good; to the Victorians, it was "achievement,"[38] while forgetting, despite constituting the commonest part of human existence, was to be deplored, because it signified the disappearance of something once known. "In proportion as we have [memory] in defect our knowledge escapes," observed Copner in his *Hints on Memory*; "the wisdom we should have gained from past experience is lost."[39] To have an effective memory, according to this principle, was to safeguard the common store of knowledge; it was to be, like Henry James's attentive fiction writer, a person "on whom nothing is lost."[40] But in human experience the reverse was more often the case. As Copner noted, "much that we see leaves no trace upon our minds, much that we read is irretrievably forgotten, and much that we hear can no more be summoned back to our remembrance."[41] To remember thus signified a kind of resistance to the oblivion that surrounded life and into which the better part of it disappeared; it was to affirm the significance of one's fellow human beings and the history they made. It was a moral act. "No wonder," writes Geoffrey Batchen, "that so many photographs made in the nineteenth century show people pensively contemplating other photographs. What could they be calling to mind, if not their

[35]Lyell, *Principles of Geology*, 166.
[36]"Physical Geography," 309.
[37]Gillian Beer, "Origins and Oblivion in Victorian Narrative," in *Sex, Politics, and Science in the Nineteenth-Century Novel*, ed. Ruth Bernard Yeazell (Baltimore: Johns Hopkins University Press, 1986), 63–87, 69.
[38]Ibid., 63.
[39]Copner, *Hints on Memory*, v.
[40]Henry James, "The Art of Fiction," 1884. *Essays on the Novel by Henry James*, ed. Leon Edel (London: Rupert Hart-Davis, 1957), 23–45, 32.
[41]Copner, *Hints on Memory*, 61.

memories?" Since to remember was to do one's duty by the dead or distant, many Victorians "wanted to be remembered as remembering."[42]

Unsurprisingly, therefore, Victorian manuals on improving the memory paid particular attention to the irresponsibility of forgetting. A bad memory was sign not just of a weak but an antisocial disposition, a fact that applied on both sides of the Atlantic. There was little sense that some amount of forgetting was inevitable or even desirable; more typical, particularly of American publications, was Copner's view that memory loss is the result of poor self-discipline or O. S. Fowler's belief that "the mind of man is so constituted as to be able, if the organs be fully developed and mind properly disciplined … to retain EVERY thing it ever received." It is unquestionable, wrote Fowler in 1872, that "our memories are originally constituted to be *fact tight*— to let *no event of our lives*, NOTHING ever *seen, heard*, or *read*, escape us, but to recall every thing committed to its trust."[43] To be in possession of a poor memory was to indicate moral laxity, or even, according to another source, an excessive "abuse of the generative organs," since the latter was known to destroy memory and leave it "a hopeless [sic] blank."[44] To have a faulty memory, wrote "Professor of Memory" William Stokes, is "to build a fortress upon crumbling sand,—to place a fortune in an unsafe bank,—to risk a cargo in a leaky ship,—to try to fill a bungless cask,—or catch a shower in a wicker basket."[45] Stokes's homily against the follies of forgetting reads like a catalog of sin:

> How pitiable, how sad is bad Memory! It makes void experience—nullifies study— blunts perception—confuses thought—cripples judgment—crushes hope—lessens aspiration—mars enjoyment-and diminishes usefulness;—it occasions needless trouble—neglect of duty—non-success—bitter disappointment—pecuniary losses—and irreparable disasters;—it causes frequent embarrassment—apparent untruthfulness—suspected dishonesty—unintentional incivility—and makes enemies;—it is a perpetual inconvenience—a constant annoyance—*a needless disgrace*—and a nuisance to society!!!—In short, it is the offspring of neglect—the parent of stupidity—the friend of ignorance and the foe of mankind!!![46]

Stokes himself made a living improving the British memory, offering lectures and private lessons on the acquisition of what Copner calls "mnemonical dodges,"[47]

[42]Geoffrey Batchen, *Forget Me Not: Photography and Remembrance* (New York: Princeton Architectural Press, 2004), 10.

[43]O. S. Fowler, *Fowler on Memory* (New York: 1872), 31.

[44]M. Lafayette Byrn, *How to Live a Hundred Years* (New York: 1876), 17.

[45]William Stokes, *Memory*, 5th ed. (London: 1865), 12–13.

[46]Ibid., 44. The prolific author Marcus Lafayette Byrn's own memory of having read Stokes does not seem to have been sufficiently well-developed, however; for a rather striking case of plagiarism from Stokes, see Byrn's invective against bad memory (Byrn, 17).

[47]Copner, *Hints on Memory*, 61.

punning, word and image association, and other exercises enabling recall. There was a thriving market for such work: the book quoted above, one of many publications by Stokes on the subject, was in its fifth printing by 1865. Fifty pages of testimonials (supplementing fifty pages of press reviews) at the back of *Memory* affirm the author's method: "I can confidently state," wrote one fan, "that, after three agreeable lessons given by you, my pupils could accomplish Feats of Memory of the most practically useful character … they obtained a power which I believe is far greater than unaided memory of the highest order."[48]

The variety and success of Stokes's work hints at the strength of transatlantic desire to improve the memory.[49] Yet what purpose was it supposed to serve? What was one to do with one's newly fluent memory, the perfect recall with which Fowler, Stokes, Copner, and others assured their readers that nothing need ever be lost? Much like twenty-first-century interest in the use of the "memory palace" as a means of recall, the passionate desire for recollection is itself probably more worthy of study than the things we seek to remember.[50] The work of Victorian memory experts boiled down to a series of parlor tricks for memorizing trivia easily found in a book; the importance of being able to recite the dates of the kings and queens of England lay far more obviously in the athletic feat of recall than it did in the substance retrieved. The point, it seemed, was to do as much as one could, faced with the fact that one could really do nothing at all. A good memory was ultimately no protection against loss, or insignificance, or loss of significance.

Loss is, of course, a necessary part of meaningful remembering. As Terdiman puts it, "Loss is what makes our memory of the past possible at all."[51] Thomas Reid wrote much the same thing in 1872: "The object of memory, or thing remembered, must be something that is past … What now is, cannot be an object of memory."[52] Even the etymology of the word "memory" recalls the loss of something that ordinarily precedes the experience of remembering it, as well as the grief that may accompany both: Edward S. Casey notes that "*Memor*, Latin for 'mindful,' and the Old English *murnan*, 'to grieve,' are both traceable to the Sanskrit *smàrati*, 'he remembers.'"[53]

[48]Stokes, *Memory*, 160.

[49]See, for example, *Stokes's Mnemonical Hints on Mental Arithmetic*; *Stokes's Syllable-ized Pictorial Alphabet*; Stokes's *Historical Chronometer* (1877); *Pictorial Multiplication Table*, etc.

[50]See Joshua Foer, *Moonwalking with Einstein* (New York: Penguin, 2012). Foer's book is just one example of recent interest in the subject of memory techniques, another being the popular British television show *Sherlock*, which might, in fact, be aptly described by Foer's subtitle: *The Art and Science of Remembering Everything*.

[51]Terdiman, *Present Past*, 22.

[52]Thomas Reid, *Works*, ed. W. Hamilton, 2 vols (Edinburgh: 1872), 340. This is, of course, Aristotle's position and one that has been much modified; for a full and subtle discussion, see Norman Malcolm, *Memory and Mind* (Ithaca, NY: Cornell University Press, 1977).

[53]Edward S. Casey, *Remembering: A Phenomenological Study* (Bloomington: Indiana University Press, 1987), 273.

While photography's detailed representation of material facts made it easy to believe that it was a technology on and through which nothing would ever be lost again, its complicated relationship to the passage of time also invited reflection on what Barthes, a century and a half later, was to identify as "*flat Death*"[54]—the tension generated in every photograph between what was, and is, the case. A photograph gives formal shape to memory. At the same time, like the souvenir which, as Susan Stewart writes, "contracts the world in order to expand the personal,"[55] it also "displaces the point of authenticity as it itself becomes the point of origin for narrative."[56] Our engagement with any given photograph has as much to do with its material circumstances (paper, pewter, framed, screen-shotted) and the circumstances of our possession of it (how it is netted into our lives; bought, made, inherited, found) as with its original content. That such displacement of the "point of authenticity" also occurs *visually* with photography, however, explains why it rapidly assumed the burden of metaphors already associated with memory.

The history of memory is rich with metaphors of sight and of visual reproduction. Aristotle found a memory to be like an imprint or drawing, and St. Augustine's description of the process of remembering similarly emphasizes the experience of "seeing" things internally: "Yet did I not swallow them into me by seeing, whenas with mine eyes I beheld them. Nor are the things themselves now within me, but the images of them only."[57] In his *Essay Concerning Human Understanding* (1689), Locke not only uses the camera obscura as a metaphor for the thought process, with ideas entering the mind as pictures from outside, but also talks about imprints on the mind having been "as it were laid aside out of Sight."[58] What distinguishes such ideas from their original sources is that they return "with this additional perception annexed to them, that [the mind] has had them before"—earmarked, so to speak, déjà vu. Hume finds memory to be a copying machine, an essentially visual duplicator of experiences; likewise Kant's *Critique of Pure Reason* (1788) treats memory under the heading of "reproductive imagination."[59] The problem was, as Locke noted, that memory's impressions, or copies, or canvases, or visions, were not fixed. "Ideas *fade in the memory*," he wrote, not through any faulty working of the mind, but because, like the images in a camera obscura, "*The pictures drawn in our minds, are laid in fading colours.*"[60]

[54]Barthes, *Camera Lucida*, 92.

[55]Susan Stewart, *On Longing: Narratives of the Miniature, the Gigantic, the Souvenir, the Collection* (Durham, NC: Duke University Press, 1993), xii.

[56]Ibid., 136.

[57]Norman Malcolm, *Memory and Mind* (Ithaca, NY: Cornell University Press, 1977), 19–20.

[58]John Locke, *Essay Concerning Human Understanding*. 1689, Chapter 10, Section 2. Ed. Kenneth P. Winkler (Indianapolis: Hackett, 1996), 60.

[59]Casey, *Remembering*, 17.

[60]Locke, *An Essay Concerning*, 61. Emphasis added.

The metaphor of the mind as a surface on which pictures are drawn, a plate on which impressions are laid down, remained useful throughout the nineteenth century as a way of conceptualizing memory.[61] Popular focus on memory, particularly in later decades, was largely on retrieval, and it was driven in part by emerging theories of the unconscious. Hermann Ebbinghaus is rightfully famous for his exhaustive efforts to demonstrate that though a particular memory might appear to be gone, it was in fact never truly forgotten. "Mental states of every kind … which were at one time present in consciousness and then have disappeared from it, have not with their disappearance absolutely ceased to exist," he argued in 1885; rather, "they continue to exist, stored up, so to speak, in the memory."[62] Philosophers differed, however, as to how they might then be recalled. In his account of the history of memory, Ebbinghaus sketches for us a decidedly Victorian Aristotle, too disorganized to put his memory-photos in the album as they proliferate: his "pale images" pile up in the storehouse of the memory, in which "earlier images are more and more overlaid … and covered by the later ones," so it gets harder to retrieve the ones underneath.[63] Other writers construed memories not as pictures but as "*tendencies*," stored not in a stack or an album, but rather a sort of primordial swamp in which "Older ideas are repressed and forced to sink down, so to speak, by the more recent ones"[64]; or memory was perceived as a kind of chain, so that "obliviscence"—forgetting; the consigning to oblivion—consisted in "the crumbling into parts and the loss of separate components instead of in general obscuration,"[65] not fading away so much as breaking off, bit by bit.[66]

From about 1840, however, among the unwieldy stack of pale images, the primordial swamp, and the fragmented, broken chain, Victorian photography inserted itself as an alternate and powerful metaphor for memory. "I believe that a shadow never falls upon a wall without leaving thereupon its permanent trace—a trace which might be made visible by resorting to proper processes. All kinds of photographic drawing are in their degree examples of the kind," wrote J. W. Draper in his work on the physiology of memory.[67] "Absolute as a photograph, the mind refuses nought. An impression once made upon the sense, even unwittingly, abides for ever more," wrote E. S. Dallas.[68] Dallas might also have added, like Aristotle, that "the organ of memory

[61]See Copner, *Hints on Memory*, 30; Frederick W. Edridge-Green, *Memory: Its Logical Relations and Cultivation* (London: 1891), 1.
[62]Hermann Ebbinghaus, *Memory: A Contribution to Experimental Psychology*, 1885, trans. Henry Ruger and Clara Bussenius (New York: Dover, 1964), 1.
[63]Ibid., 62.
[64]Ibid., 63. Here Ebbinghaus cites Herbart. See also Samuel Butler's *Unconscious Memory*, 1880 (New York: AMS Press, 1968).
[65]Ebbinghaus, *Memory*, 64.
[66]This, according to Ebbinghaus, is the view of Lotze in *Metaphysick* (1879).
[67]Douwe Draaisma, *Metaphors of Memory: A History of Ideas about the Mind*, trans. Paul Vincent (Cambridge: Cambridge University Press, 1995), 120.
[68]*The Gay Science* (1866). Quoted in Kate Flint, *The Victorians and the Visual Imagination* (Cambridge: Cambridge University Press, 2000), 143.

is that which enables us to perceive time,"[69] and raised the possibility, as least for his fellow Victorians, that the camera best fit that description. As Lady Elizabeth Eastlake famously wrote in 1857, "Every form which is traced by light is the impress of one moment, or one hour, or one age in the great passage of time"[70]; or as Barthes was to put it more than a century later, cameras are "clocks for seeing."[71]

Oliver Wendell Holmes's efforts to develop an appropriate language for photography in his *Atlantic* essays of 1859–63 thus do more than merely suggest his grasp of photography's significance; they demonstrate how perceptual shifts at specific moments in history are enabled and embodied by emergent metaphor. There is no chance of separating photography from the culture out of which its practice emerged or from the language with which that culture performed its own self-representations. The work of the camera as an Aristotelian "organ of memory" can in fact be grasped *only* through its metaphors, the special language forms crafted for it by historical imaginations.

THE RETRIEVABLE PAST

A few weeks after the details of Daguerre's technology were officially revealed in Paris, the *Literary Gazette* ran a short piece on the inauguration in Belgium of a new "iron railway" at which, "if the weather should be favourable," photography was apparently to play an interesting role:

> The camera obscura, placed on an eminence commanding a view of the royal gallery, the locomotive engines, the carriages adorned with flags, and the greater part of the procession, will be open during the delivery of the inauguratory speech; a cannon-shot will be the signal for the whole assembly to remain perfectly motionless, for the seven minutes which will be necessary to obtain the resemblance of all the persons present. This picture will be put into a leaden box, to be deposited under the first stone of the foundation of the station at Courbray [*sic*] in order to give to our posterity an exact idea of this grand ceremony. It is not said how many hundred years hence posterity is to dig it up to look at it.[72]

It is also not said, unfortunately, whether this exercise was actually performed on September 22, 1839, the actual date of the railway inauguration in the Flemish town of Courtrai (Kortrijk)—nor do we know whether the resulting picture, if there was one, was ever interred. Given the necessary requirements of good weather and seven minutes of nobody moving, not to mention the report's shaky grasp of the principles

[69]Aristotle, *De Sensu and De Memoria*, 1906 ed., trans. G. T. Ross (New York: Arno, 1973), 103.
[70]Elizabeth Eastlake, "Photography," *Quarterly Review* 101 (1857), 442–68, 465. Excerpted in Goldberg (88–99), 97.
[71]Barthes, *Camera Lucida*, 15.
[72]"Varieties," *Literary Gazette* (September 28, 1839), 621–22, 622.

of photography, neither seems likely. The story bears witness, however, to an early anticipation of the daguerreotype as a time capsule, a missive that would be sent into the future. The symbolism is irresistible: the new railway is tagged as an obvious harbinger of modernity, while the imaginary daguerreotype of Courtrai is a promise of life after representation, as in its little lead coffin the ghost of a moment in 1839 moves into the future. Of equal significance, moreover, not just to its symbolic but its semantic life, is photography's association with the grave. The daguerreotype of the grand railway inauguration is to be buried and later exhumed like a dead body, dug up like a fossil, the indexical sign of lives lived, the posthumous time traveler of the Victorian imagination.

Early daguerreotypists were commonly in the business of photographing the dead, making what Holmes calls "fossilized shadows" of children and other family members.[73] "How these shadows last, and how their originals fade away!" he wrote, unconsciously echoing a marketing slogan that urged customers to "Secure the shadow 'ere the substance fade/Let nature imitate what Nature made."[74] Disturbing as nineteenth-century postmortem photographs proved for many twentieth-century viewers, the Victorians seem to have found them to be within the bounds of good taste, presumably because of their documentary intention.[75] But in April 1856, Henry Peach Robinson caused some upset by conflating the genres of posthumous and art photography.

Part of the problem seems to have been that the photograph Robinson produced represented in detail a moment that never happened—or not, at least, to the people in his picture. "Fading Away" shows a young girl in the last stages of decline, surrounded by her grieving family (Figure 1.1).[76] In reality the subject was, as Robinson freely admitted, "a fine healthy girl of about fourteen, and the picture was done to see how near death she could be made to look"[77]—as well as in answer, presumably, to Shelley's question in "Queen Mab," which Robinson wrote on the mat of the first impression:

 Must then that peerless form,
 Which love and admiration cannot view
 Without a beating heart, those azure veins
 Which steal like streams along a field of snow,
 That lovely outline, which is fair
 As breathing marble, perish?

[73]Holmes, "Sun-Painting," 170.
[74]Newhall, *History*, 32.
[75]Victorian postmortem photography arguably differs from today's practice of photographing corpses. Most obviously, the nineteenth-century deathbed or coffin might offer the only chance to record a likeness, something that doesn't apply to today's phone-wielding funeral-goers.
[76]See Brian Lukacher's extended reading of this photograph in Ellen Handy, *Pictorial Effect, Naturalistic Vision: The Photographs and Theories of Henry Peach Robinson and Peter Henry Emerson* (Norfolk, VA: Chrysler Museum, 1994), 32–34.
[77]Henry Peach Robinson, *The Elements of a Pictorial Photograph* (Bradford: 1896), 102.

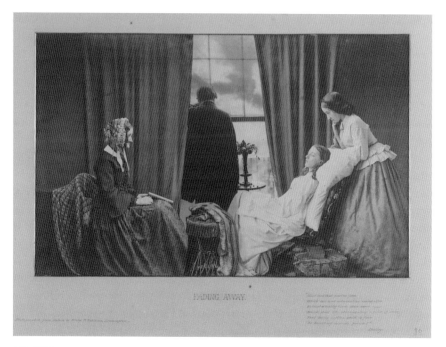

FIGURE 1.1 Henry Peach Robinson, *Fading Away*, 1858. Royal Photographic Society/ Science & Society Picture Library.

The answer, according to the photograph, was no. The "peerless form" must not— need not—perish, for Robinson's model was not only *not* about to expire, but should she ever be at risk of "fading away," Victorian photography had arrived in time to preserve her. As Holmes put it, "those whom we love no longer leave us in dying, as they did of old."[78] The model in Robinson's photograph was, instead, like those imagined crowds on the platform at Courtrai, preserved, retaining a "lovely outline" cast here by Robinson, not in marble but on paper.

"Fading Away" was exhibited in 1858 at the Crystal Palace and the Leeds exhibition. The famously mixed responses to it suggest a general unease with documenting for artistic purposes a familiar and unpleasant moment. The photograph touched, as historians have noted, "a raw place in the experience of so many viewers."[79] "Fading Away," wrote one careful reviewer, "is an exquisite picture of a painful subject."[80] Others claimed to find the photograph unequivocally offensive and made moral judgments: "'Fading Away' is a subject which I do not like, and I wonder Mr. Robinson

[78]Holmes, "Sun-Painting," 170.
[79]Margaret F. Harker, *Henry Peach Robinson, Master of Photographic Art, 1830–1901* (Oxford: Blackwell, 1988), 27.
[80]"Critical Notices," *Photographic News* (October 1, 1858), 40. Harker, *Henry Peach Robinson*, 27.

should have allowed his fancy to fix on it; it is a picture no one could hang up in a room, and revert to with pleasure."[81]

Of course, plenty of uncontroversial paintings of the period attempted the same topic, not to mention many successful novels and hundreds, if not thousands, of popular poems. The offence of the photograph arguably lay in the uncertainty of its generic affiliation and the consequent unease of its viewers in determining what "Fading Away" in this particular circumstance signified. A postmortem photograph on display in the domestic space of the home or tucked away in a private drawer was not the same as a publicly feted work by a famous photographer. The anticipated experience of each was distinct: one might be discussed as a picture, while the other was a personal matter. But the content of Robinson's work seemed designed to conflate the two, and its semantic instability, intensified by the performance of its content, was disturbing. Was *Fading Away* theater? Was it a technical display of combination printing? Or was it a photograph pretending to be a painting? Once the truth about the actual good health of Robinson's model was known, along with the details regarding the five separate negatives necessary to construct the print, thus revealing the apparent *untruth* of the photograph, the viewer was left to judge the image on aesthetic rather than documentary grounds and left, therefore, to determine what a good photograph might be if truth were left out of the equation.

The longevity of debate over this image, and others like it, betrays a genuine concern on the part of the Victorians beneath the bickering over play with focus, tints, or printing techniques. If a photograph were not reliably a sign of past objects, persons, or events, it could not truly stay the "slide into oblivion,"[82] but rather must be complicit with the increasingly unstable surface of modernity, with the continual fading away, indeed, of the past itself. At issue in mid-century battles over the ethics of photographic "interference" was the relationship of photography to the past, its truth-telling properties as a sign of what was, and its evidentiary role in both memory and history. Yet with the proliferation of all kinds of photographic images throughout the nineteenth century, whatever lines might once have been drawn between memory and history became increasingly blurred. For one thing, while the photograph was touted as an aid to memory's work of recollection, the public nature of photography's "prosthetic memories"[83] rendered them subject to the myth-making of history. As Hardy demonstrated in *Jude the Obscure* (1895), the afterlife of photographs, like that of novels, could not be controlled; they might be read by strangers as documents, or become found objects that told other cultural narratives than their intended immediate and personal ones.[84] Photographs, it seemed, were products *and* producers of history *and* memory.

[81]Sel D'Or. "Exhibition Review," *Journal of the Photographic Society* (January 1, 1859), n.p.

[82]Beer, "Origins and Oblivion," 69.

[83]Casey, *Remembering*, 10.

[84]See Jennifer Green-Lewis, *Framing the Victorians: Photography and the Culture of Realism* (Ithaca, NY: Cornell University Press, 1996), 85–88.

"We ask how recollections are to be located," writes Maurice Halbwachs, "and we answer: with the help of landmarks that we always carry within ourselves."[85] Victorian photography provided, and even substituted for, such landmarks, flagging the space of recollection as well as providing an organizational structure for thinking about past events. "What care I though the dust is spread/ Around these yellow leaves," wrote Holmes, "Or o'er them his sarcastic thread/Oblivion's insect weaves;/... Still something sparkles in the sun/For Memory to look back upon."[86] Through photography, the thing that sparkled could be retrieved and revisited; in the most literal of senses, it was available for re-vision. If "Oblivion's insect" threatened to diminish the achievement of human history, or if the yawning chasm of prehistory opened up a space in which nothing was written and of which nothing could be remembered, Victorian photography, at least, seemed to promise that from here on out there would be no more fading away.

[85]Maurice Halbwachs, *On Collective Memory*, trans. Lewis A. Coser (Chicago: University of Chicago Press, 1992), 175.
[86]Oliver Wendell Holmes, "The Last Reader," *Holmes's Early Poems* (New York and Boston: 1899), 49–51, 50.

CHAPTER TWO

"Already the Past"

The Backward Glance of Victorian Photography

One of the most visually memorable moments in Virginia Woolf's fiction is the passage in *To the Lighthouse* (1927) in which the Victorian matriarch Mrs. Ramsay turns back in a doorway for a moment to observe the last moments of an evening's dinner:

> With her foot on the threshold she waited a moment longer in a scene which was vanishing even as she looked, and then, as she moved and took Minta's arm and left the room, it changed, it shaped itself differently; it had become, she knew, giving one last look at it over her shoulder, already the past.[1]

Why, and—perhaps a harder question—*how*, does the past shape itself "differently"? Mrs. Ramsay's self-consciousness about the past as past, her sense that it *looks* different and in that specifically visual difference *becomes* past is accompanied by her own physical act of looking back ("With her foot on the threshold"), as well as her recognition that the moment is becoming memory ("even as she looked"). Moreover, the moment becomes memory at the same time that it is rendered pictorially; as it becomes the past, it is transformed into an image, circumscribed by a doorway. It becomes a view of a thing from the perspective of an onlooker, a "phenomenon," as Pierre Nora describes memory, "of emotion and magic."[2]

[1] Virginia Woolf, *To the Lighthouse* (New York and London: Harcourt Brace Jovanovich, 1981), 111.
[2] Nora, "General Introduction," 3.

Coming at the very end of a long dinner scene as it does, Mrs. Ramsay's backward glance is as functionally close to photography as anything in Woolf, and it brings into nostalgic collision a number of things that are eloquently expressed in photography's practice and yet sometimes overlooked in our accounts of it. First, there is the positioning of the agent, in this case Mrs. Ramsay, whose very awareness of the scene *as a scene* causes it to be recorded as a memory picture in the first place. She is half in, half out of the room; once part of it, she now stands at the frame. There is thus self-consciousness: she recognizes the moment from outside of it. Then there is her sense of change and fluidity: the scene as it was vanishes, while the emergent past is visibly different as it evolves and comes to be, like Holmes's wet collodion plate, "fixed." Awareness of that change from fluidity to fixity places Mrs. Ramsay in the position of spectator, a witness and a reader rather than a participant. Finally, there is a melancholy underlying the scene of which its subject is unaware: it anticipates the future death of Mrs. Ramsay herself, and, as we move outward from the novel, and as those familiar with Woolf's own biography well know, that fictional death also recalls the death of her mother, Julia Stephen, on whom the character of Mrs. Ramsay was based, and whose beauty in photographs made by her aunt, Julia Margaret Cameron, haunts the pages of this work.

With all of that "emotion and magic" to illuminate it, and despite a publication date of 1927, this scene powerfully illustrates what Helen Groth calls the "impact of photography on the nostalgic construction of Victorian literary culture."[3] Indeed, the bones of that construction loom not only beneath Woolf's modernist novels but, as I'll argue later in this book, beneath the works of other twentieth-century authors who use photography as a framework for re-viewing past experience. Loss—loss of a mother, loss of childhood, and loss of the past itself—is the meditative subject of *To the Lighthouse*. The novel eulogizes a lost home, and not only Talland house, where Woolf spent her childhood summers, but also the lost home of Victorian culture, the culture in which photography's rhetorical force, its ambiguities, and its paradoxes first developed. Acquisitive in its appetites and anxious to preserve its acquisitions, colonialism was in some ways enabled by a way of looking whose model might be described as photographic; certainly, the camera normalized its way of doing business.[4]

[3]Helen Groth, *Victorian Photography and Literary Nostalgia* (Oxford and New York: Oxford University Press, 2003), 2.

[4]Most obviously, of course, photography was enlisted in the task of transporting home those sights, places, and persons whose subject status was affirmed in their display. As Claire Lyons puts it, "the visual logic of [Victorian] photographs—self-evidently 'true' and effortlessly multiplied—was an effective tool by which Western powers leveraged political and economic advantages to establish Eurocentric hegemony over the domain of universal history." Lyons, "The Art and Science of Antiquity in Nineteenth-Century Photography." *Antiquity and Photography: Early Views of Ancient Mediterranean Sites*, eds. Claire L. Lyons, John K. Papadopolous, Lindsey S. Stewart, and Andrew Szegedy-Maszak (Los Angeles: J Paul Getty Trust, 2005), 22–66, 39.

But just as the nineteenth century had a range of "photographies" rather than one unified photographic practice, so those practices inspired a variety of ways not just of looking but of *seeing*. Despite its promise of stability, its potential to counter the "fading away" of cultural memory, its daily engagements with realism, its early associations with truth-telling, and its testimonial utility, Victorian photography also increasingly conveyed the look of the personal past—the past, that is, as it was seen in memory and imagination by its subjects. Its glance, like Mrs. Ramsay's, was backward.[5]

Photography's relationship with the backward glance was the consequence of a number of things, some merely the practical necessities involved in making the first photographs (such as the need to choose subjects both immobile and close to hand) and others more interesting in their implications (such as the kind of objects that might be close to hand for one in a social and financial position to practice photography during the 1840s). The most successful subjects during photography's earliest years were not human beings—François Arago, director of the Paris Observatory, was correct when he explained in 1839 that although it required only "a little progress," they were as yet too difficult to take satisfactorily[6]—but rather antiquities. I use that term rather loosely here to mean merely old things, most obviously architectural ruins and artifact remains, but also things presumably less exotic to the photographer while still redolent of a desire to visualize history. Daguerre's early images of shells, fossils, and plaster casts, like Talbot's calotypes of old manuscripts, books, and views of a weather-beaten Oxford, affirm not merely their photographers' fondness for old things but the camera's potential for forging links with a specifically imagined past. As Arago's report of July 3, 1839, to France's Chamber of Deputies pointed out,

> Everyone will imagine the extraordinary advantages which could have been derived from so exact and rapid a means of reproduction during the expedition to Egypt; everybody will realize that had we had photography in 1798 we would possess today faithful pictorial records of that which the learned world is forever deprived of by the greed of the Arabs and the vandalism of certain travelers.[7]

Even then, Victorian photography's *anticipated* narrative of the past was constructed to be more authoritative, more "faithful," than any other version of it. Moreover, the identification of the photograph with reality as a result of that early rhetorical construction was conflated with the backward glance of photography in the record

[5]Geoffrey Batchen notes, "For us today, these nineteenth-century images might even evoke another kind of memory—nostalgia." Batchen, *Forget Me Not*, 14. My point, however, is that Victorians were prone to the same nostalgia, which was not produced by the intervening years, but began life at the moment that the image was first viewed.

[6]Dominique François Arago, "Report," July 3, 1839, in Trachtenberg, *Classic Essays* (15–25), 25.

[7]Ibid., 17.

and pursuit of antiquity, with the result that what was *real* was ultimately identified with what was past—and thus itself *as past.*

It's worth noting, of course, that in the kind of engagement with time that photography initiates, past and future are not so easily separated. As Holmes's essays show, and later responses to photography continued to demonstrate, what really sparked Victorian imaginations was photography's promise of connection between human beings across time and space, including, perhaps especially, those not yet born. Civil war photographer Mathew Brady's recollection of once having photographed an aged "Mrs. Alexander Hamilton" thrilled his late-nineteenth-century interviewer George Townsend, presumably because, through Brady, Townsend could feel himself at three degrees of separation from George Washington. But as much as contemplation of past ages through the medium of photography provided an imaginary bridge to antiquity (or, in the ninety-three-year-old Mrs. Hamilton's case, to the founding fathers), so the backward glance of much Victorian photography could also be construed as a way of thinking about the kind of service photography might offer those yet to come. In other words, to photograph old things, as Victorians seemed powerfully drawn to do, was also to forge relations with future generations. It was an act of faith that what was valuable then would still be valuable later; it suggested that the future might even depend upon such acts of preservation and transmittal. In this way, the temporally backward glance of the Victorians arguably expressed desire for continuity, a desire that, for all its reactionary traits, has distinctly forward motion. If the act of photographing antiquity reveals Victorian desire, as Baudelaire famously put it, to "save crumbling ruins from oblivion, books, engravings, and manuscripts, the prey of time, all those precious things, vowed to dissolution, which crave a place in the archives of our memories,"[8] so it also reveals Victorian commitment to a future in which "the archives of our memories" still matter.

The nineteenth century may seem distant, but I would argue that the Victorians are more real to someone living in the twenty-first century than, say, people living in the sixteenth century. By "real," I mean (with some irony) that they seem more like us. There are a number of obvious reasons for this. We recognize the new machines in the nineteenth-century landscape—trains, cars, telephones, cameras—as versions of the same machines on which we have become dependent; we relate to the urbanization of culture; it's easier to understand the language in their literature; and so on. But the Victorians also seem real to us not just because they are closer in time, or because they could take the train instead of the stagecoach, but because we are able to see them on what we consider to be our own terms, that is, photographically. Victorian photography, in other words, marks for us the beginnings of a modern visual aesthetic.

[8]Charles Baudelaire, "Salon of 1859," in Goldberg, *Photography in Print*, 125.

Brief consideration of the language contextualizing photography's earliest decades suggests a paradox, however. For many Victorian photographers, the idea of modernity was inseparable from an active and emphatically historical imagination, an imagination given shape, form, and expression by photography's earliest images. The conflation of self-consciousness and personal loss that we saw in Woolf's writing about Mrs. Ramsay marks the famously belated condition of modernism that may also be understood as the inheritance of identifiably *Victorian* concerns regarding origins and identity, concerns that were made visible in the practice of nineteenth-century photography.

* * *

If what is real is over, is the present itself unreal? If so, what might be the aesthetic or political ramifications of identifying the present as somehow less authentic than the past? How might the initial rhetorical constructions of photography have determined its later significance to Victorian culture, specifically with regard to the narration of its past and the naturalization of its present?

An effort to address the first two questions necessarily involves some speculation and theorizing, but the third question, concerning the relationship between early rhetoric and later cultural significance, can be addressed by examining some of the earliest published works associated with photography. Admittedly, many of those works aren't especially interesting to a reader who delights in "rhetorical constructions," and sometimes it's hard to feel confident that what photography signifies can really be found in the language first associated with it. Reading early British and American photographic journals, with their long and obscure accounts of chemical compounds and dark room procedures, students of literary pattern and rhetoric may find themselves skipping over hundreds of pages to ferret out a few unrepresentative passages that bear a trace of self-consciousness, those glimpses of human effort to describe to one's community what photography *does*.

In fact, the most striking, figuratively rich language of photography's Victorian history was produced somewhat later in the century, and not much of it was written by the professional pioneer photographers of the 1840s and 1850s, whose energies were taken up either with the process itself or with making it accessible to readers through the use of precise technological terms. Most popular quotes from the history of photography do not come from photographers but rather from cultural critics who were drawn in the decades after photography's invention to meditate extensively on its potential. If we want to craft an intellectual or imaginative history of Victorian photography, such cultural criticism is invaluable, but it's worth noting from the outset the imbalance in photography's early years between, on the one hand, suggestive, thought-provoking metaphor and, on the other hand, the many more representative pages of what we might call manual-ese. It's not easy to find a narrative path for Victorian photography that accommodates both kinds of rhetoric, but we need to

familiarize ourselves with the technical language, for all its difficulty and syntactical unloveliness, if we're to have a sense of the view from behind the lens that is also part of photography's history. As it happens, both kinds of prose helped convey the two things I want to examine here, namely, the association of Victorian photographs with reality and the association of those photographs with the past.[9]

Given the amount of time he spent working on and thinking about photography, it's disappointing to find that Daguerre was less than eloquent about it. Yet although his writings are largely innocent of elegant phrasing or memorable imagery, his initial statement in 1839 that it was "a chemical and physical process which gives [Nature] the power to reproduce herself"[10] was to prove the most durable and widely used of all metaphors associated with photography. Daguerre made no space for his own agency and thus encountered, rhetorically at least, no possibility of subjective interference. The process, he wrote, simply allows for the subject to self-replicate—a rhetorical choice that drew on centuries of experiment with light, apertures, and varieties of camera obscura. Talbot used similar metaphors to describe his own, very different, production of photographic negatives, not only suggesting that Lacock Abbey was the first building known "to have drawn its own picture"[11] but also indicating that "it is not the artist who makes the picture, but the picture which makes ITSELF."[12] The images were, he wrote five years later, "impressed by Nature's hand."[13] Granting little or no space for either creative agency or interpretive practices, the shared rhetoric figured photography as a means by which the world could bring into existence another version of itself. With culture thus off to the side, photographs were initially presented by their makers as natural facts, incontrovertible and self-explanatory.

Notwithstanding the degree to which photography rapidly lent itself to creative play in the form of pre- and postproduction manipulation, its evidentiary status was further bolstered by more self-conscious efforts to gauge its cultural significance. "Photography is well suited for an age which craves cheap, prompt, and correct facts," wrote Lady Elizabeth Eastlake in 1857; "She is the sworn witness of everything presented to her view."[14] The cheap and reliable fact-checker had, moreover, a prodigious memory. Of particular interest to many early followers of photography was the camera's potential to record things previously overlooked by the human eye. In 1839, the painter Paul Delaroche reportedly observed that the daguerreotype had

[9]In identifying these threads I am influenced by Kracauer, who argues that "the principles and ideas instrumental in the rise of a new historical entity do not just fade away once the period of inception is over; on the contrary, it is as if, in the process of growing and spreading, that entity were destined to bring out all their implications." Kracauer, "Photography," in Trachtenberg, *Classic Essays*, 245.
[10]Gernsheim, *L. J. M. Daguerre*, 81.
[11]Talbot, "Some Account," in Newhall, *Essays and Images*, 28.
[12]Talbot, letter. "Photogenic Drawing," *Literary Gazette* 1150 (February 2, 1839), 73.
[13]W. H. Fox Talbot, *The Pencil of Nature* (London: 1844), n.p.
[14]Eastlake, in Goldberg, *Photography in Print*, 96.

"unimaginable precision"[15] of detail; the following year, Edgar Allan Poe wrote that "the closest scrutiny of the photogenic drawing discloses only a more absolute truth, a more perfect identity of aspect with the thing represented. The variations of shade, and the gradations of both linear and aerial perspective are those of truth itself in the supremeness of its perfection."[16] But it is probably Ruskin's words that have most resonated with post-Victorian, postcolonial readers. In a letter to his father from Venice in October 1845 he wrote:

> I have been lucky enough to get … some most beautiful, though small, Daguerreotypes of the palaces I have been trying to draw—and certainly Daguerreotypes taken by this vivid sunlight are glorious things. It is very nearly the same thing as carrying off the palace itself—every chip of stone & stain is there—and of course, there is no mistake about proportions. I am very much delighted with these and am going to have some more made of pet bits. It is a noble invention, say what they will of it, and anyone who has worked and blundered and stammered as I have for four days, and then sees the thing he has been trying to do so long in vain, done perfectly & faultlessly in half a minute, won't abuse it afterwards.[17]

Much has, justifiably, been made of Ruskin's phrase "carrying off the palace itself." It is hard to overlook the visual looting implicit in much language used to describe photographs made in the service of an imperial culture, and it's interesting to recall that on the other side of the Atlantic, Holmes had arrived at a similar metaphor in his anticipation of men equipped with cameras hunting "all curious, beautiful, grand objects."[18] More to the purpose here, however, is Ruskin's aside that "every chip of stone & stain is there." The daguerreotype was marvelous to Ruskin because he believed its record to be fully complete, and in its completeness it contained multitudes, and despite this it was "done perfectly and faultlessly."

The possibility that the camera might function as a corrective to human vision was of wide interest, and its potential to make visible hitherto unnoticed detail was part of its appeal. When the *Literary Gazette* of July 1839 exclaimed over the display of some daguerreotypes, it noted with particular delight the reproduction of "most delicate objects, the small pebbles under the water, and the different degrees of transparency which [the daguerreotypes] imparted to it,—everything

[15]Delaroche, quoted by Arago in "Report," in Trachtenberg, *Classic Essays*, (15–26), 18.
[16]Poe, "The Daguerreotype," *Alexander's Weekly Messenger* (January 15, 1840), in Trachtenberg, *Classic Essays*, 38.
[17]October 7, 1845, qtd. in Karen Burns, "Topographies of Tourism: 'Documentary' Photography and the *Stones of Venice*," *Assemblage* 32 (April 1997), 22–44, 24. No mention of Ruskin and photography is now possible, however, without mention of the invaluable and extraordinary account by Ken and Jenny Jacobson of their own acquisition of a trove of Ruskin's daguerreotypes. See *Carrying off the Palaces: John Ruskin's Lost Daguerreotypes* (Kendal, Cumbria: Quaritch, 2015).
[18]Holmes, "The Stereograph," 162.

was reproduced with incredible exactness." Precision was not all: "The astonishment was … greatly increased when, on applying the microscope, an immense quantity of details, of such extreme fineness that the best sight could not seize them with the naked eye, were discovered."[19] In *The Pencil of Nature* (1844–46), a serially published collection of Talbot's own photographs, each accompanied by an explanatory text, Talbot celebrates the photograph's occasional disclosure of a "multitude of minute details, which were previously unobserved and unsuspected," and notes that one of the "charms of photography" is that frequently

> the operator himself discovers on examination, perhaps long afterwards, that he has depicted many things he had no notion of at the time. Sometimes inscriptions and dates are found upon the buildings, or printed placards, most irrelevant, are discovered upon their walls. Sometimes a distant dial-plate is seen, and upon it—unconsciously recorded—the hour of the day at which the view was taken.[20]

Holmes experienced a similar revelation: "one may creep over the surface of the picture with his microscope and find every leaf perfect, or read the letters of distant signs, and see what was the play at the 'Variétés' or the 'Victoria' on the evening of the day when it was taken, just as he would sweep the real view with a spy-glass to explore all that it contains."[21]

If Diana Hulick is correct that "Victorian notions of truth were generated not only by observation but also by an a priori opinion about the moral structure of the world, as manifested by the telling detail,"[22] then the camera's revelation of things previously unremarked because unseen (the precise number of tiles on a roof, inscriptions on a wall, the shadow-hand of a sundial) presumably affirmed a notion of the world as finally and fully visually available. The moral, social, and philosophical structure of that world was visualized and supported by the very specifics objectified by the photograph. The "charms" which Talbot describes were similar to those enjoyed by the archeologist-historian, who sought to unearth details of a place and scene to give it greater context. Of course, the objects of Talbot's close attention were already familiar to him—his own house, say, or the colleges of Oxford. As much as the act of looking at them in photographs served to make strange the familiar, therefore, it was also an exercise in looking itself, a new demonstration of *how to see* rather than a recognition of what it was that the eye had failed a hundred times to note.

[19]"Daguerrotype" [*sic*]. *Literary Gazette*, 444.
[20]Talbot, *The Pencil of Nature*, 1844; text to plate XIII.
[21]Holmes, "The Stereoscope," 127–28.
[22]Hulick, "The Transcendental Machine? A Comparison of Digital Photography and Nineteenth-Century Modes of Photographic Representation," *Leonardo* 23.4 (1990), 419–25, 420.

But what could Talbot's previously invisible "inscriptions and dates" or "printed placards" tell him? What real knowledge was yielded by the triumphantly retrieved image of the sundial, or the pebbles in the water, or, in Holmes's case, discovering what happened to be playing at the theater on a given evening? Most details might have been, to use Talbot's word, "irrelevant" to an understanding of the object or view. The consistent delight in detail to be found everywhere on early writings on photography, however, suggests a conviction, or, perhaps, a desire to be convinced, that reality resides in the details of the object world. "To read in detail," as Naomi Schorr writes of literary texts, "is … to invest the detail with a truth-bearing function."[23] The pleasure and triumph with which photographic details were hailed seems to have signaled desire for a view of the world that was more complete and thus more real than had previously been possible.

THE PHOTOGRAPH IS ASSOCIATED WITH THE PAST

In *The Pencil of Nature*, Talbot offers a variety of photographs as illustration of his method, but none is as suggestive as his description of what inspires the photographer in his work: "A casual gleam of sunshine, or a shadow thrown across his path, a time-withered oak, or a moss-covered stone may awaken a train of thoughts and feelings, and picturesque imaginings." There are several things worth noting here, not least the attention to the internal processes acknowledged to be involved in the experience of photography. Talbot might still regard photographs themselves as the consequence of Nature's impress, but he was clearly growing more interested in his own artistic intentions and in photography's romantic potential to record the ravages of time. As he describes it in *The Pencil of Nature*, the practice of photography is reflective and creative; rather than mere documentary urges, the photographer has "feelings, and picturesque imaginings."

Talbot's own feelings and imaginings led to a selection of images for his book whose point of reference is emphatically historical. The accompanying text directs readers to focus on the value of the pictured objects with regard to their age. There are, for example, a number of pictures taken in Oxford, and the text accompanying the first plate, "Part of Queen's College, Oxford" (Figure 2.1), is typical in its initial observation that the building "presents on its surface the most evident marks of the injuries of time and weather," as well as in its desire to orient the viewer both spatially and temporally (we are "looking North. The time is morning").

The notes to plate XIII, "Queen's College, Oxford: Entrance Gateway," celebrate the details made available by photography, while the text accompanying plate XVIII, "Gate of Christchurch," instructs the viewer that "Those ancient courts and quadrangles and cloisters look so beautiful so tranquil and so solemn at the close of a summer's

[23]Naomi Schorr, *Reading in Detail: Aesthetics and the Feminine* (New York and London: Methuen, 1987), 7.

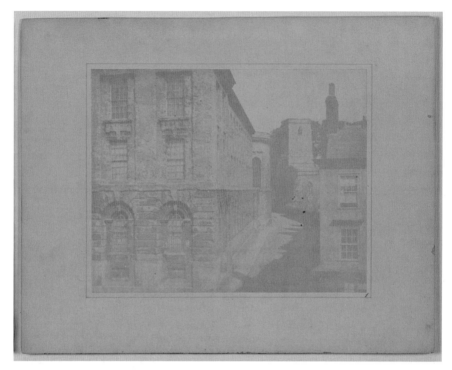

FIGURE 2.1 W. H. Fox Talbot, *Part of Queens College Oxford*, before June 1844. *The Pencil of Nature*, plate I. Salted Paper Print, 15.9 × 20.1 cm. The J. Paul Getty Museum, Los Angeles.

evening, that the spectator almost thinks he gazes upon a city of former ages, deserted, but not in ruins; abandoned by man, but spared by Time." While Talbot makes it photography's aesthetic business to visualize the passage of time by celebrating its ability to record time's "injuries," he simultaneously notes photography's recording function, that is, its ability to present the viewer with a piece of history preserved. By virtue of its photographing, this piece is now also "spared by Time."

The other narratives slide equally unsteadily between historical information on the one hand, and philosophical rumination on the other, in what appears to be an effort to locate a new kind of contemplative space for a viewer mindful of his or her relationship to the past portrayed. Plate XIX, "The Tower of Lacock Abbey," for example, is accompanied by a lengthy historical account of Talbot's ancestral home, complete with anecdotes of a spectral nun with a bleeding finger, while two efforts at a bust of Patroclus (plates V and XVII, Figures 2.2 and 2.3) attend to photography's documentary utility, with Talbot noting that statuary is an appropriate subject for photography because of its "whiteness."

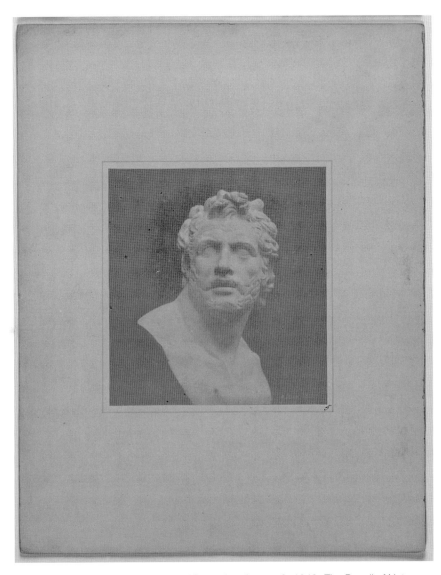

FIGURE 2.2 W. H. Fox Talbot, *Bust of Patroclus*, August 9, 1842. *The Pencil of Nature*, plate V. Salted Paper Print, 13.5 × 12.8 cm. The J. Paul Getty Museum, Los Angeles.

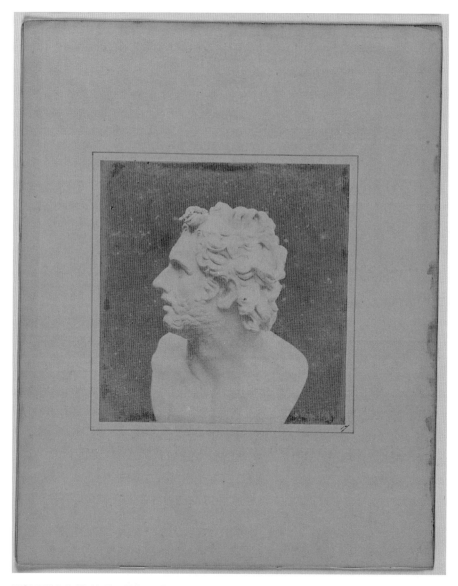

FIGURE 2.3 W. H. Fox Talbot, *Bust of Patroclus*, August 9, 1843. *The Pencil of Nature*, plate XVII. Salted Paper Print, 14.6 × 14.1 cm. The J. Paul Getty Museum, Los Angeles.

Other reminders of the vast repositories of culture and knowledge that might now be recorded by the camera are figured by the bookshelves of plate VIII, "A Scene in a Library" (Figure 2.4), and, more pointedly, by the "Fac-Simile of an old Printed Page" of plate IX (Figure 2.5). Of this last picture we are told that it was "Taken from a black-

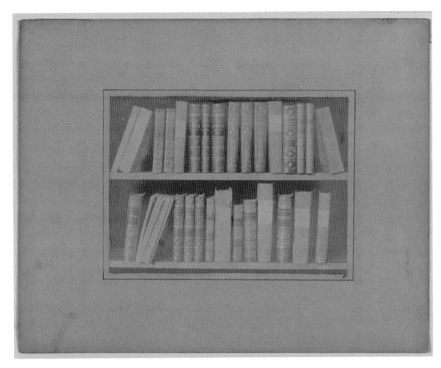

FIGURE 2.4 W. H. Fox Talbot, *A Scene in a Library*, before January 1845. *The Pencil of Nature*, plate VII. Salted Paper Print, 12.9 × 17.8 cm. The J. Paul Getty Museum, Los Angeles.

letter volume in the Author's library, containing the statutes of Richard the Second, written in Norman French. To the Antiquarian this application of the photographic art seems destined to be of great advantage."

What is the larger story being told here, if indeed there is a story? Certainly Talbot represents the past in terms that celebrate order and continuity. It's not hard to read these photographs as proof of Paul Connerton's argument that "images of the past commonly legitimate a present social order,"[24] and if so, perhaps Talbot's "application of the photographic art" is destined to be of advantage to more than the mere antiquarian. The photograph of the library shelf is one more link in the chain of the organization of knowledge, an historical knowledge that is safely contained in the peaceful places inhabited by generations of the same family. Moreover, the attention to the visibility of time itself—manifest in Talbot's fondness for details of age and decay—arguably orients the viewer of these photographs toward a consideration of the past as picturesque. *The Pencil of Nature* solicits a reading of Talbot's work

[24]Paul Connerton, *How Societies Remember* (Cambridge: Cambridge University Press, 1989), 3.

FIGURE 2.5 W. H. Fox Talbot, *Fac-simile of an Old Printed Page*, 1844. *The Pencil of Nature*, plate IX. Salted Paper Print, 16.5 × 14.2 cm. The J. Paul Getty Museum, Los Angeles.

that is sentimental and aesthetic as well as documentary; the images are of historical interest, but a history that, for the photographer, appears to have been as much a matter of the emotions as it was a matter of record.

Elizabeth Edwards argues that in its early decades photography was conceptualized as a way to create "a stable form of narration through technical processes that were

linked to total observation and inscription," yet, as *The Pencil of Nature* bears out, "assumptions about the relations between history, aesthetic style and photographic truth could not be stabilized, caught as they were between objective and romantic commemorative desires."[25] Talbot's readings of his own works are indeed profoundly unstable, revealing a tension between objective and romantic desires that, as I have suggested elsewhere, was to prove the hallmark of much writing about Victorian photography.[26] But the desire to engage imaginatively with the past was of course no invention of the photographic age. "We are not treading in the footsteps of history. We are only summoning history to conspire with our emotions," wrote Charles Nodier in 1820 in his introduction to Baron Taylor's *Voyages Pittoresques et Romantiques dans L'ancienne France.*[27] Nodier's romantic defense of Taylor's historical-emotional conspiracy seems an apt description of Talbot's project of some quarter-century later, most notably in the photographer's interest in the commemorative function of his photographs. If we agree with Eugene Vance that commemoration may be understood as "any gesture, ritualized or not, whose end is to recover, in the name of a collectivity, some being or event either anterior in time or outside of time in order to fecundate, animate, or make meaningful a moment in the present,"[28] then commemoration seems to be a necessary and even inevitable component of the naturalization of the present. In this light, Talbot's photographs, in combination with the text of *The Pencil of Nature*, may be said to function commemoratively in that their purpose, however vaguely articulated, appears to be the transmission of cultural identity through relating past to present. Moreover, as Christopher Phillips argues, "by so privileging some moment or principle of origin, commemoration inevitably calls up the simultaneous perception of the present as deficient or fallen."[29] It is thus, Phillips suggests, that nostalgia is born, a sense that the present is in some way lacking, or lesser, than the past. If the philosophical gold standard of mid-nineteenth-century culture was objective reality—its apprehension, its representation, its possession—then perhaps the latent nostalgia of much subsequent photographic discourse expressed desire for a time and a place in which the objectively real was visually located, desire for a past time, perhaps, in which the objectively real was philosophically possible.

[25]Elizabeth Edwards, "Commemorating a National Past: The National Photographic Record Association, 1897–1910," *Journal of Victorian Culture* 10.1 (2005), 123–29, 126.

[26]Geoffrey Batchen demonstrates the rhetorical uncertainty of photography's earliest thinkers and practitioners, and concludes that interpretive instability is ultimately deliberate, a sensitive refusal to commit photography to the camp of either nature or culture: "the inventors' own descriptions of photography carefully avoid any stable definition, endlessly turning back on themselves in a perverse rhetoric of circular negation." Batchen, *Burning*, 1999, 176–77. See also Green-Lewis, *Framing the Victorians*, 1996; Daniel Novak, *Realism, Photography, and Nineteenth-Century Fiction* (Cambridge: Cambridge University Press, 2008).

[27]Quoted in Christopher Phillips, "A Mnemonic Art? Calotype Aesthetics at Princeton," *October* 26 (Autumn 1983), 34–62, 54.

[28]Quoted in Ibid., 55–56.

[29]Ibid., 56.

Understandably, and in a tacit, apparently intuitive extension of Daguerre and Talbot's figurative construction of the photograph as natural fact, it was the documentary function of photography that was uppermost in the official rhetoric surrounding its invention. Arago's report to the Chamber of Deputies emphasized "the millions of hieroglyphics ... of the great monuments of Thebes, Memphis, Karnac, and others" which might now, thanks to the daguerreotype, be saved from their crumbling descent into oblivion. In this work of documentary retrieval, the triumph of the camera would be not only its "fidelity" but also its efficiency and labor-saving speed:

> By daguerreotype one person would suffice to accomplish this immense work successfully. Equip the Egyptian Institute with two or three of Daguerre's apparatus, and before long on several of the large tablets of the celebrated work, which had its inception in the expedition to Egypt, innumerable hieroglyphics as they are in reality will replace those which now are invented or designed by approximation. These designs will exce[ed] the works of the most accomplished painters, in fidelity of detail and true reproduction of the local atmosphere ... These reflections, which the zealous and famous scholars and artists attached to the army of the Orient cannot lightly dismiss without self-deception, must without doubt turn their thoughts to the work which is now being carried on in our country under the control of the Commission of Historic Monuments. A glance suffices to recognize the extraordinary role which the photographic process must play in this great national enterprise.[30]

The "national enterprise" of recording antiquities before their ultimate disappearance clearly captured imaginations and inspired photographers from across the globe to take the camera into the field. As Claire Lyons notes, within only a few months of Daguerre's announcement, "daguerreotypists ... were making pictures in Egypt and throughout the world."[31] Talbot himself was excited to promote his refinement of the calotype process by placing it at the service of archeologists and explorers. In April 1843 he wrote to Sir Charles Fellows, the discoverer of the ruins of Xanthus, that on his next expedition he should consider taking along a camera:

> I have greatly improved the invention [of the calotype] since I formerly showed you some imperfect specimens ... every minute detail is represented which is seen in the object itself. The time occupied in obtaining each picture is a minute or two, & no more; but from each of these pictures a large number of facsimile copies can be made, at any subsequent period. Nothing excels the photographic method in its power of delineating such objects as form your researches, as ruins, statues, basreliefs, &c. And I

[30] Arago, "Report," in Trachtenberg, *Classic Essays*, 17–18.
[31] Lyons, "The Art and Science," 30.

should think it would be highly interesting to take a view of each remnant of antiquity *before removing it*, & while it still remains *in situ*.[32]

Later that month, and following an interested response from Fellows, Talbot expanded upon the possibilities: "Suppose that in traveling, you arrive at some ruins unexpectedly, which you wish to have drawn—you set up the Camera, open the portfolio, and take out a sheet of paper ready prepared; slip it into the instrument, and take it out again when you think that a sufficient time has elapsed, and in ten minutes all is packed up again and you are proceeding on your journey."[33]

While Talbot, like Arago, emphasized the relative speed of photography and the photographer's ability, as a result, to cover more ground and take more pictures, the development of the paper process was far more significant since it made possible the purchase and circulation of multiple prints by a commercial readership. In little more than a decade, the immense popularity of the kind of photographs Talbot had had in mind in his letter to Sir Charles—sites of religious and mythic significance, ruins, artifacts, images of the exotic to accommodate an increasing taste among the middle classes for virtual travel—made it clear that photography already belonged to a much wider cultural context. Between 1856 and 1859, the photographer Francis Frith's travels took him, as Douglas R. Nickel puts it, "to Egypt and Palestine as an amateur and a gentleman." Following his three tours of the Middle East, Frith founded what was to become the largest photographic printing establishment in England. His work was distributed "through a number of publishing channels, from the exceptionally expensive … to popular stereo views and loose prints offered on the open market."[34] Commercially successful and widely available in Britain during the last four decades of the nineteenth century, Frith's postcard views shaped Britain's view of itself, the world, and the medium. Like the early photographers, Frith was fascinated by the

[32]Letter from Talbot to Sir Charles Fellows, April 11, 1843; document number 4799. Copy owned by Harold White. *The Correspondence of William Henry Fox Talbot*. Project director Larry Schaaf. All references to the correspondence may be accessed online.

[33]Letter from Talbot to Fellows, April 26, 1843. Note that the "You" who "set up the Camera" and prepared the "sheet of paper" was unlikely to be Sir Charles Fellows himself; the Victorian amateur photographer, especially when traveling, generally employed one or more valets (frequently retrained household staff) to carry and set up the equipment. Thus the passive "all is packed up again" is a rather evasive descriptor. In this particular case, and after some correspondence between the two regarding the necessary chemicals, cameras, and equipment, Talbot must have been disappointed to hear that Sir Charles decided against taking a camera, in part because he did not, in fact, have such a person for this expedition: "considering the great imperfection in the manufacture of paper suited to the purpose, the nicety required in using the chemicals, and the extreme cleanliness and exclusion of light in the process, I fear the science is not yet ripe enough for the use of the rough traveler … I cannot recommend its adoption unless an experienced person is sent to attend solely to the subject. I am quite ashamed at the trouble we have given you, but am sure that our whole party are sensible of the extreme beauty and promising use in the invention." Letter from Fellows to Talbot, August 1, 1843.

[34]Douglas R. Nickel, *Francis Frith in Egypt and Palestine: A Victorian Photographer Abroad* (Princeton and Oxford: Princeton University Press, 2004), 11.

"essential truthfulness" of photography and maintained that the image could speak for itself.[35] Certainly, the perceived transparency of the medium was part of the company's aesthetic, and Frith's postcards show no interest in theatricality of the kind that characterized the work of pictorial photographers like Robinson or Rejlander. Nonetheless, Nickel might be describing any of the early Victorian photographers when he posits that Frith is "best understood as situated on the cusp between the Romantic period, in which he was reared, and the Realist, in which he operated [because] his photography … simultaneously speaks of a recognizably modern worldview and modern culture's more remote, less familiar antecedents."[36] In other words, in Frith's distinctively different, commercially conceived, and widely distributed work, Nickel finds the same kind of commemorative tensions that destabilized the early rhetoric of Talbot and his peers.

THE REAL IS PAST

"The true content of a photograph," John Berger writes, "is invisible, for it derives from a play, not with form, but with time."[37] Berger is right that "a play . . . with time" is photography's "true content," but for many Victorians photography promised to make that true content visible. By selecting subjects that invited imaginative engagement with the past, photographers frequently and deliberately brought time to the fore. Some among them were sensitive to the fact that not all photography was practiced at one's country seat, with a collection of inherited antiquities conveniently to hand: in Lerebours' *Treatise*, for example, the author points out that "Few persons [have] in their possession collections of iron armour, bronze vases, stone or marble capitals of columns, wood carvings, sculptures, &c." Rather than encouraging photographers to look elsewhere for subjects, however, Lerebours suggests that those lacking in antiquities should try faking them:

> They may, with simple stained plaster models, obtain, with little cost, all the treasures of our museums. It is thus that I have, for my own part, converted into valuable matter some old models, by only daubing them over with coloured wash; for it is not at all necessary to colour the object that you wish to copy to the exact tone that it would have in nature; it will be sufficient to give it a colour having a relative approximation to that you wish to represent.[38]

[35]Ibid., 18.
[36]Ibid., 174.
[37]John Berger, "Understanding a Photograph," in Trachtenberg, *Classic Essays*, 291–94, 293.
[38]Lerebours, *A Treatise on Photography*, 77.

Photography's celebration of the aesthetics of decay, an aesthetics defined in paintings by John Constable, and reincarnated in Lerebours's text in the form of "stained plaster models" daubed with "wash," affirmed the camera's role in recording time's passage. When Ruskin lamented the cleaning of St. Mark's in Venice, what he most deplored was the erasure of visible time: "Off go all the glorious old weather stains, the rich hues of marble which nature, mighty as she is, has taken centuries to bestow."[39] What made St. Mark's beautiful to Ruskin was the work of weather, nature, and centuries, a work that might now be captured by photography before it could be done away with by the modern hand.

Ruskin's relatively brief enthusiasm for photography stemmed from its ability to depict architectural narratives of temporal continuity and material change, work that justified, he felt, aesthetic intervention. Karen Burns relates that when he was working to turn his daguerreotype "Venice, Southern Portico of the basilica of St. Mark, View from the Loggia of the Ducal Palace" into a mezzotint ("St. Mark's, Southern Portico"), Ruskin deliberately removed the gas lamps. One imagines him—working, of course, by gaslight—carefully scouring away the present, much as the walls of St. Mark's had themselves been rubbed clean of the past. From Ruskin's actions, Burns concludes, "Erasure of the present ensured the presentation of the past."[40] But the removal of the modern gas lamps also tells us that in Ruskin's interest in photography it was romantic rather than objective commemorative desire that was uppermost. His deliberate removal of the lamps conveys his sense of their being out-of-place, in some way wrong; gas lamps are at odds with a "real view" of St. Mark's. The "real view" for Ruskin contains the "glorious old weather stains" bestowed by "centuries," but not the more recent gift of nineteenth-century technology. For Ruskin, St. Mark's was better served by the erasure of the present, because what was real, and *where* it was real, was the past.

But if the real is past, is the present itself somehow unreal? In the face of the cultural belatedness that appears to be both the context and the condition for much Victorian photography this is a valid question. If a culture's epistemology privileges the very notion of the real (as Victorian culture did), then technologies that appear to collapse notions of what is real with what is past (as photography does) invite a perception of the present as less authentic. But this doesn't address the more significant question concerning what the consequences might be of perceiving the present to be less authentic than the past. Politically, one might expect to see disengagement, or distraction from present-day concerns, as being, perhaps, less demanding of public attention. Feeling that the present is somehow less "real" than the past gives rise to detachment from the current moment. Aesthetically, one could imagine a turn away from the idea of innovation in the arts and a greater investment in the celebration

[39]Burns, "Topographies of Tourism," 36.
[40]Ibid., 33.

of tradition. It may not be too much of a stretch to see the efforts of some Victorian photographers to produce images that mimicked painting as marking that turn. "Nostalgic obsession in the popular arts not only means alienation from present-day reality but implies accepting such detachment as normal and appropriate," writes David Lowenthal.[41] Nostalgia is selective, amnesiac, and elegiac; it allows us to "deny sin and escape history."[42]

Forging a relationship with the past by so selective and elegiac a means as Victorian photography can be a dangerous business, then, both for us as well as for those original makers and readers of nineteenth-century photographs. Moreover, while the class associations of early Victorian photographs—perspectives, locations, subjects—were undeniably the product of wealth and leisure, later makers, merchandisers, and consumers of nostalgia continued to trade upon views of the past that were inevitably selective. Throughout human history, what we have represented to ourselves as "the past," albeit in nineteenth-century photographs, eighteenth-century fiction, or twentieth-century souvenir, has arguably never been experienced as "the present"; the coherence of our view, like the simplicity of our longing for it, is the consequence of hindsight, of knowledge after the fact, a result of the disparity between the perceived instability of the present and the stasis of the past in which nothing happens any more and thus about which, theoretically at least, everything can be known. The intimacies of nostalgia may serve to forge bonds with those subjects of the past in whom we are most deeply interested, but at the same time, as Lowenthal argues, they underscore "universal constants of human feeling while obscuring or ignoring the broader social and cultural trends that both link and differentiate past with present."[43]

My initial question regarding the backward glance of Mrs. Ramsay (how does the past shape itself "differently"?) is of course a question about the *perception* that it does—a perception that was nurtured in the nineteenth century by the temporal self-consciousness of reading photographs and practicing photography. Mrs. Ramsay stands at the dining room door, looking back at a scene that, because she has left it, ceases to exist. As Andrew Ramsay says when trying to describe his father's work in philosophy, it's like the kitchen table "when you're not there."[44] The past shapes itself "differently" for us when we have ceased to be there. The recognition of this fact, and the peculiar sensations that emanate from it, certainly predate photography; the feeling may even be one of the things that makes us human. But only since the mid-nineteenth century has the sensation coexisted with a technology and, equally important, a metaphor, by which it can be pointedly experienced and expressed.

[41]David Lowenthal, "Nostalgia Tells It Like It Wasn't," in *The Imagined Past: History and Nostalgia*, eds. Malcolm Chase and Christopher Shaw (Manchester and New York: Manchester University Press, 18–32), 24.
[42]Ibid., 26.
[43]Ibid., 30.
[44]Woolf, *To the Lighthouse*, 23.

And what have been the consequences of the perception that the past shapes itself "differently"? A sense of distance from history, a strangeness rather than a closeness, an intensification of our own modernity? A dizzying vertigo, as though we are strapped to that imaginary crow's nest with James Hutton, the new oblivion in our wake? It's hard to say. With a photograph in hand as evidence, it's even harder: history may be distant and strange, but in its recognizable, small, visual form, it is also more intimately ours. Like Holmes, we find ourselves returning to the question of what it would be like "if there were no picture there"—if the glass plate were blank, or if a curtain dropped on Mrs. Ramsay's dining room, and none of us could watch the past shape itself into anything at all.

The relationship between our past, present, and future selves can scarcely be attempted without the metaphors which photography supplies, so dependent have our imaginations become on them. Like those early photographers whose choice of old subjects—books, architecture, geologic forms—embodied their own relationship to the workings of time and culture, Mrs. Ramsay's backward glance offers an apt figure not only for the self-conscious selection of a moment as significant and thus worthy of record but also for our nostalgic desires as postmodern readers and viewers to find evidence or traces of our selves in different visual and literary texts. The photographic past has existential value for the postmodern reader as much as it does for the Victorian Mrs. Ramsay, or her modernist author, because, as Lowenthal writes of modern nostalgia generally, it visualizes not simply "the past as it was or even as we wish it were; but ... the condition of *having been*."[45]

[45]Lowenthal, "Nostalgia Tells It Like It Wasn't," 29.

Having Been

Photography and the Texture of Time

If you've read Hardy's *A Pair of Blue Eyes* (1872), and remember anything of it, it's likely to be the scene that most concerns itself with the limits of human memory. The heroine, Elfride Swancourt, has gone down to the cliffs with a telescope to watch out for her lover, Stephen Smith, as his steamer rounds the coastline. On the way she is overtaken by another suitor, Henry Knight, and in the course of rescuing Elfride when she slides off the edge of a rock face, he becomes similarly trapped. Knight finds himself hanging by his arms against a cliff Hardy describes as having both "backbone" and "marrow" and consisting of "a vast stratification of blackish-grey slate, unvaried in its whole height by a single change of shade."[1]

This is a cliff against which Elfride and Knight are both very small indeed. It is a cliff with claims to sublimity, a Moby Dick of cliffs, "nearly three times the height of Flamborough, half as high again as the South Foreland, a hundred feet higher than Beachy Head—the loftiest promontory on the east or south side of this island—twice the height of St. Aldhelm's, thrice as high as the Lizard, and just double the height of St. Bee's."[2] Adding "terror to its height" is its "blackness," which seems "to float off into the atmosphere, and inspire terror through the lungs."[3] Like Forster's future Marabar caves, Hardy's leviathan exists beyond the organizational power of words, for which reason, he writes, it "may be called the Cliff without a Name."[4] Given all this, perhaps

[1] Thomas Hardy, *A Pair of Blue Eyes* (Oxford and New York: Oxford University Press, 2005), 192.
[2] Ibid., 195.
[3] Ibid., 195–96.
[4] Ibid., 195.

we should not be surprised to find Knight suspended against the landmass for the duration of an entire chapter, while Elfride rushes off to remove some undergarments with which to rescue him. And while much of the novel may disappear from memory, the passage in which the solitary man clings helplessly to the "Cliff without a Name" remains with the reader, as though some giant fact from the geological universe has broken through into this novel-world of romance and wistful memoir.

Our interest in the passage begins with the stratification of ages that comes into view as Knight stares at the cliff face: "He reclined hand in hand with the world in its infancy. Not a blade, not an insect, which spoke of the present, was between him and the past."[5] With his death beginning to seem increasingly imminent, Knight realizes he is face to face with a fossil:

> It was a creature with eyes. The eyes, dead and turned to stone, were even now regarding him. It was one of the early crustaceans called Trilobites. Separated by millions of years in their lives, Knight and this underling seemed to have met in their place of death. It was the single instance within reach of his vision of anything that had ever been alive and had had a body to save, as he himself had now.[6]

Knight, who has studied geology, knows that this creature is a "low type of animal existence … Zoophytes, mollusca, shell-fish, were the highest developments of those ancient dates." The fossil embodies a period that existed before there were words to describe it and thus represents "immense lapses of time" that "had known nothing of the dignity of man." For Knight, face to face with the conflation of millennia, time closes up "like a fan."[7] Receding into the distance are the stages of history and prehistory, generally apprehended as sequential, sedimentary lines; but eye to eye with the trilobite, he experiences a modernist collage of visual simultaneity in which all time is reduced to one plane: "He saw himself at one extremity of the years, face to face with the beginning and all the intermediate centuries simultaneously … the lifetime scenes of the fossil confronting him were a present and modern condition of things."[8]

This vision of prehistory to which Hardy, and later, Conrad, Woolf, and other writers will return, implies, as Gillian Beer argues, "a pre-narrative domain which will not buckle to plot."[9] Hardy's un-nameable landmass is a mystery. In its literary context it may be read as a symbol of what lies beneath, but it is also a giant refusal of the human thirst for narrative, for, as Beer puts it, "prehistory tells no story. It is time without

[5]Ibid., 199.
[6]Ibid., 200.
[7]Ibid.
[8]Ibid., 201.
[9]Gillian Beer, *Arguing with the Past: Essays in Narrative from Woolf to Sidney* (New York and London: Routledge, 1989), 162.

narrative, its only story a conclusion."[10] The eyes that meet Knight's convey nothing other than that they are dead. There is no epiphany, no illumination on Knight's part, other than the consciousness that a human may share his ending place with a trilobite. Indeed, for a long while, nothing happens but the weather, and (capriciously it seems to Knight) rain pierces him to the skin with "a torturing effect."[11] Knight finds the rain to be the heaviest and coldest of his life, while the narrator notes that it is "quite ordinary in quantity; the air in temperature";[12] he feels that Elfride has been gone for ten minutes, when according to the clock it is three. Subjective experience neither subsumes nor submits to objective reality, however, but is merely suspended alongside it.

A Pair of Blue Eyes is not a modernist novel, but its interest in the nature of subjective experience, simultaneity, and prehistory, as well as its anticipation of Conrad's concertinaed ages ("I was thinking of very old times," Marlow says in *Heart of Darkness*, "when the Romans first came here, nineteen hundred years ago—the other day")[13] suggest that its seam is pressed very close to that of the early twentieth century. Indeed, in 1917, musing in her diary, Woolf toyed with a word that Hardy might well have used to describe Knight's experience. "Roger [Fry] asked me," she wrote, "if I founded my writing upon texture or upon structure; I connected structure with plot, & therefore said 'texture.' Then we discussed the meaning of structure & texture in painting & writing."[14] How structure might be "connected" to plot, Woolf doesn't say, but by *opposing* texture to plot she suggests that texture is not causal or narrative in nature, that it isn't linear, and, by extension, that it is not teleological.

Woolf's choice of word has interesting implications not just for "painting & writing" but for photography, too, which may be said to have its own structure, or plot, in the form of content. Although Woolf doesn't mention what conclusions were arrived at regarding "the meaning of structure & texture," she implicitly affirms a meaningful distinction between *what* happens and *how*, the latter being, presumably, the formal domain of "texture." If we take her word out of context for a moment, we find it to be generally understood as haptic and self-referential, conveying the feel of the thing of which it is a part, its roughness or smoothness, the contours of its surface. Indeed, if "texture" has meaning, it lies in its own history, and in how that surface has been produced. Texture develops at points of contact between the world and the object, a contact that may be brief or extended, occurring just once or repeated over a period of time. If the latter, it is through the texture produced in repetitive action that the passage of time itself becomes visible. If that repetitive action is performed by human beings, its visibility as texture promises a connection across the ages that lends pathos, or beauty, or some intimate charm to the object itself. Indeed, it is texture

[10]Ibid.
[11]*A Pair of Blue Eyes*, 201.
[12]Ibid., 202.
[13]Joseph Conrad, *Heart of Darkness*, 1899 (New York: Dover, 1990), 3.
[14]Thursday, November 22, 1917. *The Diary of Virginia Woolf*, vol. 1, 1915–19, ed. Anne Olivier Bell (San Diego, New York, London: Harcourt Brace, 1977), 80.

that gives imaginative and historical value to the object; lacking texture, the object is without poetry as well as past. Thus Holmes, during the course of a "virtual tour" of England and the homes of its poets, courtesy of the stereoscope, remarks,

> What is the picture of a drum without the marks on its head where the beating of the sticks has darkened the parchment? In three pictures of the Ann Hathaway Cottage, before us,—the most perfect, perhaps, of all the paper stereographs we have seen,—the door at the farther end of the cottage is open, and we see the marks left by the rubbing of hands and shoulders as the good people came through the entry, or leaned against it, or felt for the latch. It is not impossible that scales from the epidermis of the trembling hand of Ann Hathaway's young suitor, Will Shakespeare, are still adherent about the old latch and door, and that they contribute to the stains we see in our picture.[15]

Note that Holmes is talking here not of a real drum but a "picture of a drum"; he believes that such a picture will have no interest for the viewer if it does not attend to the texture of the drum as produced by human hands beating on it with sticks over months and years, so that the parchment of its surface is darkened by the repetition of the action. Doing produces being, or, as Elaine Scarry puts it, albeit in a different context, "Verbs generate their own nouns as objectifications and memorializations of their own disappearance from the world."[16] In Holmes's example, the invisible verb generates a visible noun: "drumming" produces a "stain." The sound, and the drummer, may be gone, but the mark of the drumming's *having been* remains as its existential testament. Holmes is fascinated by the stereograph of Ann Hathaway's cottage because it records such a *having been*: "marks left by the rubbing of hands and shoulders" on a doorway. The "stains we see in our picture" are the stains of human passage, not just through this particular doorway but also through the wider world. Those stains, the fingerprints of Shakespeare and other "good people," provide Holmes with his point of entry into historical imaginings, and of course, the photograph itself is also a kind of stain, a mark left by physical presence. In its duplicative indexical practice, photography makes the (visible) texture of the doorway part of the (signifying, residual) texture of the picture. In art as in life, the texture of objects that have passed through human hands thus gives physical presence to the otherwise absent body. For Holmes, the object is a drum, or a doorway; in Woolf's writing, it is a kid glove, a wicker chair, a pair of shoes.[17] Other kinds of texture are not

[15]Holmes, "The Stereoscope," 155.

[16]Elaine Scarry, "Work and the Body in Hardy and Other Nineteenth-Century Novelists." *Representations* 3 (Summer, 1983), 90–123, 91.

[17]The glove belongs to Mrs. Ramsay, in *To the Lighthouse* (1927); Jacob's empty chair and shoes similarly contain his absence in *Jacob's Room* (1922). As Gillian Beer observes, Woolf "was fascinated by recurrence, perpetuity, and both by the difficulty of forgetting and by the fragmentary vestiges which are remembered" (Beer, *Arguing with the Past*, 163).

produced by human activity but nonetheless bear witness to the passage of time. For Knight, as for Hardy and his reader, the texture of the "Cliff without a Name" testifies to the dynamism of the world's continual passing away as it generates its own solid memorials to a history of otherwise untouchable moments.[18]

We don't know exactly what Woolf understood by the word "texture," or whether she was sure what she meant in choosing it ("Much no doubt is perfectly vague," she added in her diary entry of that day, "not to be taken seriously"),[19] but, just as Hardy chooses not to name his cliff-face, it's possible that meaning was precisely what Woolf *wasn't* concerned with. Certainly her interest in the subject of time reveals itself primarily as a matter of poetics, or form, rather than signification. If by "texture" we understand her to mean the affect of form, we might argue that in Woolf's own works texture is a by-product of her attention to the *having been* as well as the ongoingness of the world, and that, like the reading experience itself, it is both cumulative and experiential. In Woolf's novels, the passage of time is experienced through objects and the marks that human beings have left on them, the texture that they have acquired. But time's movement is also rendered in those syntactical and poetic choices—the déjà vu of repetition, the somatic response to alliteration—through which it is *felt*; and perhaps this, too, may be understood as a kind of "texture," that is, the way in which the work rubs up against the reader, the residual effect produced over time as the mind finds itself in friction with the shapes of language. If the reading experience is profound, its texture remains as aesthetic memory, in words retained, or in images imprinted like fossils in the mind.

With hindsight, it's easy to see the simplicity of Fry's choice (either texture *or* structure) as an instance of binary modernism swimming into view. We might even trace Woolf's development as a modernist from that same diary entry of 1917: plot goes by the way, Proustian subjectivity ascends to the literary firmament, and in 1922 Woolf's first full-length study in texture, *Jacob's Room*, is published. As Forster put it in his early reading of that work,

> blobs of colour continue to drift past, but in their midst … rises the solid figure of a young man … In the stream of glittering similes, unfinished sentences, hectic

[18]I am indebted in this line of thinking to Elaine Scarry. Although she does not use the word "texture," or consider what she calls the "reciprocal jostle" between body and world with regard to photography, Scarry's work first drew my attention to Hardy's preoccupation with sites of contact between the body and the world, particularly to those in which the repetitive doing of actions produces a sign, or monument, to those actions. Interestingly, Scarry (writing about Hardy) and Holmes (writing about photography) make use of a strikingly similar metaphor: Scarry finds that a woman's repetitive action in Hardy's fiction becomes "a substance, a film or skin grafting itself onto her" (91); Holmes likens photography to a flaying, in which "Forms, effigies, membranes, or *films*" perpetually shed by the subject are fixed on the plate of the daguerreotype (124). See Scarry, "Work and the Body in Hardy and Other Nineteenth-Century Novelists," and Holmes, "The Stereoscope."

[19]Woolf, *Diary*, 80.

catalogues, unanchored proper names, we seem to be going nowhere. Yet … looking back from the pathos of the closing scene we see for a moment the airy drifting atoms piled into a colonnade.[20]

Forster's words feel right as a description of what Woolf is up to. In founding that novel on texture, on what is not plot but rather "airy drifting atoms piled into a colonnade," surely she creates, as he claims, "A new type of fiction."[21]

The interest in texture, however, is not new. Its role in the literary techniques of modernist memory seems intuitive rather than consciously innovative, a Victorian legacy with eighteenth-century bones, neither especially modern in conception nor exclusively literary in its antecedents. The interest in texture as visual embodiment of a memorializing process unbound by the limits of human consciousness—an interest we find in Hardy, Forster, Fry, Conrad, and other early-twentieth-century writers— was present throughout the nineteenth century in a variety of ways and a number of different fields. Victorian photography brought it sharply into focus, however, and it is with photography's engagement with texture, both implicit and overt, that this chapter is concerned.

SURFACE: THE ROUGH AND THE SMOOTH

To Victorian hands touching paper photographs for the first time, the surface of a calotype was surprisingly smooth. Unlike an oil painting, there were no ridges on its surface. It was light, thinner than card, sturdier than writing paper, and different from the daguerreotype in a number of ways, not least because of variations in the paper on which the calotype was first printed. The relatively sturdy calotype could be passed from hand to hand; being paper, it was easily sent through the mail. But being paper also affected the degree of clarity that might be achieved with the process, since "the grain was perceptible, and it was frequently uneven, knotty, and speckled with particles of metal from the machinery of the paper mills."[22] This fact distinguished the calotype from the daguerreotype and won it both admirers and detractors. David Octavius Hill approvingly noted, "The rough surface and unequal texture throughout of the paper is the main cause of the calotype failing in details, before the process of the Daguerreotype—and this is the very life of it. [Calotypes] look like the imperfect

[20]E. M. Forster, "The Early Novels of Virginia Woolf," 1925. *The Mrs. Dalloway Reader*, ed. Francine Prose (New York: Harcourt, 2003), 108–18, 112.
[21]Ibid.
[22]William Jerome Harrison, *A History of Photography Written as a Practical Guide and an Introduction to Its Latest Developments* (New York: 1887), 34.

work of a man—and not the much diminished work of God."[23] By contrast, Frederick Scott Archer found the "fibrous substance" of paper to be a disadvantage, frustration with its "uneven texture" eventually leading him in 1851 to invent the wet collodion process, which used glass instead of paper to "create a smoother surface."[24] The calotype, in other words, became an aesthetic as well as a technical choice, one in Hill's view that gained in value (if it ultimately declined in popularity) because of its human imperfections. Indeed, the daguerreotype, with its perfectly realized detail, seemed to Hill too perfect. Lacking in the marks of human agency, without the mediation of paper's rough surface, its version of the world was "diminished." Moreover, its surface—for the most part iodized silver on copper plate—should *not* be touched, lest fingers mar the fragile surface that was part of its special charm. As Antoine Claudet, whose highly successful London practice offered clients both calotypes and daguerreotypes, noted, "The effect of the daguerreotype picture is formed by a very slight film similar to the bloom of the grape or the down of the wing of the butterfly, so delicate that it may be wiped off or destroyed by the slightest touch."[25]

The habitual presentation of the daguerreotype in a leather frame or case, however, made it substantial and pleasing to hold, a curio, both object and image; and just as *cartes de visite* were frequently slipped into letters and circulated through the mail, so photographs of all kinds were physically folded into the lives of their owners as furnishings, decorations, and ornaments, even embedded along with hair in jewelry such as bracelets and lockets[26] (Figure 3.1). At mid-century, the umbrella term "photograph" thus referenced different kinds of image-objects, united primarily by the historical coincidence of their invention, the novelty of their accomplishment, and an overall semantic instability. The experience of photographs themselves was far from uniform, but the "tactile looking" that many such objects invited was frequently, as Margaret Olin puts it, "more act than reading."[27]

In her long assessment of photography in 1857, Lady Elizabeth Eastlake explored the topic of surface, noting the inherent paradox that while in nature we prefer the young and the smooth, youth and smoothness as a subject for photographs are often undesirable. This, she explains, has to do with the process itself:

[23]Elizabeth Heyert, *The Glass House Years* (New Jersey: Allanheld, 1979), 21.
[24]Frederick Scott Archer, "The Use of Collodion in Photography," 1851. *Essays and Images*, ed. Beaumont Newhall, 51–52, 51.
[25]Antoine Claudet, "The Progress and Present State of the Daguerreotype Art," *Journal of the Franklin Institute* 10 (1845), 113.
[26]Lindsay Smith has recently drawn attention to the circulation of photographs in the mail in the appropriately titled *Lewis Carroll: Photography on the Move* (London: Reaktion Books, 2015). For a fascinating account of the tactile life of photographs generally, see Margaret Olin, *Touching Photographs* (Chicago and London: University of Chicago Press, 2012).
[27]Olin, *Touching Photographs*, 3.

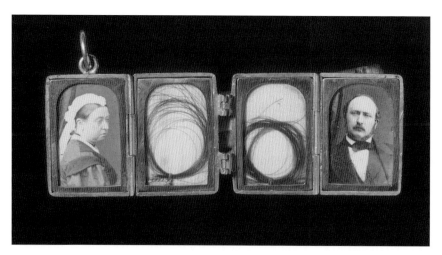

FIGURE 3.1 Gold Locket, said to have been given by Queen Victoria to John Brown. 464505837. Heritage Images/Hulton Archive.

> Things that are very smooth, such as glass and polished steel, or certain complexions and parts of the human face, or highly-glazed satin-ribbon—or smooth leaves, or brass-buttons—everything on which the light *shines* as well as everything that is perfectly white, will photograph much faster than other objects, and thus disarrange the order of relation.[28]

Chiaroscuro, the desirable end of a pleasing picture, is undermined by the camera's stronger contrasts, with the result that "[photography's] strong shadows swallow up all timid lights within them."[29] In other words, smooth things don't come out so well. The ideal subject for a photograph is therefore different, Eastlake writes, than one might suppose:

> There is no doubt that the forte of the camera lies in the imitation of one surface only, and that of a rough and broken kind. Minute light and shade, cognizant to the eye, but unattainable by hand, is its greatest and easiest triumph—the mere texture of stone, whether rough in the quarry or hewn on the wall, its especial delight. Thus a face of rugged rock, and the front of a carved and fretted building, are alike treated with a perfection which no human skill can approach; and if asked to say what photography has hitherto best succeeded in rendering, we should point to everything near and rough—from the texture of the sea-worn shell, of the rusted armour, and the fustian

[28]Eastlake, in Goldberg, *Photography in Print*, 88–99, 90, 91.
[29]Ibid., 90.

jacket, to those glorious architectural pictures of French, English, and Italian subjects, which whether in quality, tone detail or drawing, leave nothing to be desired.[30]

The roughness Eastlake describes is a roughness acquired over years, decades, and centuries, and is not merely a matter of being un-smooth. It is a roughness that belongs to stone, whether "rough" or "hewn"; it belongs to "rugged rock," to things "carved and fretted," to the "sea-worn shell," which bears the markings of its saltwater years. It is roughness that belongs to armor, rusted presumably because it is old, last worn by bodies no longer in need of it. It also belongs, of course, to the picturesque; as Uvedale Price put it in 1794:

> Observe the process by which time, the great author of such changes, converts a beautiful object into a picturesque one. First, by means of weather stains, partial incrustations, mosses, etc it at the same time takes off from the uniformity of the surface, and of the colour; that is, gives a degree of roughness, and variety of tint.[31]

While the smooth and perfect beauty of youth might be marred or underserved by the Victorian camera, Eastlake argued that "Rougher skin, less glossy hair, Crimean moustaches and beard overshadowing the white under lip, and deeper lines, are all so much in favour of a picturesque result."[32]

The term "picturesque" is well-aired in Eastlake's account of the relationship between texture and photography's aesthetic potential. Ann Bermingham claims that by "the turn of the [nineteenth] century the word *picturesque* had become so overused that it had become virtually meaningless,"[33] but Eastlake appears to be using it much as Price had, or as William Gilpin did in a letter of 1791 to Sir Joshua Reynolds, in which he defined the picturesque as pertaining to "*such objects, as are proper subjects for painting.*"[34] Like Eastlake, though of course talking of visual arts other than photography, Gilpin distinguishes between the beautiful and the picturesque in terms of surface, noting that classical beauty generally requires a smooth surface: "The higher the marble is polished, the brighter the silver is rubbed, and the more the mahogany shines, the more each is considered as an object of beauty: as if the eye delighted in gliding smoothly over a surface."[35]

Gilpin's ocular glide is accomplished through the polishing, rubbing, and shining of marble, silver, and mahogany that is undertaken by human hands, and its charm

[30]Ibid., 96.
[31]Uvedale Price, *Essay on the Picturesque* (London 1794), 51.
[32]Eastlake, in Goldberg, *Photography in Print*, 93.
[33]Ann Bermingham, *Landscape and Ideology: The English Rustic Tradition 1740–1860* (Berkeley, Los Angeles, London: University of California Press, 1986), 84.
[34]William Gilpin, *Three Essays* (London: 1792), 36.
[35]Ibid., 4.

presumably depends on the invisibility, or the *partial* visibility, of the labor that produced it. The implications of the work of cultivating the shine, the work that is required to produce smooth surfaces, would later be laid bare in Ruskin's Victorian denunciation of the craze for glass beads; human labor, he instructed his readers, is part of the story of classical beauty.[36] But in his consideration of the uniformity of surface and its relation to the aesthetic, Gilpin had the value of smoothness on good authority: "Mr. Burke, enumerating the properties of beauty, considers *smoothness* as one of the most essential."[37]

By contrast, "*roughness* forms the most essential point of difference between the *beautiful*, and the *picturesque*."[38] Roughness is produced in much the same way as smoothness, that is, by surface contact over time, but in its purest form it is produced without intent, intervention, or indeed any kind of human labor; it is a by-product of nature, a sign of time and weather. In Gilpin's theorizing, people as subjects for art belong to classical beauty only until time has its way with them. After that point, the visibility of time's passage lends picturesque interest to the human form:

[W]ould you see the human face in its highest form of picturesque beauty, examine that patriarchal head. What is it, which gives that dignity of character; that force of expression; those lines of wisdom, and experience; that energetic meaning, so far beyond the rosy hue, or even the bewitching smile of youth? What is it, but the forehead furrowed with wrinkles? The prominent cheek-bone, catching the light? The muscles of the cheek strong marked, and losing themselves in the shaggy beard? … in a word, what is it, but the *rough* touches of age?[39]

Gilpin thus draws a direct line between the passage of time and what is picture-worthy, and, given the inevitability of the former, suggests a turn away from ideal notions of beauty in favor of the texture of verisimilitude. At the same time, however, in his poem "On Landscape Painting," he also instructs us:

Scorn thou then
On *parts minute* to dwell: The *character*
Of objects aim at, not the *nice detail*. (lines 542–44)

Here Gilpin appears to be arguing for the opposite of realism, which in a matter of decades will be understood by many to be produced by the "nice detail" of mid-Victorian photography, in favor of a more general truth or "character" of the subject.

[36]John Ruskin, "The Nature of Gothic." 1851-53. *The Stones of Venice*, vol. 2, chapter 6. Ed. J. G. Links (New York: Da Capo, 2003), 157–90.
[37]Gilpin, *Three Essays*, 5.
[38]Ibid., 6.
[39]Ibid., 10, 11.

The texture that interests him (the furrow of wrinkles, the visible bone of the cheek) hints at something *beyond* its own surface; like the tip of an iceberg, the roughness of the picturesque extends from the visible into the grandeur, even the sublimity, of the invisible. As for the representation of scenes drawn not from life, but rather from "fancy," Gilpin's metaphor for the creative process is rather striking:

> The imagination becomes a camera obscura, only with this difference, that the camera represents objects as they really are; while the imagination, impressed with the most beautiful scenes, and chastened by rules of art, forms it's [*sic*] pictures, not only from the most admirable parts of nature; but in the best taste."[40]

Note, of course, Gilpin's pre-Victorian conviction that the camera shows things "as they really are"; but note also the way in which the camera view for Gilpin is rather lesser than the view that one might *imagine*, a view that could reflect not only the "most admirable parts of nature" but those parts improved upon, rendered in "the best taste."

PRECISION, DURATION, SIMULTANEITY

In Eastlake's use of the word "picturesque" to describe the best subjects for photography, and in her understanding of time's significance to each, she clearly draws on eighteen-century aesthetics to make sense of nineteenth-century practices. In this she had precedent: Talbot's *Pencil of Nature*, as noted earlier, is an outgrowth of picturesque theory, with its interest in the representation of the rugged and the timeworn, its insistence that the camera-worthy subject must represent imaginative engagement with history, and its conviction that photography's primary interest and greatest value lay in its ability to visualize that engagement. This photography did, Talbot believed, in two different ways: by making available different historical epochs at the same single visual moment, and by making visible the otherwise vanished specifics of the precise moment in time at which the photograph itself was made.

The Pencil of Nature was intended to illustrate what had so far been accomplished with photography, specifically Talbot's own recent invention of the calotype. For each plate, pasted in by hand, Talbot wrote a paragraph or two, guiding the viewer toward particular readings or giving context to the images displayed. Of "View of the Boulevards at Paris," for example, he writes, "the time is the afternoon. The sun is just quitting the range of buildings … The weather is hot and dusty, and they have just been watering the road"[41] (Figure 3.2). Talbot was interested not only in temporally situating his subjects, however, but also in the "multitude of minute details" specific to time and place that were unwittingly recorded by the photographer. "Sometimes

[40]Ibid., 52.
[41]W. H. Fox Talbot, *The Pencil of Nature* (London: 1844), 18.

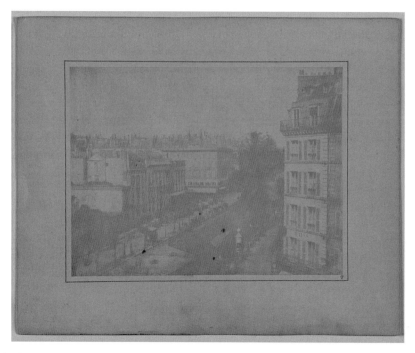

FIGURE 3.2 W. H. Fox Talbot, *View of the Boulevards at Paris*, before May 1843. *The Pencil of Nature*, plate II. Salted Paper Print, 16 × 21.4 cm. The J. Paul Getty Museum, Los Angeles.

inscriptions and dates are found upon the buildings, or printed placards most irrelevant, are discovered upon their walls: sometimes a distant dial-plate is seen, and upon it—unconsciously recorded—the hour of the day at which the view was taken."[42] For Eastlake, it was this kind of detail that gave photography its appeal: "no photographic picture that ever was taken ... is destitute of a special, and what we may call an historic interest."[43] As an essayist in the *Edinburgh Review* of 1843 put it, "The self-delineated landscape is seized at one epoch of time, and is embalmed amid all the co-existing events of the social and physical world ... Thus are the incidents of time, and the forms of space simultaneously recorded; and every picture becomes an authentic chapter in the history of the world."[44]

This is grand language, befitting a new way of engaging history as "the incidents of time, and the forms of space" at long last came together. Having stamped themselves, as Holmes puts it, "in a moment,"[45] those documentary specifics conjoining time

[42]Ibid.
[43]Eastlake, in Goldberg, *Photography in Print*, 97.
[44]*Edinburgh Review*, January 1843, in Goldberg, *Photography in Print*, 49–69, 64.
[45]Holmes, "The Stereoscope," 128.

and place in a single text now provided a legible surface for history's sleuth, whether armed with a magnifying glass (Talbot) or a microscope (Holmes). It did not matter, moreover, that chance and accident might play a role: as Robin Kelsey demonstrates, in Victorian photography it was the very *absence* of control and intention that lent excitement to discovery.[46] "The more evidently accidental" details might be, wrote Holmes, "the more trivial they are in themselves, the more they take hold of the imagination."[47] Indeed, the "incidental truths" to be found in photography "interest us more than the central object of the picture," so that we find them "running away with us from the main object the picture was meant to delineate."[48] As Eastlake observed, it was the smallest of details that lent interest to the image, with the result that photography proved unexpectedly adept at somehow rendering things *in themselves*, so that a child's shoes, or a toy, "minor things" that ordinarily lacked meaning,

> are given with a strength of identity which art does not even seek. Though the view of a city be deficient in those niceties of reflected lights and harmonious gradations which belong to the facts of which Art takes account, yet the facts of the age and of the hour are there, for we count the lines in that keen perspective of telegraphic wire, and read the characters on the playbill or manifesto, destined to be torn down on the morrow.[49]

The "facts of the age and of the hour" belong to history. Like Holmes's vision of a photographic "stamp," Eastlake's counting and reading of what is "there"—a specific moment in time toward which the photograph points—suggest that in its Victorian collaboration with newly developed chemical processes, the camera had indeed become a "clock for seeing."[50]

As noted in Chapter Two, temporal precision and its accompanying metrics had obvious appeal in the face of the incomprehensible magnitude of prehistory. The Victorian experience of time as vast and small, vague and precise, objective and subjective, is on display in William Dyce's well-known painting *Pegwell Bay, Kent: A Recollection of October 5th, 1858*, whose aesthetic, like much pre-Raphaelite art, is photographic (Figure 3.3). What I mean by "photographic aesthetic" is the kind of reading this painting invites and celebrates. With its chilly late afternoon light, its minute attentions (to shells, rock striations, fishing nets, striped clothing), and its titular date ("October 5th, 1858"), the painting sets precision against the vastness of time's backdrop which is brought into visibility by the chalk cliffs in the background. The cliffs are a study in texture, every layer revealing the different

[46]Kelsey, *Photography and the Art of Chance*, 2015.
[47]Holmes, "The Stereoscope," 152.
[48]Ibid., 151.
[49]Eastlake, in Goldberg, *Photography in Print*, 97.
[50]Barthes, *Camera Lucida*, 15.

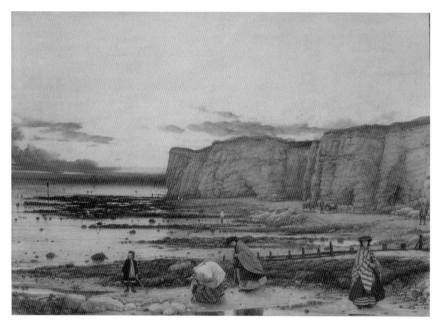

FIGURE 3.3 William Dyce (1806–64). *Pegwell Bay, Kent: A Recollection of October 5th, 1858*, 1858–60. Oil paint on canvas, 635 × 889 mm. N01407 © Tate, London 2015.

temporal narratives that only in Dyce's lifetime had achieved language. There is also a third dynamic represented in the painting: the human experience of time, time in this case recalled, set apart from other moments as "A Recollection," a personal, significant time to which one returns, as Dyce does here, in the ever-present tense of art and memory. The identities of the figures on the beach (Dyce's wife, her sisters, and son) locate the picture for us in human terms; it is a family memory for the artist, who also paints himself in at the far-right side of the canvas as a figure engaged in active contemplation of the scene. Donati's comet, seemingly unremarked far above their heads, further locates the picture in the contexts of history and science as evidence of a particular date and a peculiar atmospheric detail; and the cliffs behind mark a vast prehistory, millions of years in which humans, and thus comets, did not register at all.[51]

Informing the Victorian viewer's experience of this painting was the fact that only a decade earlier, in December 1847, Britain had adapted standard ("railway") time, the conclusion to a process set in motion by the Great Western Railway in 1840. By

[51]See Lee Russell, "The Geology of Pegwell Bay."

mid-century, the vast majority of the public was living according to Greenwich Mean Time,[52] although time itself was not legally standardized until August 2, 1880. As Stephen Kern notes,

> The introduction of World Standard Time created greater uniformity of shared public time and in so doing triggered theorizing about a multiplicity of private times that may vary from moment to moment in the individual … thinkers about the texture of time were divided between those who focused on its public or its private manifestations. The popular idea that time is made up of discrete parts as sharply separated as the boxed days on a calendar continued to dominate popular thinking about public time, whereas the most innovative speculation was that private time was the real time and that its texture was fluid.[53]

Both kinds of time are visibly present to Dyce's canvas: even the title gestures in both directions, toward public, or shared, time ("October 5th, 1858") and private time ("A Recollection"),[54] while the painting itself draws multiple experiences of time—large, small, present, past—into one visualized moment. Created during a period when some clocks had two hands, one for local time, one for Greenwich Mean Time, the painting, like photography, makes temporal simultaneity not merely visible but an existential fact, part of the modern condition which at mid-century finds the Victorian unexpectedly isolated in the waning light, contemplating Matthew Arnold's "vast edges drear/And naked shingles of the world."[55] Moreover, in its style, as I noted earlier, the painting references photography, inviting the close scrutiny of viewers to trawl its surface for previously unremarked details. According to Marcia Pointon, whether or not Dyce actually used photographs to help him make this painting has been "hotly disputed," although, as she points out, "Dyce had been a close friend of

[52]Sue Zemka writes: "By 1855, 98 percent of the public clocks in Great Britain were set to Greenwich Mean Time." *Time and the Moment in Victorian Literature and Society* (Cambridge: Cambridge University Press, 2012), 5.

[53]Kern, *The Culture of Time and Space*, 33–34.

[54]The distinction between "public" and "private" time is Jerome Buckley's:

"Public time" … involves the attitudes of the society as a living changing whole, the *Zeitgeist*, as Mill understood it, the general preoccupation with the upward or downward movement of the "times," and the commitment to the contemporary. "Private time" … relates to the subjective experience of the individual, his memories of a personal past, his will to accept or oppose the deans of the public present, and finally his effort to conquer time, to escape from the tyranny of the temporal, to find beyond the flux of things some token of stability.

Jerome Buckley, *The Triumph of Time: A Study of the Victorian Concepts of Time, History, Progress, and Decadence* (Cambridge: Harvard University Press, 1966), viii.

[55]Matthew Arnold, "Dover Beach," 1867. *The Norton Anthology of English Literature*, 7th ed., vol. 2, eds. M. H. Abrams and Stephen Greenblatt (New York and London: W.W. Norton, 2000), 1492.

David Octavius Hill since the 1830s and certainly knew about photography."[56] Pointon also observes that he "would certainly have been familiar with Lyell's theories,"[57] a likelihood that lends significant weight to a reading of *Pegwell Bay* as "a painting about time, explored through an image of a particular moment in time."[58]

Dyce was far from unique in the self-consciousness he shows in the painting regarding his own historical moment; John Stuart Mill (1806–73) apparently claimed that his entire generation had an "unprecedented awareness of time, and of itself in time."[59] Yet photography's relationship to time, particularly its ability to show variety and simultaneity both in and at one moment, was initially not easy to grasp. In the short essay he wrote to accompany plate III of *The Pencil of Nature*, a photograph of china objects arranged on three shelves (Figure 3.4), Talbot found it necessary to explain that making the picture was technically no more or less demanding than it had been to photograph the Paris boulevard or the Oxford college, since "however numerous

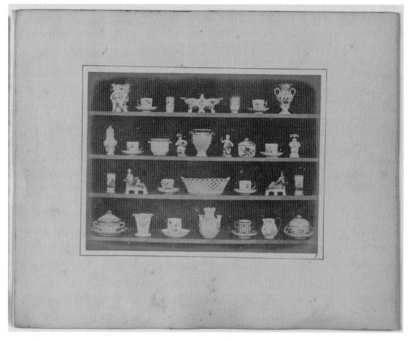

FIGURE 3.4 W. H. Fox Talbot, *Articles of China*, before June 1844. *The Pencil of Nature*, plate III. Salted Paper Print, 13.2 × 18.2 cm. The J. Paul Getty Museum, Los Angeles.

[56]Marcia Pointon, "The Representation of Time in Painting: A Study of William Dyce's *Pegwell Bay: A Recollection of October 5th, 1858*," *Art History* 1.1 (March 1978), 99–103, 100.
[57]Ibid., 101.
[58]Ibid., 100.
[59]Buckley, *The Triumph of Time*, vii.

the objects—however complicated the arrangement—the Camera depicts them all at once."[60] Odd as this now sounds, the logic that required the explanation is clear: the more complex and various the subject of a photograph, the longer a viewer might think the camera must take to record it. Unlike with painting, which provided the conceptual model for most early viewers of photography, the time necessary to make a photograph was entirely independent of the number of parts possessed by its subject.

Talbot's book offers numerous variations on the theme of simultaneity. For example, he includes the fact that his country house, Lacock Abbey, was "erected early in the thirteenth century," but in presenting photographs of it to readers, he also remarks that different eras in the abbey's history may be seen at a glance in a single picture, its long narrative reduced to one surface plane in a kind of flat archeology—like the cliffs of Pegwell Bay, visible all at once. The spectator can observe "The tower which occupies the South-eastern corner of the building … believed to be of Queen Elizabeth's time," while also noting "the lower portion," which is "much older, and coeval with the first foundation of the abbey." While that foundation was "in the reign of Henry III," the cloisters "are believed to be of the time of Henry VI." As Graham Smith writes of one of Talbot's Oxford pictures, "first there is the immediate past, the time when the picture was taken; next there is the "perfect' tense of the 18ᵗʰ century, which is encapsulated in the view of the exterior of Queen's College; and, finally, the 'pluperfect' is embodied by the church of St Peter's in the East."[61]

Contemporary interest in temporal simultaneity was sustained by the popular preoccupation with architecture and its ruins. Later in the nineteenth century, as technology permitted, guidebooks and ruminations on ruins made use of photographs to invite historical engagement, lending a peculiar authority to the romantic work of imagining the past. Howitt's preface to *Ruined Abbeys and Castles of Great Britain* (1862) observes the "authenticating" virtues of its photographic illustrations and its ability to liberate readers from the "imaginations, the caprices, or the deficiencies of artists."[62] With photographs to accompany his narratives, Howitt anticipates that readers will feel "that we are not amused with pleasant fictions, but presented with realities." Nonetheless, it was the imagination that Howitt worked hard to engage. Each of his chapters, centered on a ruin, makes a fetish of simultaneity by repeatedly asking readers to use the mind's eye to grasp all ages at once, a feat that the photographs of the ruins also invite. A striking number of them give shape to the active work of imaginative contemplation by placing a human figure in the foreground to gaze at the ruin, just as Dyce had painted himself into his own work as an invitation to observe the activity of viewing as well as the thing viewed (Figure 3.5).

[60]Talbot, *Pencil of Nature*, n.p.
[61]Graham Smith, "Time and Memory in William Henry Fox Talbot's Calotypes of Oxford and David Octavius Hill and Robert Adamson's of St Andrews," in *Time and Photography*, eds. Jan Baetens, Alexander Streitberger, and Hilde Van Gelder (Leuven, Belgium: Leuven University Press, 2010), 67–84, 69.
[62]William Howitt, *Ruined Abbeys and Castles of Great Britain* (London: 1862), n. p.

Each figure, painted or photographed—or simply imagined, as in the many passages in Hardy's novels in which we are asked to see someone watching—is a small-scale reminder of the agency of human consciousness. Each is in sharp contrast to the years signified by ruined buildings or ancient landforms. Howitt's photographed figures function much as Dyce's painted ones do: isolated, tiny, and poignantly insignificant in the newly realized scheme of things, their bones will be the latest small additions to the accumulation of the ages.

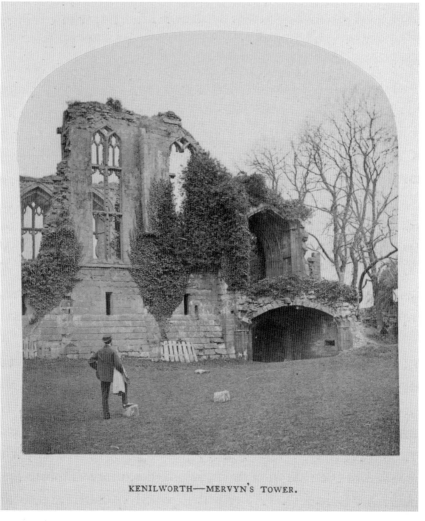

KENILWORTH—MERVYN'S TOWER.

FIGURE 3.5 Stephen Thompson, *Kenilworth: Mervyn's Tower*. William Howitt, *Ruined Abbeys and Castles of Great Britain and Ireland* (second series), London 1864. © British Library Board. C.44.d.7, 8 (item 26).

THE FOSSIL AND THE PHOTOGRAPH

On March 30, 1839, Christopher Rice Mansel Talbot wrote to his cousin Henry Talbot regarding a recent package he had received:

> Many thanks for your photogenic specimens. That representing an etching has faded away since it came, but at first, it was beautiful. Every body here is mad for photogeny, but I have not yet burnt my fingers with it....[63]

We don't know whether the "specimens" were the kind Talbot made by positioning small objects (lace, leaves, a feather) on light-sensitive paper or whether they were the products of one of his wooden box cameras. Family correspondence suggests some confusion regarding how Talbot had "drawn" or otherwise produced his early images. What is clear is that "photogeny" was not yet able to guarantee the longevity of its subjects, and was prone to fade away. Christopher Talbot tactfully makes no mention of Daguerre, whose invention had been made public just three months earlier in Paris. Instead, he describes a discovery closer to home, the result of excavations on the family estate in Wales:

> I have lately discovered in a new harbour we are excavating here, the singular phenomenon of a sea wall 15 feet *below* the level of the sea [.A] little below the same level of 15 ft we discovered the foundations lintels and doorposts of two cottages or sheds, and the still standing trunks of trees and hedge-rows, a roman coin, and an old shoe of leather, were also found with considerable quantity of human bones, & a Druidical circle of stones. Further out, we found Stag's horns, & innumerable foot-marks of Deer and oxen all 20 feet below the present levels. I mean to write an account of it to Buckland.

The "Buckland" to whom Christopher Talbot planned to write was the Reverend Dr. William Buckland, a famous theologian, geologist, and paleontologist, author of the first full-length account of the Megalosaurus, future dean of Westminster, and, at the time, far more famous than Daguerre. Christopher Talbot's fascination with those layers of human, animal, and prehistoric past that were made visible by the excavation of the harbor reminds us of the way in which history generally was coming into focus for the Victorians.[64] But his letter also invites consideration of the way that

[63]Christopher Rice Mansel Talbot to W. H. Fox Talbot, March 30, 1839. Document number 2528. British Library, London. Fox Talbot Collection.

[64]Three years prior to this, Henry Talbot wrote to his stepfather, Charles Feilding, about the thrill of discovering some old architectural plans to Lacock Abbey which showed what the place was like before renovations began in 1717. The plans allowed Talbot to perceive the bones of the older structure in its nineteenth-century incarnation. Outdoors, he writes, "the ancient track is very visible in the field, but I never understood till now what it was ... I think you will allow that our occasional conjectures respecting the former state of things, have been exceedingly wide of the truth: as the ideas of Geologists concerning the primitive world, would probably be found, could a similar revelation be made to them." Talbot to Rear Admiral Charles Feilding, June 7, 1836. British Library, London. Fox Talbot Collection.

photography could give material form to the imaginatively challenging concepts of prehistory—as did Henry Talbot when in 1843 he photographed geologists "reading" a cliff face in Chudleigh, Devonshire, producing a miniature of engagement with literacy, texture, and time that one might expect to find tucked away somewhere on the canvas of *Pegwell Bay* (Figure 3.6).

Talbot's photograph offers a meditation not only on the work of the geologists—a man and a woman, possibly Buckland himself, and his wife, Mary, reading a detail of Dorset's Jurassic coastline[65]—but on photography itself in the context of deep time, photography here producing a further fossilization, since both shadow and rock left versions of themselves as traces on Talbot's calotype.

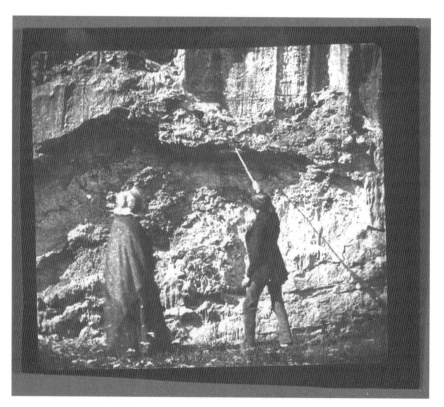

FIGURE 3.6 W. H. Fox Talbot, *The Geologists*, 1843. © National Media Museum/Science & Society Picture Library.

[65]There is speculation regarding the identity of the pair, with the interesting possibility that they are Henry de la Beche, president of the National Geographical Society, and Mary Anning (1799–1847), which would make this the only known photograph of the famous fossil hunter; but in fact there are a number of female geologists who might have been present, including, as noted, Mary Buckland, the wife of the same "Buckland," to whom Christopher Talbot was going to write about his geological discoveries. See Suzanne Pilaar Birch, "Google doodle celebrates the missing woman of geology." *Guardian* online, August 21, 2013.

Consciousness of prehistory is continually netted into the context of Victorian photography, either by the visual emphases of specific photographs such as this one or by the utilities of metaphor. Holmes shared figurative territory with both Talbot and Eastlake when he considered the picturesque appeal of the aging human subject:

> The sitters who throng the photographer's establishment are a curious study. They are of all ages, from the babe in arms to the old wrinkled patriarchs and dames whose smiles have as many furrows as an ancient elm has rings that count its summers. The sun is a Rembrandt in his way, and loves to track all the lines in these old splintered faces. A photograph of one of them is like one of those fossilized sea-beaches where the raindrops have left their marks, and the shellfish the grooves in which they crawled, and the wading birds the divergent lines of their foot-prints,—tears, cares, griefs, once vanishing as impressions from the sand, now fixed as the vestiges in the sand-stone.[66]

The raindrops, the shellfish, the wading birds—all are gone, but the dropping, the crawling, and the wading, like the human passage through Ann Hathaway's cottage door, have left a legible landscape that embodies the passing of time. Likewise, the emotions have their vestigial remains: "furrows" on a face are like rings on a tree, produced over the years. The photograph, a "fossilized sea-beach," like that of Dyce's *Pegwell Bay*, gives texture to the ephemeral and makes time emphatically visual.

Holmes was not the first to fancy that a photograph might itself be a kind of fossil. Daguerre invited the metaphor early with his daguerreotype of fossils and shells (Figure 3.7). His choice of subject was practical: unlike buildings or landscapes or people, fossils could be purposefully arranged, set immobile in bright light for hours on end, and they were also, as Eastlake remarked of shells, rough and textured in a variety of ways that made interesting subjects for the camera. But a daguerreotype of fossils has figurative significance, because, as an index of its subject, it offers a reflexive comment on form as well as content. A photograph of a fossil (indeed, a photograph of anything) is arguably a fossil in itself; like the trilobite, it is a material trace of something that once was. Moreover, like a fossil, photography's historical significance does not depend on the moment of its making, but develops over time. From this point of view, the technology of the daguerreotype, like that of the calotype, was a means of conveyance as well as of record, a timely vehicle that permitted prehistory to move forward in new guise into the future.

Fossils were of great interest to many mid-century Victorians. In his books on ruins, Howitt frequently draws attention to sites of fossil hunting, offering an alternate version of the relationship between sentient beings and the architectural casings in which they once existed; beyond the history of those human beings whose dwellings provide him with his narrative thread, we catch glimpses of earlier pre-human worlds

[66]Holmes, "Doings of the Sunbeam," 256–57.

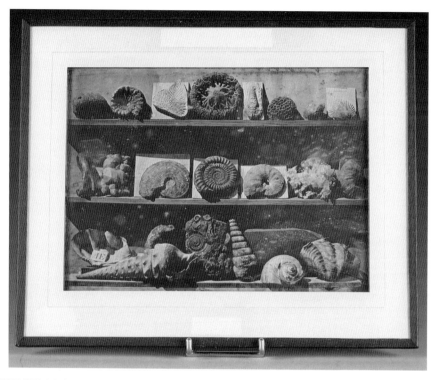

FIGURE 3.7 Louis Jacques Mandé Daguerre, *Collection de Coquillages et Divers*, 1839. © Musée des arts et metiérs-Cnam, Paris. Photo: P. Faligot.

that underlie their foundations. Thus, for example, in reading about the long history of Lindisfarne Priory, and with Howitt bringing each age into view, we move back in time beyond the oldest parts of the church, back beyond the Saxons, to find ourselves among the "fossils, called *Entrochi*, or, popularly, St Cuthbert's beads [which] are still found among the rocks," fossils that also crop up, Howitt notes, in Scott's poetry, as small linguistic markers of ancient times.[67]

The meaning of fossils themselves had in fact shifted some years earlier, largely as a a result of Georges Cuvier's late-eighteenth-century theories of catastrophism. Cuvier's work transformed fossils, as W. J. T. Mitchell notes, "from freaks of nature or mere curiosities into traces of extinct life and evidence for a series of

[67]William Howitt, *Ruined Abbeys and Castles of Great Britain and Ireland* (London: 1864), 60. In his contemplation of the beach at Whitby Abbey, Howitt again turns to Scott as a Romantic guide to the many ammonites there that "resemble snakes coiled up." The second canto of *Marmion* (1808), which he quotes, tells a history of how such objects came to be, although in Scott's version they are signs of instantaneous magic, rather than of geology's long slow narrative (82).

catastrophic revolutions in the history of the earth."[68] Fossils became, in other words, signs of something beyond themselves, understood to be parts of another, older story in which humans had no part. Like literary realism, nineteenth-century photography arguably counters catastrophism in the narrative power that it offers over a scaled-down world. As I suggested earlier, the "much diminished work of God" of the daguerreotype undoubtedly lent some thinkers a sense of control over what was seen. But early discourse on Victorian photography was also frequently characterized by a perceived lack of agency on the part of the photographer. In this view, the camera took what it must; its achievement of content was without human interference, "impressed by the agency of Light alone," as Talbot put it, "without any aid whatever from the artist's pencil. They are the sun-pictures themselves, and not, as some persons have imagined, engravings in imitation."[69] Victorian photography's construction as the product of natural laws—a construction that was by no means monolithic, but was nonetheless common in the first decades of its use—obviously gave some heft to the fossil metaphor, and when human prints did find their way onto the surface of a photograph, and agency was actually a visible part of the photograph, the metaphor continued to hold—presumably because, as Mitchell puts it, "As a petrified imprint, both icon and index, of a lost form of life, the fossil is already an image, and a 'natural image' in the most literal sense we can give these words."[70] A fingerprint left on a photographic plate, sign of a living presence at some portion of the photograph's history, serves as a second temporal seam, a fossilized version of agency itself. Ultimately, of course, the metaphor of the fossil attached itself to the material life of the photograph simply because it was useful; it had staying power because what it said about photography was something that was *felt* to be the case.

TEXTURE AND THE MATTER OF PHOTOGRAPHY

Julia Margaret Cameron's fingers on her sticky glass plates produced smudges on the resulting photographs that today promise a sense of connection such as Hardy's Knight feels, eye to eye with the trilobite. We cannot *feel* Cameron's fingerprints; there are no ridges of hardened oil paint over which to run our fingers. Were we to hold a print that Cameron herself had made, our contact with her would still exist only at the level of metaphor. Nonetheless, descriptions of the desire for haptic intimacy have, over the years, become part of the life of photography and of Cameron's work in particular.[71] Because the texture of photography has to do with *how* rather than *what* photography signifies, with circumstances that over time produce what might

[68]W. J. T. Mitchell, "Romanticism and the Life of Things: Fossils, Totems, and Images," *Critical Inquiry* 28.1 (Autumn 2001), 167–84, 174.

[69]Talbot, *Pencil of Nature*, n.p.

[70]Mitchell, "Romanticism and the Life of Things," 183.

[71]No one has explored this relationship so vividly as Carol Mavor. See particularly *Pleasures Taken: Performances of Sexuality and Loss in Victorian Photographs* (Durham, NC: Duke University Press, 1995).

be called the fabric or, better, the *matter* of photography, then to consider the texture of Cameron's work calls for a consideration of its smudges (see, for example, the two smears at the bottom right corner of Figure 3.8).

While they are an important part of the history of Cameron's photographs, those two inky smears also belong to the history of photography, because our interest in them teaches us something about the relationship between photography and human desire, or what we might call, though rarely do, the sentimental life of photography. Because, as noted earlier, the photograph is an object that is passed around, owned, displayed, hidden, given, sold, and lost, and because, at least to some degree, it is in this way *made*,

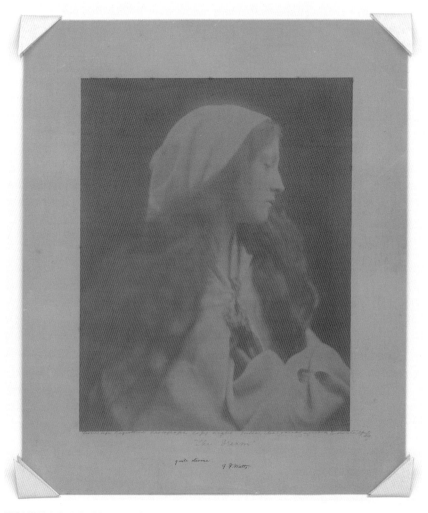

FIGURE 3.8 Julia Margaret Cameron, *The Dream*, 1869. Courtesy of the Harry Ransom Center, University of Texas at Austin.

it grows a material presence over time, a significance that may have little or nothing to do with what it represents. If we wish to read photography in terms other than the purely aesthetic, as evidence, perhaps, of what people thought about, it makes sense to consider the material life of the photograph a significant part of that thought: to study, in other words, what adheres to a picture over the course of its life as a thing. This is what texture means in the context of photography: texture is what sticks. Attending to the texture of photographs involves thinking about how they acquire material presence, about *how they become things* rather than remain merely objects.

Such thinking acknowledges the flexible boundaries of photography's significance, for while a thing may tell us about the world, it "can hardly function as a window," as Bill Brown notes. "The story of objects asserting themselves as things … is the story of a changed relation to the human subject and thus the story of the thing really names less an object than a particular subject-object relation."[72] It is precisely this relation that a history of photography should tell, but it does not require thinking about what photographs *are* in intellectual terms so much as asking *how they matter*. Mattering is, as Daniel Miller observes, a "diffused, almost sentimental association," a focus which in scholarly work "is more likely to lead us to the concerns of those being studied than those doing the studying."[73] At the same time, as Elizabeth Edwards has argued, "a shift away from a purely intellectual approach" in the study of nineteenth-century photographs is "a way of allowing a space for the subjective"[74]—which surely includes the responses of today's readers as much as it does the Victorians for whom those photographs were first made.

Victorian enthusiasm for the wider "historicity of things"[75] was clearly more than intellectual in its reach, and had to do with how those things mattered, a mattering that was neither stable nor fixed, but changed through time. Some of the rhetorical themes from photography's history touched on here—surface, precision, simultaneity, duration—offer ways to think about photographic history independently of what Edwards terms the "forensic 'noise' of content"[76] by bringing into focus a photograph's material significance. Thinking about texture, as Woolf was apparently doing in 1917, and as Hardy was in 1873, and Holmes in the 1850s, and Talbot in the 1840s, may not help us to understand what any literary text or photograph may *mean*, but it draws our attention to the ways in which time and emotions rub against the surface of objects, words, and photographs, so that those objects, words, and photographs themselves become markers of presence, embodiments of absence, part, indeed, of the matter of memory.

[72]Bill Brown, "Thing Theory," *Critical Inquiry* 28 (Autumn 2001), 1–19, 4.

[73]Daniel Miller, *Material Cultures: Why Some Things Matter* (London: University College London Press, 1998), 11.

[74]Elizabeth Edwards, "Photography and the Material Performance of the Past," *History and Theory* 48 (December 2009), 130–50, 136.

[75]Mitchell, quoting Foucault, 176.

[76]Edwards, "Photography and the Material Performance of the Past," 136.

The Photograph as Time

CHAPTER FOUR

Literary Memory and Victorian Stylistics

To describe prose as "photographic" is generally to suggest that emotional involvement on the part of the author is absent or kept at a distance, in abeyance, somehow, to the service of objectivity. "Photographic prose" thus usually implies a mimetic correspondence between noun and thing, between sign and signified; the words refer to something identifiable in the world, as well as a democracy of attention, a sense that nothing signifies more or less than anything else. What matters is the cumulative effect of a reality achieved through inclusion rather than selectivity. "Photographic style" when it applies to painting is similar: by it we probably mean painting whose representation of content is its primary (though not necessarily only) objective. An artist painting in a photographic style reproduces, in terms familiar to that particular cultural and historical moment, what an observant person would be able to see in the world. Logically enough, therefore, photographic style in painting is likely to be identified by the viewers for whom it was intended as "realistic." The aims of such work might not be limited to its representational goals, but nonetheless the term "photographic" denotes in painting, as it does in writing, a correspondence that, supposedly, does not involve any complex translation for those living in the same time and place.

The effort in the visual arts to depict content "photographically" is historically independent of the invention of Victorian photography, but in its wake visually mimetic painting came to mean something rather different. To paint a picture rather than to take a photograph became a choice, and thus to some extent also a statement about what painting was. (Victorian) William Powell Frith's famously realist canvases depicting crowd scenes may not be the aesthetically bereft historical documents that

(ex-Victorian) Clive Bell later found them to be,[1] but their informational emphasis arguably deflects from their potential to move us beyond their subject matter. Frith used his paints as he might have used a camera, and, except for his use of color, with similar results. Actually, Frith *did* use a camera (more precisely, he employed the services of a photographer), in order to make preliminary models for his canvases before translating the contents of the photographs into paint. The purpose of Frith's painting *as* painting, its aesthetic life according to which the medium was a necessary part of its expression, becomes doubtful when considered in light of photography, however, which is, perhaps, one reason that Frith, like Burne-Jones and Rossetti, and possibly Dyce, was discreet about his use of photography and its role in his creative work. Frith's paintings look like photographs in that they look like the things that photographs might, and, at that time could, depict. For many viewers, in fact, the value of Frith's paintings depended on the degree to which they could function as photographs. Their detail was, as it still is, remarkable. If the standard of verisimilitude is a photograph, then we may meaningfully identify Frith's style as "photographic." Moreover, even in the absence of the knowledge that Frith was working from photographs when he painted, for example, *The Railway Station* (1862) (Figure 4.1), we could say that he was working "from photographs"—that is, he was working in a world in which photography provided a standard for what was real, which meant a way of looking both *like it* and *at it*.

Any kind of descriptive act from the mid-nineteenth century onward was to some extent describing "from photographs," because photography, in a variety of forms, became part of the day-to-day visual and cultural experience, and thus influenced, to a lesser or greater extent, and more or less consciously, descriptive emphases and

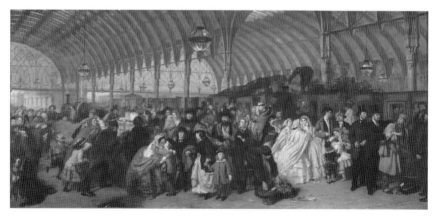

FIGURE 4.1 William Powell Frith, *The Railway Station*, 1860–62. © The Royal Holloway College, University of London.

[1]Clive Bell, *Art* (London: Chatto & Windus, 1914).

impulses. Indeed, owing to the sheer variety of platforms and technologies through which camera-based images were viewed and distributed, it's not possible to identify any one kind of literary description as more obviously "photographic" than another. Nonetheless, at some periods of literary history, the influence of image-making on writing is easier to see than at others, especially when the camera provided a model for narration. Literature of the 1930s and 1940s, for example, saw some evaporation of the formal linguistic experimentation of the 1920s, and in the years leading up to the Second World War, much British and American literature and photography seemed increasingly preoccupied with representational transparency and truth-telling. With some notable exceptions,[2] the increasingly desirable model of authorship was noninterventionist, and the representational standard for the writer was photography. As Christopher Isherwood noted on the first page of his story collection *Goodbye to Berlin* (1939): "I am a camera with its shutter open, quite passive, recording, not thinking."[3]

Google the term "photographic writing style," and you'll get more Americans: nineteenth-century writers such as Crane and Dreiser, considered in relation to photographs by Jacob Riis, for example; or Hemingway, whose spare prose suggests to some readers Isherwood's model of noninterventionist reportage. What you won't find is any extended discussion of what "photographic writing style" means, presumably because we think it obvious that a style of stripped-down reportage is how the camera left its mark on writing. In this part of the book, however, I will suggest that photography's mark is not confined to writing with an overtly documentary impulse; in fact, photography's most significant influence on fiction has had surprisingly little, if anything, to do with objectivity or content.

What any of this has to do with modern memory will become clearer if we look closely at some figurative writing. While poetry, plays, and short fiction are all potential sources for such a study, the Victorian novel's interest in memory is especially acute, so if we're looking for examples of how photography was incorporated into how we remember, and in particular how we write about what we remember, the novel is a good place to start.

PHOTOGRAPHY, REMEMBRANCE, AND THE NOVEL

"As I never saw my father or my mother, and never saw any likeness of either of them (for their days were long before the days of photographs), my first fancies regarding what they were like, were unreasonably derived from their tombstones."[4] Pip's parenthetical, buried inside the first sentence of the first page of *Great Expectations*

[2]T. S. Eliot's plays come to mind, as does Woolf's *Between the Acts* (1941), although David Jones's *In Parenthesis* (1937) is probably the best refutation of this argument.
[3]Christopher Isherwood, *Goodbye to Berlin* (New York: New Directions, 2012), 3.
[4]Charles Dickens, *Great Expectations*, 1861 (New York and London: Penguin Classics, 1996), 1.

(1861), reminds the reader of a small but significant fact about the time "long before the days of photographs": for the vast majority of people, the pre-photographic age was the age of posthumous visual oblivion. Retaining a visible presence after death, or simply when absent, was, before the 1840s, largely the prerogative of the well-to-do, as well as some middle-class people who could afford to be painted, sketched, or silhouetted. The great divide between Pip and his parents is not the fact of the parents' death, but rather that they lived in an age before photographs. Pip's working-class parents have left no visual marker of themselves, hence his imaginative association of them with their graves. Dickens thus begins his novel with a reminder of what it means to be modern: no longer do we need to trace our family resemblance with our fingers on its tombstones. We remember our dead differently now.

For many people in the early days of Victorian photography, its most significant potential function was to provide a visual reminder of the dead. Early use of the camera for this purpose makes sense, as does the later popularity of spirit photography. Such images were powerful embodiments of loss and desire visibly fused by a significantly *invisible* technology. Indeed, the invisibility of their means of production was initially an important contributor to their emotional force. Photographs did more than merely represent the dead. Like the fossils on the beach at Pegwell Bay, they affirmed the once unmediated physical presence of their subjects, keeping them visually in the present tense of memory.

It is desire for his parents' presence that occasions Pip's mention of photographs in *Great Expectations*, but the reference may also have been a nod to Dickens's close friend Chauncey Hare Townshend, the person to whom the novel is dedicated, and the foremost collector of photographs in Britain at the time after Prince Albert.[5] Townshend's fascination with visual objects of all kinds is evidenced by the contents of his study, which included "a hand glass, a brass kaleidoscope, five stereoscopes … a large stereoscope, and cases of stereoscopic slides (both glass and mounted on card) which are listed as twenty-four stereoscopic slides, groups of thirty-six, fifteen, twenty-eight, and twenty-four glass slides, and 113 plain card slides,"[6] while Dickens's own interest in photography is suggested by the publication of several articles on the subject during his tenure as editor of *Household Words*.[7]

But as much as photography was a symbol of modernity for Dickens, a marker of the present moment to which Pip and his readers belonged, it also embodied an extraordinary confrontation of the ages. As we have seen, the many pioneer photographers who had their cameras focused on the past as an antidote to forgetting

[5]Mark Haworth-Booth, ed. *The Golden Age of British Photography, 1839–1900* (New York: Aperture, 1984), 18.

[6]Ibid.

[7]March 1850–May 1859. See Anne Lohrli, *Household Words: A Weekly Journal 1850–1859* (Toronto: University of Toronto Press, 1973).

offered in some sense a remedy for that dissolution of form to which Pip's parents and siblings have succumbed in *Great Expectations*. Richard Terdiman argues that the Victorian fear of forgetting took literary form in the plots of their novels, which "present themselves as the diegesis of history's stress: much more under the sign of a tense exploration of the past's disjunction from the present than under the more traditional guise of rehearsing some consecrated mythology symbolic of the community's consciousness of itself."[8] Novelistic representation of the present moment's relationship to past history, in other words, increasingly reflected a view of the Victorian present as newly and disturbingly discontinuous from the past.

Is it possible to imagine an artifact that more cogently expresses and defies physical and temporal discontinuity than a photograph? The *fact* of the photograph affirms the moment's having ceased to be, its pastness: its separation from present flux. At the same time, the *experience of reading* the photograph affirms the opposite: the subject exists in the ever present. Elizabeth Barrett's sense of the daguerreotype in 1843 as a "facsimile" of a man ("It is not merely the likeness which is precious … but the association and the sense of nearness involved in the thing … the fact of the very shadow of the person lying there fixed for ever!")[9] was widely shared, as thriving sales for daguerreotypes throughout the 1840s attest. It's hardly surprising that early photography shows a heightened sensitivity to the ambiguities of its relationship to the passage of time, both in its choice of subject matter as well as its early critical discourse. Indeed, as I will suggest in this chapter, photography's most significant contribution to the nineteenth-century novel may lie in the occasion that it provided for organizing its readers' thoughts about the past.

The work of Victorian novels was, among other things, to represent a world in which photography had begun to shape the experience of being human. Photography was not merely just the latest way of representing reality; it provided its viewers with a *standard* of what was real. Whether Victorian authors made self-conscious use of photography or not, the books they wrote were subject to that standard; the degree to which their novels seemed "real" was at least in part a result of their relationship to photography's familiar register. Nancy Armstrong argues that, by the mid-1850s, "fiction equated seeing with knowing and made visual information the basis for the intelligibility of a verbal narrative." The visual emphasis of Victorian fiction was in part a consequence of photography's semantic attachment to the real, and the fact that, as Armstrong puts it, "In order to be realistic, literary realism referenced a world of objects that either had been or could be photographed."[10] Despite the fact that as early as the 1840s photography's potential for use in deceit and trickery was well known, in their day-to-day lives most Victorians seem to have regarded photographs

[8]Terdiman, *Present Past*, 25.
[9]Haworth-Booth, *The Golden Age*, 25.
[10]Nancy Armstrong, *Fiction in the Age of Photography: The Legacy of British Realism* (Cambridge and London: Harvard University Press, 1999), 7.

as generally reliable views of a shared world, a world that was visually accessible, knowable, and, for the most part, semantically stable. Victorian fiction's occasional engagement with the subject of photography or its makers suggests an ongoing interest in the material culture of that modern world, as well as a preoccupation with the interplay of images, words, and things.

But fiction's preoccupation with that interplay—its exploration of the complexities of truth-telling, for example, as well as the creativity and unpredictability of this new visual medium whose limits were as yet unknown—also suggests, as I have argued elsewhere, that despite its being "framed" by the culture of realism, photography's appeal was due in part to its association with the *un*known, the *un*real, the *un*stable.[11] Daniel Novak goes further, arguing that both fiction and photography were in fact "perversely unrealistic practices."[12] In the effort to consider how photography shaped the Victorian novel, then, it's important to acknowledge its more disruptive, magical powers as well as its material presence and documentary capabilities, and to recognize that its influence on nineteenth-century literature was, at the very least, far from uniform.

THE LANGUAGE OF REVIEWS: REALISM AND DETAILS

Photography was not the only cause of Victorian literature's visual sensitivity. A whole range of optical technologies helped develop a nation of observers and a culture that increasingly privileged and enjoyed spectatorship.[13] Despite the fact that most people did not know what to expect in their first sightings of a photograph, they were nonetheless eager to engage with such images, and by the 1850s, reading them was part of ordinary life. By that point, as Holmes pointed out, it was increasingly hard to remember a time when photography didn't exist—somewhat akin, presumably, to today's feeling that it's hard to remember a time before e-mail. Novels were being produced for, and consumed by, an increasingly middle-class population for whom a photograph was fast becoming both symbol and substance of reality. If novels were to render the lived reality of their readers, they must depict the visible world, and, by mid-century, to be visible, as indeed, to be memorable, was also to be both photographable and photographed.

This is no mere metaphor, though as I've already noted, photography's metaphorical reach is striking, and arguably nowhere more so than in the many literary reviews that found photography to be a fresh and useful analogy. When Elizabeth Rigby (later Lady Eastlake) praised *Vanity Fair* (1848) for being "pre-eminently a novel of the day … a

[11]Green-Lewis, *Framing the Victorians*, 1996.

[12]Novak, *Realism, Photography*, 139.

[13]See Jonathan Crary, *Techniques of the Observer* and, for a useful accounting of the nineteenth-century expansion of visual technologies, Joss Marsh, "Spectacle," in *A Companion to Victorian Literature and Culture*, ed. Herbert Tucker (Malden, MA, and Oxford: Blackwell, 1999), 276–88.

literal photograph of the manners and habits of the nineteenth century, thrown on to paper by the light of a powerful mind,"[14] she seemed to be commenting on that novel's similarity to real life, its documentary faithfulness, as though the novel were a kind of window on the real world. Stylistically speaking, however, *Vanity Fair* is probably *not* what a modern reader would call photographic: that is, it makes little pretense at the objectivity or authorial distance that supposedly characterizes a photograph. Thackeray's narrator intrudes at various moments, both visually (in illustrations) and textually (in digressions, asides, and commentary). The novel is farcical, over-the-top, and its puppet characters are hardly lifelike. For the postmodern reader, *Vanity Fair*'s brand of realism is more theatrical than photographic: its recital of a world of stuff is full of the pleasures of association and unruly imagination, and it offers none of the tidy visual-linguistic correspondences that might today be identified as "documentary"–if, in fact, that's what Rigby meant by "literal photograph."

But perhaps it's worth asking what exactly Rigby *did* mean? If we borrow Charlotte Brontë's famous distinction that, because it lacked "sentiment" and "poetry," she found Jane Austen's writing to be "more real than true,"[15] perhaps it was not that Rigby found *Vanity Fair* real but that she found it *true*; in other words, she found that Thackeray engaged with more than merely surface realities and instead rendered substantive and essential truths about human beings. Rigby's metaphor, in fact, expresses a view of photography as something that disrupts or intensifies our understanding of the world, as much as it may be said to reflect it. What is photographic here is, to borrow Novak's phrase, "perversely *un*realistic."[16]

Brontë herself turned to the camera for a metaphor when she tried to describe the kind of detail she found in Austen, but unlike Rigby, her choice conveys disappointment rather than enthusiasm: "I had not seen *Pride and Prejudice*," she wrote, "and then I got the book. And what did I find? An accurate daguerreotyped portrait of a common-place face; a carefully-fenced, highly cultivated garden, with neat borders and delicate flowers—but no glance of a bright vivid physiognomy—no open country—no fresh air—Brontë concludes that "Miss Austen is only shrewd and observant."[17] For Brontë, Austen's faithfulness to detail aligned her with the science, not the art, of representation; her accomplishment was therefore merely technical, and thus limited. The accuracy of the daguerreotype was small virtue, given what Brontë perceived as Austen's lack of emotional realism.

The point here is obviously not whether a camera-made image is either or more true or real, but that by 1848, the year in which both Rigby and Brontë wrote, photography evidently provided a model of representation against which literature

[14]Elizabeth Rigby, "*Vanity Fair*—and *Jane Eyre*," *Quarterly Review* 84.167 (December 1848), 153–85.
[15]Charlotte Brontë, Letter of January 18, 1848 to George Lewes. *The Letters of Charlotte Brontë*, vol. 2, 1848–1851, ed. Margaret Smith (Oxford, Clarendon Press, 2000), 14.
[16]Novak, *Realism, Photography*, 139, emphasis added.
[17]*The Letters of Charlotte Brontë*, January 12, 1848 to George Lewes, 10.

might be meaningfully measured. The idea that literature might be like a photograph, for better or worse—that thinking about a photograph might help the reader think about writing—suggests a newly energized effort to describe the progress of realism in general and the novel in particular.[18] In her own exploration of the relationship between images and "abstract or collective terms" (as she terms it, "the picture writing of the mind"), George Eliot famously wrote of Dickens that "while he can copy Mrs. Plornish's colloquial style [in *Little Dorrit*, 1855–57] with the delicate accuracy of a sun-picture … he scarcely ever passes from the humorous and external to the emotional and tragic, without becoming as transcendent in his unreality as he was a moment before in his artistic truthfulness."[19] As with Brontë and her Austen-as-daguerreotype metaphor, what Eliot deems photographic in Dickens suggests limited, rather than comprehensive, truths: Dickens has, as it were, an eye (or an ear) for the outer; he can "copy" as well as a camera can; but he is blind (or deaf)—"transcendent in his unreality"—in his efforts to convey the inner life. A similar note was struck by a less exalted critic in the *North British Review*, who complained generally of

> ludicrous minuteness in the trivial descriptive details [which] induces us to compare Mr. Dickens' style of delineation to a photographic landscape. There, everything within the field of view is copied with unfailing but mechanical fidelity. Not a leaf, or stone, or nail is wanting, or out of place; the very bird is arrested as it flits across the sky … He lavishes as much attention on what is trivial or useless as on the more important part of the picture, as if he could not help painting everything with equal exactness.[20]

Note the reviewer's tenuous grasp on his own metaphor: Dickens writes like a camera, as if he "could not help *painting* everything." Photography thus viewed is incontinent painting, a documentary urge that can't be turned off.

The analogy of writing to photography was popular, if occasionally pejorative, and reading Dickens, interestingly, seemed to occasion it. A reviewer for the *Illustrated London News* found in *Bleak House* (1853) "many intellectual daguerreotypes to carry away"[21]—presumably a good thing, though the strained figure of speech makes it unclear how enthusiastic this reader really is. More overtly critical was the unsigned

[18]The effort to describe the work of realism in terms of the visual arts may have been energized by photography, but it was far from new, painting having previously provided critics with analogies for describing a work's achievement. See, for example, Walter Scott's review of Austen's *Emma* (1816), a novel which recalled for him "the merits of the Flemish school of painting"; or Anna Barbauld's 1804 characterization of Richardson as having "the accuracy and finish of a Dutch painter." Both quoted in Ruth Bernard Yeazell, *Art of the Everyday: Dutch Painting and the Realist Novel* (Princeton: Princeton University Press, 2008), 1, 2.

[19]George Eliot, "The Natural History of German Life," 1859, in *Selected Essays, Poems and Other Writings*, eds. A. S. Byatt and Nicholas Warren (New York and London: Penguin, 1990), 107–39, 107, 111.

[20]Thomas Cleghorn, "Writings of Charles Dickens," *North British Review* (May 1845), 186–91. In Philip Collins, *Dickens: The Critical Heritage* (London: Routledge, 1971), 190.

[21]Unsigned review, *Illustrated London News* (September 24, 1853), 247; Collins, *Dickens*, 282.

review of the same novel in the *Spectator*: "So crowded is the canvas which Mr. Dickens has stretched and so casual the connexion that gives to his composition whatever unity it has, that a daguerreotype of Fleet Street at noon-day would be the aptest symbol to be found for it; though the daguerreotype would have the advantage in accuracy of representation."[22] Dickens's "crowded … canvas" figures once again as the consequence of a kind of literary accident, as though the author has set his easel down and merely taken a picture of everything before it with minimal editorial interference. Painting gives way to daguerreotype as "the aptest symbol," but as it does, Dickens's prose suffers by comparison. Canvas, daguerreotype, novel—all overwhelm with those "trivial descriptive details" newly in focus, despite the fact that, according to Mark Haworth-Booth, a "profound fascination with precision" was "a dominant characteristic of Victorian intellectual life."[23]

Evidence of photography's contribution to the preoccupation with detail was everywhere in the 1850s and 60s, carrying over from the earliest encounters with the daguerreotype some fifteen or twenty years before. In his study in Boston in 1859, Holmes was enchanted with the way that his "stereoscopic views of the arches of Constantine and of Titus give not only every letter of the old inscriptions, but render the grain of the stone itself. On the pediment of the Pantheon may be read, not only the words traced by Agrippa, but a rough inscription above it, scratched or hacked into the stone by some wanton hand during an insurrectionary tumult."[24] As another American practitioner enthused in 1853, "Not only does [the daguerreotype] delineate every object presented to its operation, with perfection in proportions, perspective, and tint … but it delineates objects which the visual organs of man would overlook, or might not be able to perceive, with the same particularity, with the same nicety, that it depicts the most prominent feature in the landscape." In this way the camera was superhuman: "it acts with a certainty and extent, to which the powers of human faculties are perfectly incompetent. And thus may scenes of the deepest interest, be transcribed and conveyed to posterity, not as they appear to the imagination of the poet or painter, but as they actually are."[25]

The writer's evaluation of daguerreotypes as things "as they actually are" reveals his intuition that reality itself resides in the details, a view apparently shared by many viewers who were delighted by the newly enhanced power of the eye. "I once looked at a small daguerreotype of a landscape through a magnifying glass," wrote a reviewer for the children's magazine *The Schoolmate*; "every little object appeared distinct and life-like. The leaves could be plainly seen upon the trees, and little birds appeared upon the branches, which no one supposed were in the picture. In a distant house,

[22]George Brimley, from an unsigned review, *Spectator* (September 24, 1854), 923–25; Collins, *Dickens*, 284.
[23]Haworth-Booth, *The Golden Age*, 10.
[24]Holmes, "The Stereoscope," 108.
[25]A. Bisbee, *The History and Practice of Daguerreotyping*, 1853 (New York: Arno, 1973), 19–20.

every brick could be counted."[26] Delight in the counting of tiny bricks and birds was matched by excitement at the new mobility and depth of vision. The visual prosthesis of the camera, like that of the magnifying glass held over the daguerreotype, allowed the human gaze to explore the world more thoroughly than it ever had, both up close and at a distance—indeed, as far as the moon itself. As the *Schoolmate* article notes,

> Mr. Whipple, the daguerreotypist of Boston, has been very successful in daguerreotyping the moon … [his] crystalotype of the moon ranks among the wonders of the age, and, by its easy reproduction, enables every person, whose cultivated taste leads them to care for such things, to possess a picture of the moon, actually drawn by herself. The picture, let us observe, is a faithful copy of the lunar features—as faithful as an ordinary daguerreotype of a friend's face.[27]

The celebration of the moon's self-portrait, and its rhetorical erasure of its famous photographer in the process, has an obvious counterpart in theories of literary realism that overlook the nineteenth-century novel's frequent self-consciousness about authorial agency. Indeed, it's easy to see how the history of the novel collided with the history of photography in discussions centering on the representation of the object world commonly assumed to be the subject or primary domain of realism. In their identification of certain works as more real than others ("more real than true"), many Victorian readers developed views of the world that appeared to correspond with photography's own. The documentary effect of novels by authors such as Gaskell or Gissing, or, later, Bennett, Galsworthy, and Wells, similarly led readers to identify them as more "realist" than novels by authors such as Dickens, Brontë, and Thackeray. Certainly, when photographs show up in novels as objects, are given as gifts, are passed around among characters, or propped on mantelpieces, they signal adherence to a standard of verisimilitude in representation that's on full satirical display in the title of one of Trollope's best-known works, *The Way We Live Now* (1875). But, like that title, they also signal authorial self-consciousness about the status of the novel as a representing object in competition with other such objects. The appearance of photographs in novels as symbolic furniture and tokens of reality was much like the later twentieth-century use of brand names in literary texts: such objects "fixed" their owners in terms of taste and aspiration by situating them temporally and economically. That these object-photographs appear more frequently in the later decades of the nineteenth century suggests increasing interest on the part of late-Victorian novelists

[26] "Daguerreotypes of the Moon," *The Schoolmate*, January 1854, 75.
[27] "Daguerreotypes of the Moon," John Adams Whipple's "yankee ingenuity" was arguably best demonstrated by his installation of a "steam engine in his gallery to run the buffers, heat the mercury, fan the clients waiting their turn, and revolve a gilded sunburst over the street entrance" (Newhall, *History of Photography*, 33). He was not the first to train his camera on the moon, however: Douwe Draaisma writes that the first daguerreotype of the moon was made in 1840 by John William Draper. Draaisma, *Metaphors of Memory*, 116.

in the relationship between human beings and the things on which they spent their money—the way, indeed, they lived "now."

Sherlock Holmes's pursuit of a compromising photograph in "A Scandal in Bohemia" (1891) embeds that short story in its historical moment, since the plot hangs on the detail that a cabinet photograph is too big to fit in a lady's purse.[28] Much like the photograph of Mrs. Manston in Hardy's *Desperate Remedies* (1871), Irene Adler's image is both a product and marker of modern material culture as well as the object of pursuit and desire. Likewise, Amy Levy's *The Romance of a Shop* (1888), a novel remarkable for its treatment of photography as a workable career choice for women, uses its familiarity with the broader print culture within which photography circulated to self-identify as modern. Its story concerns four sisters who set up a studio and become photographers after they are left penniless on the death of their father. While the women scandalize the neighborhood with their decision to support themselves by working, photography itself is not the cause of eccentricity— indeed, even after marriage, one sister, Lucy, maintains a successful photographic practice of her own. The content of *The Romance of a Shop*, in other words, is notably modern. Gertrude, another sister, reads *The British Journal of Photography*; there is mention of lithographs, slides, and sketches; Lucy's future husband, Frank Jermyn, is an engraver for a newspaper called *The Woodcut*, and has the modern job of a war correspondent. Perhaps because of these references, presumably reflecting Levy's interest in the material details of the lives of her characters, the novel has the same flat quality as Wells's later *Tono-Bungay* (1909), which is similarly noteworthy for its author's attention to surface realism. Yet it is on Levy's *style* that photography really leaves its mark, the novel's many cultural references creating a collage of contemporary tastes and technologies. Each chapter is marked with epigraphs, and characters continually recall snippets of poems and novels. In the decades after the daguerreotype had yielded in popularity to the reproducible photograph, literary descriptions of the photograph rarely convey Elizabeth Barrett's early feelings of "association" and "nearness." Although Hardy's short story "An Imaginative Woman" (1898) offers a notable exception, in late-century novels photographs are more likely to emphasize a public than a private relationship, and embody distance rather than intimacy, while the casual sale or exchange of photographs by their owners (as in Hardy's own *Jude the Obscure*, 1895) seems to symbolize characters' modernist rootlessness. In Hardy, to own a photograph is not to know its subject, but rather the reverse, affirming Novak's argument that for some Victorians, at least, "rather than capturing identity, photography effaces it."[29]

[28]Arthur Conan Doyle, *Sherlock Holmes: The Major Stories with Contemporary Critical Essays*, ed. John Hodgson (Boston and New York: Bedford Books, 1994).
[29]Novak, *Realism, Photography*, 118.

THE FLASH OF INSIGHT: METAPHOR AND NARRATION

When, in *The Romance of a Shop*, Gertrude is assigned to photograph the recently deceased Lady Watergate, Levy's description of the corpse essentially reproduces the image Gertrude is about to make: "A woman lay, to all appearance, sleeping there, the bright October sunlight falling full on the upturned face, on the spread and shining masses of matchless golden hair."[30] Gertrude's assignment is not to document the fact of death. Although on occasion postmortem photographs might show their subjects in their coffins, the dead were more frequently represented, like Lady Watergate, "to all appearance, sleeping"—in the case of children, often in their mother's arms. Gertrude's job is to bear photographic witness to the fact that the subject once *lived*. As portrait photographer William Friese-Greene put it in 1889, "faces vanish like the dreams of night/But live in portraits drawn by beams of light."[31] The postmortem photograph was not a truth-teller so much as an aide-mémoire: a means of recalling a subject and resisting a loss.

Hard as it is to document specific changes in readers' memory-making processes throughout the nineteenth century, how the Victorians reconstructed and recollected their pasts is just as significant for a history of literary realism as the degree to which realism references objects in a recognizable world. Certainly novelistic interest in themes of identity, inheritance, memory, and loss marked a shift in habits of viewing and remembering that were permanently fused by the advent of photography. While literary realism, as Nancy Armstrong argues, "showed readers how to play the game of modern identity from the position of observers,"[32] modern identity also necessitated engagement with the images not merely of things but of things recalled. Part of the connective tissue among Victorian readers was the shared experience of observing *and* remembering.

Gertrude's photograph of the deceased clearly speaks to that experience, and indeed the passage concludes with another version of it: Gertrude-as-camera takes a mental photograph of the grieving husband. His face "formed a picture which imprinted itself as by a flash on Gertrude's overwrought consciousness, and was destined not to fade for many days to come."[33] Levy's conflation of photograph with both memory and the flash of insight is suggestive, though, by 1888, unoriginal. Henry James had already crafted a scene for Isobel Archer in *Portrait of a Lady* (1881), in which a moment of great insight impresses itself upon the passive but receptive heroine: "the thing made an image," wrote James, "lasting only a moment, like a sudden flicker of light."[34] In fact, flash lighting had long been part of the concept, if not practice, of photography.

[30] Amy Levy, *The Romance of a Shop*, 1888, ed. Susan David Bernstein (Ontario, Canada: Broadview, 2006), 86.
[31] William Friese-Greene, "Fox Talbot—His Early Experiments," *The Convention Papers*. Supplement to *Photography* 1.36 (1889), 6.
[32] Armstrong, *Fiction in the Age of Photography*, 26.
[33] Levy, *The Romance of a Shop*, 87.
[34] Henry James, *Portrait of a Lady*, 1881 (New York: Penguin, 1983), 408. I have discussed this scene elsewhere: see Green-Lewis *Framing the Victorians*, 89–92.

Henry Talbot published an announcement of his own experiments with artificial light—"illuminating [subjects] with a sudden electric flash"—as early as 1851.[35] And in his reading of *Bleak House* (1853), Ronald Thomas argues that Dickens's famous detective, Inspector Bucket, with his sudden mental flashes of insight, "stands in for the dreamed-of but as yet unrealized photographic technology in the novel."[36] While the technology of flash continued to evolve (flash powder itself was not developed until the late 1880s), so the "language of flash," as Kate Flint writes, became "both the language of revelation and recollection."[37] With or without flash, James's and Levy's metaphor of mind as a receptive photographic plate is an historically appropriate if essentially unaltered component of Aristotle's metaphor of memory as a drawing or imprint, which, as we've already seen, was popular during the eighteenth century and still much in use throughout the nineteenth.

Levy does not say what became of Lady Watergate's portrait, whether it was displayed on the piano or hidden away in a drawer. As paper prints superseded daguerreotypes in private collections, however, a more popular storage option emerged. Descendant— or cousin perhaps—of the scrapbook, the Victorian photograph album gave shape and solidity to the life-affirming act of recollection. Albums were, as Patrizia Di Bello writes, "an important aspect of the visual culture of the time, crucial sites in the elaboration and codification of the meaning of photography, as a new, modern visual medium."[38] Women's private albums in particular, which frequently included materials and techniques from scrapbooking, "operated as tactile as much as visual objects. They juxtapose photographic images and other mnemonic traces, always pointing to something that no longer is—as it was when photographed—with the here-and-now of tactile experience."[39]

The commercialization of the handheld Kodak camera in the later decades of the century, and the relative ease with which photographs might be made, meant that albums were increasingly curated in middle-class homes. Kodak itself, as Nancy West has demonstrated, shaped the narratives of those albums by teaching "amateur

[35]"On the Production of Instantaneous Photographic Images," *Athenaeum*, December 6, 1851. Cited in Ivan Kreilkamp, "One More Picture: Robert Browning's Optical Unconscious," *ELH* 73 (2006), 409–34, 427.

[36]Ronald Thomas, "Making Darkness Visible: Capturing the Criminal and Observing the Law in Victorian Photography and Detective Fiction," in *Victorian Literature and the Victorian Visual Imagination*, eds. Carol Christ and John O. Jordan (Berkeley: University of California Press, 1995), 134–68, 144. Mark Haworth-Booth makes a similar argument about Inspector Bucket's "enumerative, all-encompassing sort of vision." Haworth-Booth, *The Golden Age*, 19–20.

[37]Kate Flint, "Photographic Memory," *Romanticism and Victorianism on the Net*, 53 (2009), 10. In her reading of Levy's novel, Flint notes that early experiments with *blitzlichtpulver*, "the first widely used flashpowder," were "enthusiastically written up in the photographic press … in language that … drew parallels between the science of photography and the sudden, awe-inspiring shock of illumination produced by natural lightning" (9).

[38]Patrizia di Bello, *Women's Albums and Photography in Victorian England: Ladies, Mothers and Flirts* (Hampshire: Ashgate, 2007), 2.

[39]Ibid., 3.

photographers to apprehend their experiences and memories as objects of nostalgia." As West notes, "the easy availability of snapshots allowed people for the first time in history to arrange their lives in such a way that painful or unpleasant aspects were systematically erased."[40] It seems equally plausible that Kodak's success in this regard lay in an already thriving album culture that was ready to accommodate photography's images. In all of this novels played a part.

LITERARY DESCRIPTION AND THE STRUCTURE OF RECALL

When Brontë begins chapter 11 of *Jane Eyre* (1847) by noting that "A new chapter is something like a new scene in a play; and when I draw up the curtain this time, reader, you must fancy you see a room in the George Inn at Millcote," we are being prepared for instructions not just on what but *how* to see. We are to imagine a variation on something that we already know: "such large-figured papering on the walls as inn rooms have; such a carpet, such furniture, such ornaments on the mantelpiece, such prints, including a portrait of George the Third, and another of the Prince of Wales, and a representation of the death of Wolfe." We are given, that is, both specificity ("George the Third") and generality ("such a carpet, such furniture"): the thing and the type of the thing. We are also told about visual contingencies: "All this is visible to you by the light of an oil lamp hanging from the ceiling, and by that of an excellent fire, near which I sit in my cloak and bonnet." Note the positioning of the narrator as both the subject of events and interpreter-observer of them. "Reader," Jane concludes, "though I *look* comfortably accommodated, I am not very tranquil in my mind."[41]

This turn to a self-consciously observed moment is everywhere in nineteenth-century novels. The pre-photographic, pre-Victorian Jane Austen makes use of it in *Pride and Prejudice* (1813), for example, when Elizabeth Bennett takes on the role of the informed spectator to avoid walking with others, because: "You are charmingly group'd, and appear to uncommon advantage. The picturesque would be spoilt by admitting a fourth,"[42] or when she famously first sees Darcy's estate from the top of a hill, and finds "the eye was instantly caught by Pemberley House."[43] The scenes are visually self-conscious: how the house *appears* rather than what it is, how the group of persons is *perceived* rather than who they are, is the subject for consideration. At the far end of the same century, Hardy's novels are even more sensitive to point of view, the significance of vantage point, the implications of the gaze, and the many ways in which it might be mediated. *The Woodlanders* (1887) is an exercise in visual self-consciousness informed, as has frequently been observed, by all the long hours

[40]Nancy West, *Kodak*, 1.
[41]Charlotte Brontë, *Jane Eyre*, 1847 (New York and London: Penguin Classics, 2006), 111.
[42]Jane Austen, *Pride and Prejudice*, 1813 (New York and London: Penguin Classics, 1996), 52.
[43]Ibid., 235.

Hardy spent in front of impressionist paintings, while *Tess of the D'Urbervilles* (1891) is notable for the many passages in which Hardy draws attention to the airborne matter—mist, smoke, pollen, dust—which, in his novel, mediates every act of looking.

Literary description in the nineteenth-century novel was so frequently coupled with a sense of picture-making, its metaphors so often informed by the visual frames of theater or painting, that at mid-century, about halfway between Austen and Hardy, readers may barely have noticed or considered that such description was now also shaped by photographs. The naturalization of photographic ways of representing and knowing meant that they were almost invisible, and, for the middle and upper-middle classes who had greater exposure to photographs, that naturalization was also relatively rapid; as early as 1851, what might be simply described as a visual or painterly emphasis in Dickens's work may be more usefully understood in light of photography. But we can go back rather earlier to see how photography was folded into the history of the novel.

By 1839, the official year of photography's "invention," the novelistic structure within which photography was to do its memorial work was already in place. Novels were already sites of visual description, ekphrastic opportunities for making pictures and exploring human relations to them. Moreover, the *desire* for something like photography existed, though in Austen's day it had neither name nor shape. When Elizabeth Bennett anticipates the pleasures of her travels with the Gardiners, she is ecstatic: "Oh! What hours of transport we shall spend!" But just as wonderful as imagining the trip itself, she realizes, is imagining what it will be like in the future to recall that trip:

> And when we *do* return, it shall not be like other travellers, without being able to give one accurate idea of any thing. We *will* know where we have gone—we *will* recollect what we have seen. Lakes, mountains, and rivers, shall not be jumbled together in our imaginations; nor, when we attempt to describe any particular scene, will we begin quarrelling about its relative situation.[44]

Austen does not tell us whether Elizabeth's desire for perfect recall was in fact realized, once the tour was done. Did she take good notes? Make accurate drawings? What strikes the reader is how passionately determined Elizabeth is to remember: "We *will* know where we have gone—we *will* recollect what we have seen." Elizabeth's desire for a better memory is a desire for ownership of her future past.

This was, of course, also Henry Talbot's desire, and it kept him wrestling with drawing machines on the shores of Lake Como in the 1830s, determined as he was to fix images from his travels. It wasn't just that he wanted to be a better drawer; he

[44]Ibid., 152.

wanted to draw better in order to remember more fully. The desire for recollection of the past was both real and urgent in the early nineteenth century, and the Victorian novel became a privileged site for satisfying that desire. For one thing, it made an art out of the necessity of remembering characters and plots from month to month in frequently serialized narratives. For another, the visual engagement of the nineteenth-century novel, what might be called its pictorial emphasis, broadened in scope to include photography's ways of organizing visual information. Just as Elizabeth Bennett intuits that the significance of her journey will lie not in its immediate experience but in her later recollection of it, so the signs of photography's influence on the novel are more overt in those passages involving recollection. In the novel, as in life, photography became a means of looking back—something, that is, to look forward to.

THE PICTORIAL PRESENT

The Victorian novel continually draws our attention to the close relationship between visualization and the processes of memory. First, and most obvious in terms of stylistic markers, is its frequent shift to the present tense. This is the pictorial present of painting and theater and of novelistic scene-making in general, the present tense that Brontë uses, paradoxically, to remind us that *in reality* she narrates from a temporal distance. ("Here I am at the beach," we might say of ourselves in a forty-years old photograph, or "here is my Grandmother," a deceptively simple shift to the present that belies the tense in which the grandmother resides, she who died before we were born.) The present tense lifts a moment out of its narrative progression to set it aside in another temporal vein. By doing so, the prose style calls attention to the "removed" moment, emphasizing its significance and suggesting that we pay particular attention to it. When Brontë makes her stylistic shift into the present in the example given earlier ("when I draw up the curtain ..."), she evokes the metaphor of theater and assigns the reader the role of spectator. What makes the present tense additionally and specifically *pictorial*, rather than merely theatrical, however, is the way in which its moment is not merely removed but also rendered static, apart from the narrative flow of ordinary time. The stasis of the moment (in Jane's case, she is waiting for something to happen; the action has not yet begun) is worth noting, and I'll return to its significance later; suffice it for the moment to say that stasis is part of the photographic condition and that it is the photograph's stillness that most mystifies, frustrates, and entrances.

But a shift to the present tense in novels is not necessarily photographic, or even pictorial in its effect. Austen's "It is a truth universally acknowledged, that a single man in possession of a good fortune, must be in want of a wife" is epigrammatic, apocryphal; it is the voice of common sense, or gossip, but it's not the stuff of images. Likewise, Eliot's shift to the present tense at the close of *Middlemarch*: "Every limit is a beginning as well as an ending. Who can quit young lives after being long in

company with them, and not desire to know what befell them in their after-years?"[45] or Thackeray's musings at the end of *Vanity Fair* (1847): "Which of us is happy in this world? Which of us has his desire?"[46] The effect of the present tense in these famous lines is to invoke a kind of theorizing that bridges the fictional world of the novel with our own. Moreover, the pictorial can effectively be evoked *without* recourse to the present tense. One of the better-known examples of pictorial prose—by which I mean prose organized according to the descriptive principles of a picture, and which, as a result, is sometimes called "painterly"—is David Copperfield's description of steerage on the ship that Peggotty and Emily must take to Australia. David identifies his position as spectator, and thereby ours too, in the first line of the paragraph:

> It was such a strange scene to me, and so confined and dark, that, at first, I could make out hardly anything; but, by degrees, it cleared, as my eyes became more accustomed to the gloom, and I seemed to stand in a picture by OSTADE. Among the great beams, bulks, and ringbolts of the ship, and the emigrant-berths, and chests, and bundles, and barrels, and heaps of miscellaneous baggage—lighted up, here and there, by dangling lanterns; and elsewhere by the yellow day-light straying down a windsail or a hatchway—were crowded groups of people, making new friendships, taking leave of one another, talking, laughing, crying, eating and drinking; some, already settled down in to the possession of their few feet of space, with their little households arranged, and tiny children established on stools, or in dwarf elbow-chairs; others, despairing of a resting place, and wandering disconsolately. From babies who had but a week or two of life behind them, to crooked old men and women who seemed to have but a week or two of life before them; and from ploughmen bodily carrying out soil of England on their boots, to smiths taking away samples of its soot and smoke upon their skins; every age and occupation appeared to be crammed into the narrow compass of the 'tween decks.[47]

Aside from Dickens's instructions that we are to imagine this scene, as David does, as though it were a Dutch genre painting (whose artist is identified for the reader), what makes it pictorial? First, it is something *seen*: David may feel himself to be "in a picture," but he is its spectator rather than its subject. Moreover, because he looks at the scene *as* a picture, so must we. We look at the scene, and we look at David looking. But there is more: the democratic attention to detail (no object is more important than any other), the recitation of nouns, and thus of busy material presence, in short, the many things to look *at*, also make this scene pictorial, as does Dickens's attention to the varieties of persons "'tween decks," whose activities constitute their presence as a kind of *doing* against the object background which merely *is*. It is a literary version

[45]George Eliot, *Middlemarch*, 1874 (New York and London: Penguin, 1994), 832.
[46]William Makepeace Thackeray, *Vanity Fair*, 1847 (Oxford: Oxford University Press, 2008), 878.
[47]Charles Dickens, *David Copperfield*, 1850 (New York: Norton, 1989), 683.

of the crowd scenes mentioned earlier and popularized by Frith. As with *David Copperfield*'s Ostade "painting," the eye has no obvious resting place in Frith's work; wherever it lights, the detail is the same, the focus uniform. It is the focus, arguably, not of the eye, but of the camera, and it is in part the detail of the description, both visual and literary, that suggests that it was conceived in the age of photography.

That detail, as mentioned earlier, was a hallmark of the fascination with photography which had brought so much that was previously unseen into human focus. The detail that permitted Holmes his experience of virtual travel as he placed a card with two photographed images into his stereoscope, or perused the surface of a daguerreotype with a magnifying glass in hand, was the detail that collapsed time and space. Consider Eliot's famous opening lines to *Adam Bede* (1859), which celebrate the magic of summoning up the past as much as they do the specifics visualized:

> With a single drop of ink for a mirror, the Egyptian sorcerer undertakes to reveal to any chance comer far-reaching visions of the past. This is what I undertake to do for you, reader. With this drop of ink at the end of my pen I will show you the roomy workshop of Mr Jonathan Burge, carpenter and builder in the village of Hayslope, as it appeared on the eighteenth of June, in the year of our Lord 1799.[48]

Here the influence of Dutch genre painting meets that of the microscope as a "roomy workshop" from the past is sought and found in a present drop of ink. The finer the detail in that drop, Eliot implies, the stronger the magic; the stronger the magic, the greater the realism. Not only will the drop of ink mirror the "roomy workshop of Mr Jonathan Burge," with our spectatorship necessarily implied by the choice of verbs ("as it appeared"), but it will give us "far-reaching visions of the past"—a specific day, in fact, of a specific year, recalling Holmes's delight with the temporal precision of the daguerreotype from which he could read the time on a clock from years past.

The magic that can grow "a single drop of ink" into a workshop, in a village, on a precise day in a given year, is not in itself new; the visual detail of the daguerreotype was always a possibility for the imaginative novelist, and detail was an important part of the novel's quest for authenticity. As George Levine notes, "From Defoe on, realistic narratives have depended on circumstantial particularity to establish verisimilitude."[49] But in addition to its particularity, the verisimilitude of realism is also established where we are reminded of its contingency. In Brontë, the reader sees by virtue of "an oil lamp hanging from the ceiling"; in Eliot, by the "slanting sunbeams … through transparent shavings." As much as the technology of early photography intensified and fed interest in detail, its invitation to reflect on the complex relationship between perspective and time also affirmed the kind of literary

[48]George Eliot, *Adam Bede* (New York and London: Penguin Classics, 1985), 49.
[49]George Levine, *The Realistic Imagination: English Fiction from Frankenstein to Lady Chatterley* (Chicago and London: University of Chicago Press), 151.

realism that privileged exploration of the subject position—which in these examples included the contingencies of light. For many Victorian novelists, this resulted in an acute and lasting self-consciousness about scene-making, made all the more pointed by inclusion of the spectator. From David looking at the Ostade, to Barber Percomb looking at Marty South's hair as he stands outside the frame of her doorway in *The Woodlanders* (1887), the Victorian novel continually asks us to consider what it is that we do when we look at something *as though it is a picture*. It is a question that every act of photographing and each emerging photograph seems to invite and address.

Brontë's perceptual instructions ("you must fancy you see") show her interest in authorial control, but also her instinct that readers welcome and even expect the particulars that she provides. Her prose may be considered pictorial because of its sensitivity to the spectacle that is fiction, and its inclusion of the authentic details of furnishing, lighting, and perspective. But in Brontë's prose we also find the shift to the present tense, the simple temporal shift that fixes the moment for the reader as something to be understood in visual terms. As I noted earlier, the shift to the present is not inevitably that of photography, and the present tense itself is frequently found in novels of the pre-photographic age as part of description that defers to the picturesque, the theatrical, or the merely picture-like. But during the Victorian period, not only was there a marked increase in the use of the pictorial present, but its emotional effect played overtly on the reader's sensitivity to the lapse in time between the act of narration (or viewing) and what was being narrated (or viewed). Jane Eyre looks back at herself as present to the scene; she is its narrating subject *and* its object. David Copperfield similarly looks at his younger self; he is the object of his own gaze. Precisely because of its production and, more importantly, its consumption in the age of photography, the pictorial present of the Victorian novel creates a complicated *yet familiar* semantic space in which the subject is suspended out of time.

The "far-reaching visions" of *Adam Bede*, visions that take us back to a pre-photographic past, thus had a new layer of potential significance to the Victorian reader who, by 1859, had already lived twenty years in a world in which photographs existed. That reader necessarily interpreted the word "visions" somewhat differently than her eighteenth-century grandparents, much like the words "text" and "message" may signify differently for twenty-first-century readers than for their twentieth-century parents. Visions of the kind that Eliot evokes in *Adam Bede* may reference the past as far as the author is concerned, but the modern material forms of mid-Victorian visions—the calotype, the daguerreotype, the tintype, the stereograph, and other varieties of photography—belong as much to the future as to the past. Indeed, it is precisely through those material forms that we now experience our own "far-reaching visions" of the Victorians.

This is, interestingly, the kind of forward–backward time travel that the pre-photographic Elizabeth Bennett imagines when she anticipates the afterlife of her future travels as memories ("We *will* know … we *will* recollect"). It is the time travel realized by photography in its anticipatory backward glance, a temporal paradox

experienced by Barthes when he recognizes that a nineteenth-century photographic subject is both always alive and yet already dead. It is a way of thinking about the self through time for which there had been, until Victorian photography, no convenient metaphor. An acute temporal sensitivity, once we start noticing it, is everywhere in Victorian novels, and it is most obviously present in works that make the work of reminiscing their primary field. First-person narratives, simply by virtue of their structure, are alert to the complexities of remembering; the voice that speaks to us of childhood—Jane Eyre, Pip, David Copperfield—always does so in light of subsequent events. That interest in the narrative of hindsight marks a mid-century preoccupation with the complexities of narrating the self through time, a preoccupation that has been frequently observed in the temporal restlessness of modernist works but which found equally powerful expression in the literary productions of the first photographic age.

PAST AS PICTURE: *DAVID COPPERFIELD*

Dickens makes no reference in *David Copperfield* to the camera or its artifacts, but stylistically there is no mistaking his shift into photography's pictorial present tense and no denying the emotional consequences for the reader of that shift. The novel's past is stable and determinate. Take, for example, the visual album of school memories that David shows us in chapter 7. In this early retrospective, a mature David presents his school days to the reader as a series of framed and static images that gain resonance because of the repetitive ritual of their display: "*Here I sit* at the desk again," begins one paragraph with a description of himself under the gaze of Mr. Creakle; "*Here I sit* at the desk again," begins the next paragraph; "*Here I am* in the playground" (emphasis mine); and so on.[50] "I look back on these trifles," the grown-up David tells us, "with an aching heart."[51] But this present-day adult looking is at a far distance from the present tense of school memories. It is performed safely on the other side of the novel's events, which are, in the world of retrospect, always and already the past. While the stasis of the moment out of narrated time emphasizes the text as image,[52] here it is also the *repetition* of images that produces, and reproduces, the sensation of remembering. Mnemonic emphasis of this kind replicates viewing practices that for many people had been rehearsed by time spent with photograph albums, albums that, as I suggested earlier, invited perusal and re-perusal of unchanging visual moments.

Twenty-two chapters later in *David Copperfield*, Dickens makes similar use of visual repetition in his depiction of Steerforth sleeping. Chronologically the moment precedes David's knowledge of his friend's future betrayal, but in formal terms it already contains

[50]Dickens, *David Copperfield*, 83.
[51]Ibid., 85.
[52]Mary Ann Caws's term for this is a "stressed field"—that is, a portion of the text to which the author wishes to draw our attention, and does so through stylistic shifts. See *The Eye in the Text* (Princeton: Princeton University Press, 1981), and *Reading Frames in Modern Fiction* (Princeton: Princeton University Press, 1985).

the weight of its future significance: "I was up with the dull dawn," David recalls, "and, having dressed as quietly as I could, looked into his room. He was fast asleep; lying, easily, with his head upon his arm, as I had often seen him lie at school." Just in case we haven't picked up on the visual alert, David adds, "The time came in its season, and that was very soon, when I almost wondered that nothing troubled his repose, as I looked at him. But he slept—let me think of him so again—as I had often seen him sleep at school."[53] This is, of course, déjà vu, with its immediate recall of the phrase "as I had often seen him lie at school," and its echo of the end of chapter 6 when David watches Steerforth asleep, "his head reclining easily on his arm,"[54] but it also contributes to the accretion of the fully realized image in chapter 55 of the drowned Steerforth on the beach, who lies "with his head upon his arm, as I had often seen him lie at school."[55]

David's self-consciousness about such moments is marked, as noted above, by a shift in tenses that occurs whenever moments are taken out of narrative progression. Similar "album scenes" in fact occur regularly throughout the novel, stylistically set off from the text but also flagged for the reader by their chapter titles: "A Retrospect," "Another Retrospect," and "A Last Retrospect." The first titled retrospect is another one of David's school days, individual moments lifted from "the silent gliding on of my existence—the unseen, unfelt progress of my life." Looking "back upon that flowing water," David seeks representative images of his life, "marks along its course, by which I can remember how it ran."[56] We see him first as a boy in the cathedral; we move from that moment to a later one when "I am higher in the school."[57] Time steals on, he writes, "unobserved," though the effect of such passages is the observation of time itself. There is "A blank ... and what comes next! *I am the head boy, now.*"[58] And so on. In discrete moments, presented to the reader as observed memories of the "now," rather than lived experience, David recounts his "progress to seventeen" and invites us, as though seated beside him on the sofa, to observe his life.

The sensation of watching oneself act, of being the subject of one's own life movie, is considered a modern or postmodern phenomenon, but Dickens's emphasis, like Brontë's, on the observation of the self, suggests otherwise. Likewise, it's a common observation that Victorian novels are "filmic"—by which we generally mean that they lend themselves easily to the screen. We might speculate that this is because they are strong on plot and lengthy on description, or that they are "visual." But, as I suggested in the introduction, perhaps Dickens is really not filmic so much as film is Dickensian; the narrative structures of film that interest us aesthetically and emotionally are inherited from the novel forms that preceded film, novels that gave us

[53]Dickens, *David Copperfield*, 370.
[54]Ibid., 81.
[55]Ibid., 669.
[56]Ibid., 229.
[57]Ibid., 230.
[58]Ibid., 231.

a sense of what narrative ought to look like. And for much of the nineteenth century, what narrative ought to look like, or what might inspire it, what its authors every day saw, collected, exchanged, stared at, sat for, and even slept with,[59] was not film, which had yet to be invented, but photographs.

The death of David's wife, Dora, gets its own album of visual moments. Chapter 53 shifts to the present with the framing device of a pause: "there is a figure in the moving crowd before my memory, quiet and still, saying … Stop to think of me—turn to look upon the little blossom, as it flutters to the ground!"[60] The initial stasis here of Dora's figure, the "quiet and still" photograph of the dead against the moving pictures of the living, demands our attention, while the cessation of narrative ("I do. All else grows dim, and fades away. I am again with Dora") is again framed and set off from the more generalized narrative past. In his mental album of Dora, David's shift to the present separates out the times of day ("It is morning" gives way to "It is evening" and the inevitable "It is night"), naturalizing Dora's death, but also rendering her progress toward it in static terms, like a narrative painting, or a series of photographs that may be made to tell a story. At the end, with grief's descent, memory, and thus vision, fails: "for a time," concludes the chapter, "all things are blotted out of my remembrance."[61]

The novel thus reproduces David's past not as process, but rather as a succession of images that do not change. The moments are as static and as monumental as David's last glimpse of his mother at the gate as he heads off to school. "I was in the carrier's cart when I heard her calling to me," he recalls. "I looked out, and she stood at the garden gate alone, holding her baby up in her arms for me to see. It was cold still weather; and not a hair of her head, or a fold of her dress, was stirred, as she looked intently at me, holding up her child." Here, the picture is produced not out of a tense shift but rather from the stillness of the day, which establishes the conditions for memorial stability, producing a single fixed moment to which David will return—as, indeed, he immediately does: "So I lost her. So I saw her afterwards, in my sleep at school—a silent presence near my bed—looking at me with the same intent face—holding up her baby in her arms."[62] The reproduction of the image through, as it were, instant replay, a visual echo, produces both the déjà vu of memory and the burden of hindsight on which much of the emotional force of the novel rests.

Scene-making of the kind that Dickens does here frames or makes memorable moments that already have a cultural freight attached to them, and they are moments that, by the 1840s, were the frequent subjects of paintings just as, during and after the 1850s, they became the subjects of photographs by Henry Peach Robinson, Oskar Rejlander, and others. Such photography followed the lead of paintings and novels,

[59] According to Patrizia di Bello, after the death of Prince Albert, Queen Victoria slept with his photograph attached to the wall above his side of the bed (di Bello, 140).
[60] Dickens, *David Copperfield*, 643.
[61] Ibid., 648.
[62] Ibid., 110.

and it's as true to say that it was shaped by them, as it is to claim the reverse. Moreover, the relationship between painting and the novel had a long pre-photographic history, and the formative presence of painting in Victorian novels can hardly be overemphasized. Painting's language and its metaphors, an interest in scale, perspective, and the use of color, the inclusion of painting as a subject and artists as characters—these are everywhere in the pages of Victorian fiction, poetry, and literary criticism.[63] In such an intensely visually oriented culture it's hardly possible to separate out photography's influence on the novel as distinct from the many other popular visual technologies of the period; nor is it likely that photography immediately superseded painting in its influence over literature. Nonetheless, the ubiquity of photographs, coupled with their specifically and peculiarly forceful mnemonic emphasis, meant that during the second half of the nineteenth century a great many people experienced a previously unavailable visual access to their individual and collective pasts. As a result of that access, which so effectively naturalized the relationship between reading images and remembering, photography became an inextricable part of the novel's own history.

COMBINATION PRINTING AND NOVELISTIC MEMORY

Fiction depends very heavily on memory, and not just textual memory, but the memory of our own perceptions. Reading fiction is a process of recall as well as of recognition, in which readers are asked to remember their own experiences and emotions, in order to imagine something like them.[64] It is logical that any direction that readers might receive from a novel on how to imagine something (Jane Eyre's surroundings in the inn, for example, or David Copperfield's last sight of his mother) would be shaped by contemporary visual technology, because such direction arguably depends upon historically and culturally determined mental processes of creating images. Put simply, our image-making mental processes when we read are deferential to those processes by which we make images when we're *not* reading.

Looking at photographs, which rapidly became a part of ordinary daily existence in a commercial culture, dramatically shaped those image-making mental processes. According to Halbwachs, "No memory is possible outside frameworks used by people living in society to determine and retrieve their recollections."[65] If he is right that the forms of memory are entirely socially and historically contingent,

[63]For an overview, see Jeffrey Spear, "The Other Arts: Victorian Visual Culture," in *A Companion to the Victorian Novel*, eds. Patrick Brantlinger and William B. Thessing (Malden, MA: Blackwell, 2002), 189–206. For in-depth discussions of the formative role of painting and illustration in Victorian novels, see Flint, *The Victorians and the Visual Imagination*; Julia Thomas, *Pictorial Victorians: The Inscription of Values in Word and Image* (Athens: Ohio University Press, 2004); and Yeazell, *Art of the Everyday*.
[64]See Elaine Scarry's discussion of novels as structures of production that aim to give rise to the perception of what is imitated. *Reading by the Book* (Princeton: Princeton University Press, 2001).
[65]Halbwachs, *On Collective Memory*, 43.

then it is no exaggeration to say that for the Victorians, photography was part of the framework of determination and retrieval that made memory possible. *David Copperfield*'s invitation to read and reread images from David's memory and its fascination with textually framed still moments were informed by a culture that had already recast the activity of reading pictures of the past in photography's terms. *David Copperfield* self-identifies as a realist text, not because Dickens renders a world of things that corresponds precisely to his readers' world of objects—in fact, he doesn't—but because David's mode of envisioning his world corresponds to the Victorians' own practices of looking at images, particularly photographic images. Nineteenth-century readers had a way of understanding David's memories that had been forged by an active culture of looking: looking at albums, at magic lantern shows, at stereographs, panoramas, and visual wonders of all kinds. The practice of keeping scrapbooks and photographic albums is an obvious model for David's form of memorializing.[66] Through the borrowed practice of cutting out moments from the flow of time, and inserting them into spaces to be read and re-read (an activity Woolf revisits on the first pages of *To the Lighthouse*, when James works on his scrapbook), *David Copperfield* implicitly identifies the stasis of pictures with the past and invites a nostalgic response to them.

For nostalgia, with its "retrospects, expectations, ellipses, elisions, reminders," its "languages of time," as Nicholas Dames puts it, provides both the emotional context and the purpose of Dickens's novel, which is profoundly shaped by the "nostalgic evasion" that, Dames argues, characterizes the Victorian period.[67] The evasion of truth and the frequent substitution for it with something more pleasing, both central to the workings of nostalgia, are on full display in *David Copperfield*, whose pleasing pictorial moments serve as substitutes for uglier originals. By the time David first writes of Steerforth asleep with his head on his arm, for example, Steerforth is already dead and gone, having left the wreck of a family behind him; but in David's insistently repeated memory of him, he is shrunk like the contents of a locket to the dimensions of a single image, removed from time, forever young and innocent, forever a schoolboy. David's memory-picture of Steerforth is an example of forgetting posing as remembering, just as the stasis of his memory of Clara Copperfield, "holding up her baby in her arms," allows David to forget her real failures as a mother to protect him from the abuses of Mr. Murdstone.[68]

[66]For discussion of the culture of the album see Alan Thomas, *The Expanding Eye: Photography and the Nineteenth-Century Mind* (London: Croom Helm, 1978), 43–64; and Di Bello, *Women's Albums and Photography*, 2007.

[67]Dames, *Amnesiac Selves*, 11.

[68]Dames has observed that a "peculiarity unique to Victorian narratives" is "the equation of remembrance to a pleasurable sort of forgetting" (5). Certainly the poignancy of Steerforth's death depends upon that "pleasurable sort of forgetting."

It is as though Dickens has taken a leaf out of a book by H. P. Robinson, one of the best-known and most successful Victorian pictorial photographers. "The pleasures of memory are enormously increased," wrote Robinson in one of his many practical works for the aspiring photographer, "if to your mental picture-gallery you can add a gallery of truthful aids to memory." But then he goes on to argue for the benefits of selective recall. The art of photography, he argues, has no obligation to be anything but beautiful; and "Memory, like the sundial, need mark no hours but the bright ones."[69] Notwithstanding Robinson's play with the genre of postmortem photography in *Fading Away* (1858), his energies were consciously directed away from the perceived unpleasantness of both the modern and the real. As he lamented, "A passion for realism is the affectation of the hour in art and literature, and is making some of our novels so dirty—in the name of art—that one scarcely likes to mention even the titles of them."[70] At the same time, however, Robinson's work was frequently textually inspired; indeed, the art of photography, he felt, lay in its "poetry, sentiment, story," what he called the "literary part of a picture."[71]

Robinson's work, remarkable for its extensive use of combination printing, provides an interesting visual analog for *David Copperfield*'s series of images in chapter 64, "A Final Retrospect." Combination printing involved making multiple prints from a variety of negatives out of which the final image was crafted, and called for extensive manipulation (in the form of scissors, glue, masking tape, and additional exposures) on the part of the photographer.[72] Rather than offering the reader a linear, or chronologically driven, conclusion, Dickens instead follows Robinson's practice of reducing "temporal links to spatial contiguity," as Novak describes it,[73] lifting his characters out of their chronological narrative to relocate them in the present as collage. David looks back "once more—for the last time—before I close these leaves," to give the reader what is functionally a combination print. Again, note the pictorial present tense: "I see myself, with Agnes at my side ... I see our children and our friends around us." Each image is held before the reader, in apparently random order: "Here is my aunt ... here comes Peggotty ... I see an old man making giant kites ... Who is this bent lady ... what English lady is this ..."[74]—and so on, in a triumphant parade of just desserts that ends with a homecoming: the face of Agnes, David's final resting place.

Robinson's early defense of his photographic manipulations ("I maintain that I can get nearer to the truth ... with several negatives than with one")[75] speaks to his

[69]Robinson, *The Elements of a Pictorial Photograph*, 138.

[70]Ibid., 65.

[71]Ibid., 13–14.

[72]See Newhall's description of the extraordinarily painstaking details involved in making some of the more ambitious images, such as Rejlander's "The Two Ways of Life" (1857). Newhall, *History*, 74.

[73]Novak, *Realism, Photography*, 14.

[74]Dickens, *David Copperfield*, 734.

[75]Robinson, "Composition NOT Patchwork," *The British Journal of Photography* 7.121 (July 2, 1860), 190. Cited in Novak, *Realism, Photography*, 4.

commitment to agency, the fictionalizing that he felt necessary to effective truth-telling. In the cutting and the pasting, the re-photographing, Robinson's aim was, he later wrote, "not truth exactly, much less fact; it is effect."[76] Fiction and reality in his photographs are neither distinct nor fully independent of each other; indeed, as Novak puts it, "photographic fictions are both *more* realistic and more *photographic*."[77]

David Copperfield's final juxtaposition of images results in a peculiar disruption of temporality, a kind of leveling of pictures to the absolute present which participates in the aesthetics of Robinson's combination printing as well as those of the photo-collage in the private album. Somewhere between the prescribed spaces of the later snapshot albums and the earlier free play of the scrapbook, the popular practice of photo-collage offers another model for thinking about photography's potential in the creation of *un*reality, or representational anarchy. The social context of Victorian photo-collage (like much of Dickens's work) is both comedic and performative; as Marta Weiss writes,

> Often displayed in fashionable drawing rooms, these volumes belonged to the same atmosphere of performance and sociability as tableaux vivants and the photographs they inspired … not only was the construction of a photo-collage comparable to other photographic practices that combined the apparently factual medium of photography with fictional subject matter, but motifs of performance—from the enactment of social roles to more overt forms of theatricality—also recurred in many of these albums.[78]

But where does this leave the Victorian reader of *David Copperfield*, who is also the reader of albums and collages, of publicly displayed combination prints and privately possessed postmortem photographs, of glass daguerreotypes and paper photographic prints? If we consider Dickens's grand finale of portraits in that novel as a kind of literary collage or combination print, why is the reading experience not disrupted or undermined by the synaptic chaos of the closing chapter?

Perhaps it is that long-time readers of serialized works enjoyed this kind of repetitive contact with the familiar images of persons. Perhaps it also has something to do with the kind of forgetting that reading novels necessitates. After all, "novelistic totality," as Novak argues, depends on "the ability to forget both the text's composite history and the reader's role in constructing the text through the act of reading."[79] Reading Victorian novels, as much as it requires some feat of memory (all those characters and plots), also engages us in some feat of forgetting. The naturalization

[76]Robinson, *The Elements of a Pictorial Photograph*, 81.
[77]Novak, *Realism, Photography*, 4.
[78]Marta Weiss, "The Page as Stage," in *Playing with Pictures: The Art of Victorian Photocollage*, ed. Elizabeth Siegel, with essays by Patrizia Di Bello and Marta Weiss (Chicago: Art Institute of Chicago and Yale University Press, 2010), 37–48, 37.
[79]Novak, *Realism, Photography*, 32.

of photography in the process of reading images from one's past involves a similar suspension of memory, if not an absolute forgetting of our own status as reading subjects.

David Copperfield is emotionally powerful, not because in reading it we are reminded of looking at photographs, but precisely because we are *not*. We don't notice; we merely have a textual version of that experience, and it is all the more powerful because it is, in fact, *how we remember now*. In addition to its function as a cipher of modernity, its metaphysical playfulness, and its work as a normative standard of visual representation, photography shaped the novel most by providing it with structures for reading, retrieving, and organizing the past, thus giving its readers a formal way of thinking about the passage of human identity through time. That those structures are largely invisible to us today is instructive: it suggests how much the ways we see and remember the past have indeed become "a part of what it is."[80]

[80]Stevens, "A Postcard from the Volcano," 158.

CHAPTER FIVE

Modernism's Photographic Past

Most people living in Europe and America after the First World War grew up with what might be called a photographic consciousness. They were used to being photographed; their households were likely to contain a camera. They might think of a moment as worth remembering, and thus also, by definition, consider it worth photographing. They were sensitive to the idea that certain moments might be significant at a later date. In other words, they looked forward to looking back.

At some point, most people had had the experience of being part of group pictures taken for households, clubs, and institutions: the army, the workplace, the school, the cricket club, the shooting syndicate, the church, or the musical group. They were accustomed on a daily basis to seeing photographs used in marketing, in newspapers, in books, in shop windows. Many people had also grown up looking at family pictures in photograph albums and by 1920 might have inherited albums in which their own parents and grandparents appeared as children. Increasingly, they possessed their own personal visual histories in the form of photographs.

The postwar population was, as a result, very accustomed to the practice of conceiving and arranging life as a sequence of images of varying social and personal significance. People were used to participating in such arrangements, to being subject to the camera as well as to taking their own photographs, and to viewing the results and choosing among them for placement in albums for future readers. They enjoyed writing captions for them in white ink that would stand out on the dark paper of albums. The identification, interpretation, and sharing of images were all part of the pleasure of photography. An event deemed significant to one's life history was one that required photographing; things that mattered were increasingly identified in that way.

In a matter of decades, consciousness of the personal past had been shaped by photography to such an extent that it could hardly be extracted from recollection itself. Moreover, during the First World War and after, photography gained further symbolic resonance as photographs themselves became valuable artifacts of a lost world. Where Dickens's Pip in *Great Expectations* (1861) has tombstones to substitute for his pre-photography parents, Virginia Woolf writes in *Jacob's Room* (1922) that Florinda "for parents had only the photograph of a tombstone"[1]—a photograph, one imagines, of a *Victorian* tombstone, marker not just of absent parents but also of a world that for many people had, during the course of the war, gone missing.

Photography's intensified resonance as a result of the massive losses of the war was reflected in the powerful appeal of postwar material culture, including the nostalgic desire for objects expressed in many works of literary modernism. "It almost breaks my heart," says Birkin of an old chair that he and Ursula debate purchasing in *Women in Love* (1920): "When I see that clear, beautiful chair, and I think of England, even Jane Austen's England—it had living thoughts to unfold even then, and pure happiness in unfolding them. And now, we can only fish among the rubbish-heaps for the remnants of their old expression."[2] Like Lawrence's ahistorical but nonetheless war-wounded English landscape, T. S. Eliot's *Waste Land* of 1922 is full of such remnants of the past and the human need to go fishing for them. The much-storied shift in focus from the (prewar) detailed bricks and mortar of Victorian and Edwardian materialism to the (postwar) un-photographable interior life doesn't hold up to scrutiny, although it makes for a tidy narrative concerning the supposed end of Victorian realism, a narrative bolstered by Woolf's own version of it in her essay "Mr. Bennett and Mrs. Brown" (1923). In fact, there is plenty of evidence in modernist works that the appeal of the material world remained vigorous in the early twentieth century.[3] Likewise, although modernist works are often regarded as seeking to break with Victorian paradigms, their preoccupation with the passage of time and their efforts to represent the complexities of the personal, rather than the historical, past were discernibly shaped by the visual devices through which their authors in childhood had learned to view the world. The magic lantern, the kinetoscope, the kaleidoscope, and other old-fashioned instruments that by the 1920s belonged to the past rather than the present, show up in works of the period as residue from outmoded ways of looking that framed their authors' earliest memories.

It is no coincidence that postwar fiction draws our attention to spectatorship, to acts of framing and watching, because in a photographed world remembering involves looking. One consequence of being a photographic native, of having been born into photography, is that it is not just that people are able to remember *what* they have seen

[1]Virginia Woolf, *Jacob's Room* (San Diego, New York and London: Harcourt Brace, 1950), 77.
[2]D. H. Lawrence, *Women in Love* (New York: Penguin, 1981), 347.
[3]See Liesl Olson's excellent study, *Modernism and the Ordinary* (Oxford and New York: Oxford University Press, 2009).

(because they have a photograph of it) but they are also likely to *remember having seen it* (either in the photographing, or in the subsequent viewing of the image). Listening to Uncle Patrick talk about the past in Woolf's *The Years* (1937), Peggy Pargiter "fancied as she half listened that she was looking at a faded snapshot of cricketers; of shooting parties on the many steps of some country mansion."[4] Twentieth-century photographically acculturated Peggy—like Woolf, born a Victorian—experiences another person's memory as though she is looking at a photograph. She remembers having *seen* that memory before. It's a familiar sensation and a distinctively modern one, to be unable to distinguish between a memory of something and having seen its photograph.

By the end of the Victorian period, of course, photography itself was no longer considered modern. While photographs continued to show up in late-century literary realism as part of the stuff of everyday life (Hardy's work offers examples), their presence also increasingly conveyed irony and detachment, a failure on photography's part to account for the meaning of what it showed (Hardy's work offers further examples).[5] Meanwhile, in more formally experimental works, many of the objects associated with the production, display, and projection of images—the stereoscopes and the magic lanterns as well as the heavy parlor albums and the bulky, slow-acting cameras—did so as anachronistic signifiers of a perceptually outmoded visual culture. Thus while the novel experience of going to the movies increasingly embodied and excited preoccupation with motion of all kinds,[6] for many writers it was the still images of photography that had accompanied them through childhood that haunted recollection and gave shape to the scenes they recalled.

But what is it in these early-twentieth-century works that is being remembered? Is it, in fact, the past? Or is it Peggy Pargiter's sensation, refined by generations of Victorians, of having at some point watched that past already, in the shapes, frames, and social exchanges enabled and promoted by photography? And, if that's so, should the crises and frustrations of modern literature be considered primarily spectatorial rather than existential dramas, a consequence of the Victorian experience of watching one's life play out in photographs?

In this chapter I will address those questions by examining some of the ways in which Victorian photography persisted as a structuring principle in early-twentieth-century literary representation of memory. By "structuring principle," I mean that photography influenced writing at the most fundamental level of style, producing effects that arguably constituted a way of looking at the past. Do these stylistic decisions indicate a special awareness of photography, a conscious attention to its role in modern memory? I don't think so, necessarily (though a case can be made for

[4]Virginia Woolf, *The Years* (New York and London: Harcourt Brace, 1965), 352.
[5]*Jude the Obscure* (1895) provides instances of both; see also "An Imaginative Woman" (1894).
[6]See Enda Duffy, *The Speed Handbook: Velocity, Pleasure, Modernism* (Durham, NC: Duke University Press, 2009).

Proust); but I do think that in the elements of style we can see the marks of an inherited and evolving photographic culture. Of course, as I noted earlier, one cannot claim that the style of a scene in literature only recalls photography and *not* painting. While Woolf's writing, in particular, provides plenty of opportunity for stylistic analysis, it's hard to say definitively whether what we're seeing in her work is influenced more by postimpressionist painting, her lifelong interest in photography, or her passion for going to the movies. We don't, however, have to choose, given that her writing was informed by a culture within which a number of differently reproduced images were operating. Americans and Europeans were used to seeing a variety of kinds of images in their daily lives, a far greater variety, in fact, than we are. Look through any catalog today and you'll find only one kind of photograph, but in 1905, the *Army and Navy Illustrated Furnishing Catalogue*, a treasury of options for home furnishing, included reproductions of engravings, paintings, and sketches, as well as photogravures, the occasional black-and-white photograph (a bureau, a chair), and some brilliantly colored visual samples (of linoleum): a mishmash of visual forms dictated by cost as well as different print technologies (Figure 5.1).

Readers of the *Illustrated London News* experienced a similar range of kinds of illustration, images whose relationship to the object world was semantically framed by their inclusion in a magazine about daily life in urban culture and authenticated, as Geoffrey Belknap so effectively demonstrates in his study of the periodical press,

FIGURE 5.1 *The Army and Navy Catalogue*, 1905, pp. 72–73.

by their frequently designated appearance "from photographs."[7] Framing, point-of-view, perspective: these were, and remained, shared terms within that culture, learned from painting, used in photography, re-appropriated by painting. But photography's authoritative hold as a cipher for the real in the visual marketplace continued to grow, while its formal imprint on literature of the period was more subtle and various than might at first be supposed.

PAST INACCESSIBLE

The First World War

In the last chapter we saw how Dickens shaped *David Copperfield*, a work deeply invested in the work of memory, using methods of recall associated with photography. The mental album of images that David consults as he reviews his formative years, as well as his preoccupation with fragmented moments and his temporal shifts to the pictorial present to convey the passage of time—each of these achieves a kind of poignancy made familiar to readers by their own encounters with photographs of their own personal pasts. Understandably, Dickens's way of evoking David's past became particularly meaningful to readers as the Victorians left the nineteenth century and descended into the horrors of the First World War.

Vera Brittain's memoir *Testament of Youth* (1933) may strike a modern reader as Dickensian precisely because Brittain makes use of those same stylistic traits regarding memory in reconstructing her own foray into the past. Like David, Brittain writes with the distance of years and the burden of knowledge; like David, she turns that burden into its own aesthetic. It's a nice coincidence that on New Year's Eve, at the end of 1914, she goes to the theater with her fiancé, Roland Leighton, to see a production of *David Copperfield*. It's no coincidence, however, but a self-consciously literary choice when Brittain later reflects on the passage of time with a reference to that theater visit, accessing the memory by quoting from a letter that she had sent Roland:

> "And shall I really see you again, and so soon?" it had concluded. "And it will be the anniversary of the week which contained another New Year's Eve—and *David Copperfield*, and two unreal and wonderful days, and you standing alone in Trafalgar Square, and thinking of—well, what were you thinking of? When we were really both children still. ..."[8]

Note the echo of David's nostalgia for his childhood days with Little Emily, his fantasy of the two of them "never growing older, never growing wiser, children ever, rambling hand in hand through sunshine and among flowery meadows"; a "picture" as he

[7]Geoffrey Belknap, *From a Photograph: Authenticity, Science and the Periodical Press, 1870–1890* (London: Bloomsbury, 2016).
[8]Vera Brittain, 1933. *Testament of Youth* (New York: Penguin, 2004), 234.

later writes, "with no real world in it."[9] Later, when Roland is killed in France, *David Copperfield* again provides Vera with an interpretive structure, this time for her own loss:

> Whenever I think of the weeks that followed the news of Roland's death, a series of pictures, disconnected but crystal clear, unroll themselves like a kaleidoscope through my mind.
>
> A solitary cup of coffee stands before me on a hotel breakfast-table; I try to drink it, but fail ignominiously.
>
> Outside, in front of the promenade, dismal grey waves tumble angrily over one another on the windy Brighton shore, and, like a slaughtered animal that still twists after life has been extinguished, I go on mechanically worrying because his channel-crossing must have been so rough.[10]

The debt to Dickens is striking, both in the shift to the pictorial present tense that we saw leading up to the deaths of Dora and Steerforth as well as the "disconnected" images that call for narration. Brittain cannot really be said to be thinking "photographically," and nor is she adopting the present tense in this passage because it evokes the ever-present of photography, but what she *is* doing is reaching for a literary model that serves her very well precisely because of its own debt to photographic practices. *David Copperfield*'s litany of recorded moments to convey the passage of time—like all past moments, time lost, but here retrieved as individual, unconnected visual moments—provides a kind of structural memory or urtext for Brittain's account of grief and loss, just as the Victorian photograph album is the urtext for David's experience of reading the book of his life.

> In an omnibus, going to Keymer, I look fixedly at the sky; suddenly the pale light of a watery sun streams out between the dark, swollen clouds, and I think for one crazy moment that I have seen the heavens opened …
>
> At Keymer a fierce gale is blowing and I am out alone on the brown winter ploughlands, where I have been driven by a desperate desire to escape from the others …
>
> It is late afternoon; at the organ of the small village church, Edward is improvising a haunting memorial hymn for Roland, and the words: "God walked in the garden in the cool of the evening," flash irrelevantly into my mind.
>
> I am back on night-duty at Camberwell after my leave …
>
> I am buying some small accessories for my uniform in a big Victoria Street store, when I stop, petrified, before a vase of the tall pink roses that Roland gave me on the

[9]Dickens, *David Copperfield*, 131.
[10]Brittain, *Testament*, 239.

way to *David Copperfield*; in the warm room their melting sweetness brings back the
memory of that New Year's Eve …

It is Sunday, and I am out for a solitary walk through the dreary streets of
Camberwell …

It is Wednesday, and I am walking up the Brixton Road on a mild, fresh morning of
early spring. Half-consciously I am repeating a line from Rupert Brooke:

"The deep night, and birds singing, and clouds flying …"[11]

The present tense, the isolated moments, the falling away of connective tissue that
might give narrative coherence and a semblance of significance—all of these are
common to both modernism and postmodernism, familiar to the photographic
native, and, unsurprisingly, prevalent in war literature which must inevitably wrestle
with the yawning gulf between present and past. Certain small words here do
interesting work: a phrase comes into Brittain's mind as a "flash"; the beauty of flowers
causes her to be "petrified"—not afraid, but rather made still. The days, counted off,
are disconnected; parts are missing. Just as we saw David naturalize Dora's death by
describing the passage of time ("It is morning … It is evening … It is night"),[12] so
here we see Brittain, one moment in the late afternoon, the next on night duty: "It is
Sunday … It is Wednesday." It is as though vast tracts of her life have been rubbed out.
The artificial filler that is novelistic memory is absent, leaving only images without
narrative insight or concluding wisdom. Brittain's text reminds us, indeed, how much
in life is forgotten, and how photographs of specific moments offer only a pretense of
memory or a substitute for it, while all else vanishes.[13]

In *All Quiet on the Western Front* (1928), Erich Maria Remarque shows that his
protagonist's ability to connect present with past is as broken as Vera Brittain's. While
on sentry duty in the trenches, the young soldier, Paul, is haunted by memories of his
childhood; yet those memories cause him to reflect not on the past, but rather on the
shapes in which it now exists:

It is strange that all the memories that come have these two qualities. They are always
completely calm, that is predominant in them; and even if they are not really calm, they
become so. They are soundless apparitions that speak to me, with looks and gestures
silently, without any word—…

[11] Ibid., 240.

[12] Dickens, *David Copperfield*, 644.

[13] Also tonally reminiscent of *David Copperfield* is a passage in which Brittain recalls the embarkation of the
Hospital Ship *Britannic*: "As we left the harbour a transport of the R.F.C. cheered us and waved their hats.
We sailed down the Solent just as the sun was setting; on either side of us the colours of the mainland were
vividly beautiful. The sinking sun made a shimmering golden track on the water which seemed to link us
in our tender to the England we were leaving behind " (293). See David's description of the ship's departure
for Australia at the end of chapter 57 (*David Copperfield*, 684).

They are quiet in this way, because quietness is so unattainable for us now. At the front there is no quietness and the curse of the front reaches so far that we never pass beyond it …

Their stillness is the reason why these memories of former times do not awaken desire so much as sorrow—a vast, inapprehensible melancholy. Once we had such desires—but they return not. They are past, they belong to another world that is gone from us.[14]

Self-consciousness about the dislocation of the self is not hard to find in wartime, though few have written about the chasm between present and past so heartrendingly as Remarque. When Paul returns home on leave, he imagines that he will somehow gain access to the past, but soon realizes that in fact his prewar self has vanished into a world of books and words that for the present-day soldier has become impenetrable surface. The past sanctuary of his book-lined room is now a temporal space into which re-entry is impossible: "I cannot find my way back, I am shut out."[15] Again, as in the Dickensian memory picture, the reader experiences stasis produced both by the continued use of the present tense as well as Paul's self-conscious passivity as the spectator of his life: "Nothing stirs … I sit there and the past withdraws itself."[16]

The idea of home in *Women in Love* is similarly problematic, though in Lawrence's case the past that it symbolizes must be abandoned. Gudrun's fantasy of what married life with Gerald Crich would be like takes the form of an old-fashioned painting: "She suddenly conjured up a rosy room, with herself in a beautiful gown, and a handsome man in evening dress who held her in his arms in the firelight, and kissed her. This picture she entitled 'Home.' It would have done for the Royal Academy."[17] It's safe to say that *Women in Love*, despite its visual emphasis, opposes anything that might have "done for the Royal Academy." In fact, Lawrence's strenuous resistance to home and to the past as sources of nostalgia emerges as a rejection of the visual forms with which both are associated, and a countering with the more modern influence of film. Take, for example, the scene in which Ursula is on a night train to Innsbruck. She is leaving everything English behind, including, or so she hopes, her past; but as she travels she sees fragments of that past in the Belgian farms flashing by. Lawrence's vehicle of modernity is the train, the speed of which allows Ursula, as a passive spectator inside the moving car, the anonymity and speed of a movie. It is as though her consciousness itself is a film projector, casting its images outward into the dark:

At last they were moving through the night. In the darkness Ursula made out the flat fields, the wet flat dreary darkness of the continent. They pulled up surprisingly soon—

[14]Erich Maria Remarque, 1928. *All Quiet on the Western Front*, trans. A. W. Wheen (New York: Fawcett Crest, 1958), 120–21.
[15]Ibid., 172.
[16]Ibid.
[17]Lawrence, *Women in Love*, 368.

Bruges! Then on through the level darkness, with glimpses of sleeping farms and thin
poplar trees and deserted high-roads....

A flash of a few lights on the darkness—Ghent station! A few more spectres moving
outside on the platform—then the bell—then motion again through the level darkness.

Ursula saw a man with a lantern come out of a farm by the railway, and cross to the
dark farm-buildings. She thought of the Marsh, the old, intimate farm-life at Cossethay.
My God, how far was she projected from her childhood, how far was she still to go!
In one life-time one travelled through aeons. The great chasm of memory, from her
childhood in the intimate country surroundings of Cossethay and the Marsh Farm—
she remembered the servant Tilly, who used to give her bread and butter sprinkled with
brown sugar, in the old living-room where the grandfather clock had two pink roses
in a basket painted above the figures on the face—and now, when she was travelling
into the unknown with Birkin, an utter stranger—was so great, that it seemed she had
no identity, that the child she had been, playing in Cossethay churchyard, was a little
creature of history, not really herself.[18]

The arbitrary details that somehow survive the "great chasm of memory"—the brown
sugar and the clock with its painted roses—surface as random pieces of a history that
has come unmoored from its narrative underpinnings. As a result, Ursula is unable
to connect what she sees as she travels, either with past or with present. In Basle, "She
remembered some shops—one full of pictures, one with orange velvet and ermine. But
what did these signify?—nothing."[19] Later, in a high and snowy valley of the Tyrrol, she
catches a glimpse of farm life as a man with a lighted lantern disappears into a barn,
and again she has a sudden memory of her own past life. The pain of recognition is
sharp and unexpected: "Oh, God, could one bear it, this past which was gone down the
abyss?"[20] It is not the fact of the past's having gone down the abyss that causes pain, but
the fact of the past's having been at all; it now appears to Ursula "like views on a magic
lantern: the Marsh, Cossethay, Ilkeston, lit up with a common, unreal light."[21] Ursula
thus recalls her past through a technology historically bound to it, but that technology
represents a way of signifying that Lawrence is determined to smash. In fact, Ursula's
own emergent modernism, a counter to her old, Victorian, "un-real" self, depends on it:

There was a shadowy unreal Ursula, a whole shadow-play of an unreal life. It was as
unreal, and circumscribed, as a magic-lantern show. She wished the slides could all
be broken. She wished it could be gone for ever, like a lantern-slide which is broken.
She wanted to have no past. She wanted to have come down the slopes of heaven to
this place, with Birkin, not to have toiled out of the murk of her childhood and her

[18]Ibid., 381.
[19]Ibid., 382.
[20]Ibid., 399.
[21]Ibid.

upbringing, slowly, all soiled. She felt that memory was a dirty trick played upon her. What was this decree, that she should 'remember'! Why not a bath of pure oblivion, a new birth, without any recollections or blemish of a past life … What had she to do with parents and antecedents?[22]

Lawrence's rejection of pictorialism as redolent of the "murk" of the past contrasts with his earlier scene-making in *The Rainbow* and *Sons and Lovers*, passages of which recall Hardy and Eliot in their domestic and rural nostalgia. *Women in Love* suggests an effort to be free from that kind of place-based history; its representation of memory is corrupted rather than enriched by its association with stasis.

Countering memory, and in contrast to it, is movement, the force that defines the modernity of this novel. From Gerald Crich's naked dive into the space of a blank sheet of water to the various train journeys across England and Europe and to the final pages in which the four main characters engage in "an ecstasy of physical motion, sleighing, ski-ing, skating, moving in an intensity of speed and white light that surpassed life itself,"[23] Lawrence's energies are not engaged with accessing but rather breaking away from the past. What remains of it, like Gerald's frozen corpse, is as dead for Lawrence as a photograph.

"THE DEAD"

Photography and the Persistence of the Object

"The Dead" (1914) is not about photography any more than *Women in Love* or *David Copperfield*, but like those works it is informed by cultural shifts in which photography played a part. Joyce's short story arguably charts a move from an aesthetics informed by the still life of literary and photographic realism, in which spectator and table are linguistically distinct, to the perceptually enmeshed experience of modernism in which photography's role is harder to describe. In "The Dead," a photograph of Gabriel's mother and brother that sits in front of the mirror at his aunts' house is no more or less indexical than the picture hanging on the wall of Romeo and Juliet, or Aunt Julia's cross-stitched needlework sampler of the two murdered princes. All three images are depicted by Joyce as physical objects rather than points-of-view; they are markers of realism and history, reminders of the broader visual culture within which photography operated.[24] None of them offers the reader insight into the adult at the center of Joyce's story.

[22]Ibid., 399.
[23]Ibid., 411.
[24]See, for example, Arnold Bennett's *Anna of the Five Towns*, in which the parlor walls of the Tellwright house display both "an engraving of 'The Light of the World,' in a frame of polished brown wood" as well as "some family photographs in black frames" (Oxford and New York: Oxford University Press, 1995), 29.

Photography's presence in the story as *a way of looking*, however, is more obvious, particularly in the extended description of the dinner table, which offers a full page of the kind of specificity many Victorians encountered in the detail of daguerreotypes. The effect of the passage depends upon a verbal equivalence of word and thing. Nouns correspond precisely to the objects they summon forth, and plenty of color is attached to them:

> A fat brown goose lay at one end of the table and at the other end, on a bed of creased paper strewn with sprigs of parsley, lay a great ham, stripped of its outer skin and peppered over with crust crumbs, a neat paper frill round its shin and beside this was a round of spiced beef. Between these rival ends ran parallel lines of side-dishes: two little minsters of jelly, red and yellow; a shallow dish full of blocks of blancmange and red jam, a large green leaf-shaped dish with a stalk-shaped handle, on which lay bunches of purple raisins and peeled almonds, a companion dish on which lay a solid rectangle of Smyrna figs, a dish of custard topped with grated nutmeg, a small bowl full of chocolates and sweets wrapped in gold and silver papers and a glass vase in which stood some tall celery stalks. In the centre of the table there stood, as sentries to a fruit-stand which upheld a pyramid of oranges and American apples, two squat old-fashioned decanters of cut glass, one containing port and the other dark sherry. On the closed square piano a pudding in a huge yellow dish lay in waiting and behind it were three squads of bottles of stout and ale and minerals, drawn up according to the colours of their uniforms, the first two black, with brown and red labels, the third and smallest squad white, with transverse green sashes.[25]

This is a table whose appeal, like its significance, lies in its visual echo of other such parties over the years. Like all holiday tables it invites nostalgia; the table must be as it always has been, and its standard of excellence is the past.

The word "nostalgia," of course, references not just the past, and the home that was once to be found there, but also a longing that has arisen from the *loss* of home. In the case of "The Dead," the lost home of Joyce's story is neither a time (the past) nor a place (Dublin), nor even a country (Ireland), so much as it is a kind of *writing—* Joyce's representational first home, perhaps, the place where he started from and that is still present to those stories that precede "The Dead" in *Dubliners*. By the time we get to the conclusion of this final story in the collection, however, that earlier style seems to be evaporating, and the description of the table is more or less where it ends. The extended visual realism of the passage, which is the realism of a photograph, or of a painting that looks like a photograph, suggests a world in which there is still a correlation between word and thing, but it also yokes that part of the story to a world that is past. It is the literary *style* in which the table is described that is, or soon

[25]Joyce, "The Dead," ed. Daniel Schwartz (Boston and New York: St. Martin's Press, 1994), 38.

will be, "the dead." From this perspective, the drama of the story lies in the apparent dissolution of visual realism at the end, when the third-person observation of the colors and lines of the table is effaced by the imagined grays and darks and silvers of Gabriel's sleepy consciousness. The fixed and distinctively colored memory of the table is distanced, even obscured, by the implicit final whiteness of the story's famous last scene. In contrast to what Joyce calls "the solid world," the *new* world into which the story ultimately begins to move is cumulative and kinetic; it is developing; it is coming-into-being.

One problem with this reading of Joyce's story, of course, is its implication that the object-rich world of photographic realism is somehow vanquished or done away with by the shift to the human interior. But as I suggested earlier, and as the briefest of glances at *Ulysses* (1922) shows, the world of objects is the undead, and Joyce clearly continued to be preoccupied with its material presence. (The many references to photographs in *Ulysses*, and the fact that Milly Bloom is apprenticed to a photographer, suggest that Joyce was also sensitive to photography's central role in Dublin's commercial culture.) His stylistic turn from the narrative clarity of visual realism does not signify a turn from the object world or from photography, any more than Zola's work repudiates that same world in its gradual drift toward literary impressionism.[26] Instead, and as Liesl Olson argues, "In *Ulysses*, a reader is confronted … with the problem of representing ordinary experience, if only because the styles of *Ulysses* are marked by their discontinuities from one chapter to the next. The novel almost seems to be searching for a style best suited to its ordinary subject matter."[27]

Twentieth-century confidence in the ordinary world might have been justifiably dwindling by 1914, but many self-consciously post-Victorian writers were still preoccupied with its signs, as though the objects once at home in literary realism might be retrieved and dusted off for another purpose. Think of "Prufrock," and its marmalade, tea, novels, teacups, and trailing skirts. Like Woolf's careful and repeated attentions to shoes, sofas, hats, buckets, dresses, flowers, knitting needles, cutlery, and kid gloves, and like Joyce's lists in *Ulysses*, Eliot's recitation of objects attests to their persistence in modernism. Any of those objects named were also to be found in photographs—photographs in books, newspapers, and of course in the *Army and Navy Catalogue*, where a small boy with a pair of scissors might find a picture of a refrigerator to cut out for his scrapbook.[28]

[26]See Ilona Mannan, "Early Modernist Vision: Emile Zola and Photography," *Ecloga: Journal of Literature and the Arts.* "New Work in Modernist Studies," ed. Andrew Campbell (Special Edition, 2014), 85.

[27]Olson, *Modernism and the Ordinary*, 46.

[28]James Ramsay, on the first page of *To the Lighthouse*, demonstrates one of the many uses of catalogs, while Mrs. Ramsay's laments about the shabbiness of her house suggest she is of necessity a browser, rather than a shopper.

WOOLF

The "Now" Of the Photographed World

Woolf's representation of a modern family in *To the Lighthouse*—the parents are Victorian, but the children belong to the twentieth century and will suffer for it—embodies a specific kind of homesickness for the past that is both contained and elicited by its pre- and postwar structure. Mrs. Ramsay's intuition that her children will never again be as happy as they are "now"[29] is an expression of her heightened consciousness of the elusiveness of the present, her effort to experience it fully, and her simultaneous desire to consign it to the safe remove of memory. After Mrs. Ramsay's death, Lily Briscoe remembers her in terms of that desire, which is also the cry of the photographer: "Mrs. Ramsay saying, 'Life stand still here'; Mrs. Ramsay making of the moment something permanent."[30]

Mrs. Ramsay is anticipatorily nostalgic: she thinks forward to a time when she will look back. She longs for the present as the present itself passes away from her and, though nobody actually produces a camera in *To the Lighthouse* to record the moments that pass, there are passages that seem to do just that. Mrs. Ramsay's pause in the frame of the doorway after dinner is one such moment; another occurs during Lily's act of putting away her paints: "—she nicked the catch of her paint-box to, more firmly than was necessary, and the nick seemed to surround in a circle forever the paint-box, the lawn, Mr. Bankes, and that wild villain, Cam, dashing past."[31] The circle in which paint-box, lawn, man, and child are enclosed is a tiny one, shrunk to the dimensions of the "catch." The disparate elements will be part of the memory—stuck randomly to the paper, as it were, through the accident of the round camera lens that catches them. In this case it is not just the self-consciousness of the moment but also the *speed* of capture that suggests photography rather than painting as the mnemonic reflex. The image is instantaneous but permanent: The "circle forever" surrounds them—art, nature, human beings, a world within a wedding ring—as each is caught on the fly by Lily's mental snapshot.[32]

The peculiar intensity of this moment of self-consciousness is apparent in its earlier more explicit incarnation as a scene of photography in *Jacob's Room* (1922). We could say, indeed, that *To the Lighthouse* offers a later print of the same scene, one version of a mentally recorded moment to which Woolf repeatedly returns in her effort to develop its significance. In its earlier version, the Edwardian family gathered for a summer's evening in view of the sea are not the Ramsays but the Durrants;

[29]Woolf, *To the Lighthouse*, 59.

[30]Ibid., 161.

[31]Ibid., 54.

[32]The fecundity and generative magic of memory in *To the Lighthouse* is arguably its characters' salvation. It is into a memory enabled by Mrs. Ramsay ("which survived, after all these years complete") that Lily is able to dip her paintbrush and complete her painting; the memory affects her "like a work of art" (160). It is, similarly, on barely conscious memories of their mother that James and Cam draw to achieve insight, self-affirmation, and a sense of safety.

instead of the painter Lily Briscoe, there is the photographer Miss Eliot, closing the scene by "planting her tripod on the lawn." The random and disparate elements of the picture recalled are similarly thrown before the reader: "The children were whirling past the door, throwing things high into the air"; Mr. Wortley, in his yellow slippers, trails the *Times* and holds out his hand to departing guests; Mrs. Durrant is on the terrace "where the fuchsia hung, like a scarlet ear-ring, behind her head."[33] The abrupt manner in which Woolf ends this chapter with the taking of a photograph as present slips into past ("'Mr. Flanders! … Jacob Flanders!' 'Too late, Joseph,' said Mrs. Durrant. 'Not to sit for me,' said Miss Eliot") suggests both the old desire for art's permanence as well as pleasure taken in photography's new instantaneousness. There are the "scraps and orts," as Woolf will later term life's fragments in *Between the Acts* (1941), which most family photographs will one day themselves become; there is self-consciousness about those fragments in the context of time passing; and there is the camera as a means of framing and recalling them. All combine in Woolf's postwar novels to create an aesthetic that may be considered photographic, not despite but precisely *because* of the way in which that aesthetic explores subjectivity.[34]

Part of that subjectivity entails, as I've already noted, the experience of time. In W. S. Merwin's foreword to *In Parenthesis* (1937), David Jones's novella-length poem about the war, Merwin notes the "sensual details of every kind" that are part of Jones's poem: "the sounds, sights, smells, and the racketing and shriek of shrapnel set against the constant roar of artillery to snatches of songs overheard or remembered, reflections on pools of mud, the odors of winter fields of beets blown up by explosives, the way individual soldiers carried themselves at moments of stress or while waiting. All of these," writes Merwin, "become part of the 'nowness' that Jones said was indispensable to the visual arts."[35] Jones's "nowness" is the absolute present of collage, the arrangement of objects on the same visual plane such that time and space are flattened into spectacle; his apparent defiance of any kind of semantic hierarchy recalls the temporal conflations of *The Waste Land* (1922), as well as its kaleidoscopic juxtaposition and fragmentation.

Woolf too is clearly interested in exploring the absolute present. On the first page of *Mrs. Dalloway* (1925), her use of the word "now" produces a kind of narrative split that allows for simultaneous temporal experience. Clarissa Dalloway's descent into

[33]Woolf, *Jacob's Room*, 63.

[34]Woolf herself, as has been wonderfully documented by Maggie Humm, was familiar with the process of making and developing photographs. Humm writes that photography "was a continuous part of the Woolfs' lives even if their photographic albums do not tell a coherent life story." Given Woolf's lack of commitment as a writer to the orthodoxies of chronology, it makes sense that her own collections of photographs were instead organized around thematic groupings and repetitions. See Maggie Humm, *Modernist Women and Visual Cultures: Virginia Woolf, Vanessa Bell, Photography and Cinema* (New Brunswick, NJ: Rutgers University Press, 2003), 40. See also Diane Gillespie, "'Her Kodak Pointed at His Head': Virginia Woolf and Photography," in *The Multiple Muses of Virginia Woolf*, ed. Diane F. Gillespie (Columbia and London: University of Missouri Press, 1993), 113–47.

[35]W. S. Merwyn, introduction. David Jones, *In Parenthesis* (New York: NYRB Classics, 2003), iv.

present-day London occurs at precisely the same moment as she re-enters memories of her life as a young girl in the country; both expeditions begin with the sound of a door's hinges "which she could hear *now*."[36] It's a figure of speech, of course; we don't think Clarissa literally hears the French doors at Bourton opening, because we understand Woolf to mean that Clarissa *remembers*. In the present-day world of the novel, what Clarissa hears, presumably, is her own front door opening onto the street, but the "now" marks a memory; it opens up a time that we understand is in fact *not* now. A similar kind of simultaneity emerges in the concluding pages of *To the Lighthouse*, where Lily's view from the land is intercut with the view from Mr. Ramsay's boat out at sea. Cam, who is in the boat, feels that "it seemed as if they were doing two things at once; they were eating their lunch here in the sun and they were also making for safety in a great storm after a shipwreck."[37] The lighthouse is, as her brother James recognizes, more than one thing: it is both the misty image watched from afar and the painted tower seen up close. It is what it *was* and what it now *is*. Likewise he, James, is both six years old, on the floor at his mother's knee, cutting out pictures, and also, at the same time, a teenager in a boat with his father.

As *To the Lighthouse* demonstrates, Woolf's interest in the present moment is almost always as a site of negotiation with the past. Like the lighthouse itself, the word "now" is more than "simply one thing," and its various incarnations in Woolf's writing hover continually between intensity and anxiety. Clarissa Dalloway's effort to forget war and celebrate "this moment of June" is doomed to fail; it is an exercise in trying to repress the past that cannot be achieved. "The War was over," she thinks; "it was over; thank Heaven—over."[38] But, through Septimus, for whom the war has never truly ended, the reader learns that the word "over" is meaningless. Nothing in Woolf is ever "over," just as "now" is never really *now*.

Toward the end of the "Time Passes" section of *To the Lighthouse*, the housekeeper Mrs. McNab's recollection of Mrs. Ramsay makes full play with the word "now," in a passage that suggests both the word's conceptual impossibility as well as Woolf's sense of its potential capaciousness. Mrs. McNab's memory begins with a refrain, repeated as Mrs. Ramsay starts to come into her mind's eye: "She could see her, as she came up the drive with the washing, stooping over her flowers (the garden was a pitiful sight now, all run to riot, and rabbits scuttling at you out of the beds)—she could see her with one of the children by her in the grey cloak." The reader understands the phrase "she could see her" as figurative; Mrs. Ramsay is dead, and no longer to be seen, except in the dreams and memories of others. The confusion of pronouns ("she … her … she … her") suggests that this remembered version of Mrs. Ramsay is dependent on Mrs. McNab, while the "now" of that sentence about the garden is an interjection, a crude means of distinguishing postwar present from prewar past. But

[36]Virginia Woolf, *Mrs. Dalloway* (London: Harcourt Brace, 1953), 3. Emphasis added.
[37]Woolf, *To the Lighthouse*, 205.
[38]Woolf, *Mrs. Dalloway*, 5.

the phrase "she could see her" hasn't finished its work, and nor will the distinction between now and then, or past and present, remain fixed. Woolf continues:

> Yes, she could see Mrs. Ramsay as she came up the drive with the washing.
> "Good-evening, Mrs. McNab," she would say.
> She had a pleasant way with her. The girls all liked her. But, dear, many things had changed since then (she shut the drawer); many families had lost their dearest. So she was dead; and Mr. Andrew killed; and Miss Prue dead, too, they said, with her first baby; but every one had lost some one these years. Prices had gone up shamefully, and didn't come down again neither. She could well remember her in her grey cloak.
> "Good-evening, Mrs. McNab," she said.[39]

The shift into habit and recurrence ("she would say") gives the memory substance; what happens in this passage is something that happened more than once. But note how the sense of Mrs. McNab's memory coming into focus is intensified by revision: "'Good-evening, Mrs. McNab,' she would say" becomes "'Good evening, Mrs. McNab,' she said"—a delicate shift into specificity and detail. Finally, Mrs. McNab's memory develops fully with the sudden appearance of one word: "She could see her *now*, stooping over her flowers; and faint and flickering, like a yellow beam or the circle at the end of a telescope, a lady in a grey cloak, stooping over her flowers, went wandering over the bedroom wall, up the dressing-table, across the wash-stand ..."[40]

What has just happened? Woolf has developed a conventional, historic "now" into a more flexible, porous, modernist version of the word, in which it contains both past and present. She has, in fact, redefined "now" just as it is redefined by the peculiar temporal space that is a photograph; recall Barthes's famous lines on Alexander Gardner's photograph of Lewis Payne: "He is dead and he is going to die."[41] Is Mrs. Ramsay both dead and going to die? Are Mr. and Mrs. Ramsay really here, *now*? If not, what does the word "now" really mean?

The linguistic indeterminacy that erases meaningful distinction between past and present permits Mrs. Ramsay a presence that is more than merely ghostly. In the postwar section of the novel, Lily resumes work on her painting. After some difficulty getting started, things seem inexplicably to take a turn for the better:

[39]Woolf, *To the Lighthouse*, 136.
[40]Ibid., 136, emphasis added. And what of that yellow beam, the light from the lighthouse, that suggests the projection of an image from the past? It is both filmic and, being round like "the circle at the end of a telescope," like the lens of a camera that carries us through the distance of time rather than space. Thus Mr. Ramsay, too, comes into sight: "the telescope fitted itself to Mrs. McNab's eyes, and in a ring of light she saw the old gentleman" (140).
[41]Barthes, *Camera Lucida*, 95.

Suddenly the window at which she was looking was whitened by some light stuff behind it. At last then somebody had come into the drawing-room; somebody was sitting in the chair. For Heaven's sake, she prayed, let them sit still there and not come floundering out to talk to her. Mercifully, whoever it was stayed still inside; had settled by some stroke of luck so as to throw an odd-shaped triangular shadow over the step. It altered the composition of the picture a little. It was interesting. It might be useful.[42]

The moment, tense with creation, is one of the most powerful in all of Woolf's novels. And then two things happen: within the room a "wave of white went over the window pane"; and Lily's erupting grief for the loss of Mrs. Ramsay becomes suddenly ordinary and object-like. The passage ends this way: "Mrs. Ramsay—it was part of her perfect goodness—sat there quite simply, in the chair, flicked her needles to and fro, knitted her reddish-brown stocking, cast her shadow on the step. There she sat."[43]

Again, what has just happened? Woolf's language—"There she sat"—will not permit us to make a definitive case either for or against the presence of Mrs. Ramsay. If we think she is a ghost, we fix the words one way; if we argue that this is memory only, we take another position. But the fact is that the language accommodates both. Mrs. Ramsay is dead and she is going to die. "There she sat" cannot be assailed; it is a rock against which time and interpretation can do no damage. In the ever-present "now" of the photographable world, Mrs. Ramsay is always present.

Woolf's interest in the "now" only gained in urgency throughout the 1920s; indeed, *The Waves* (1931) is arguably structured around the concept. The interludes that offer narration without human subjectivity recall Mr. Ramsay's philosophical work on the world seen without a self, while alternating with those sections are soliloquys that convey detached human subjectivity in moments hung together like images:

> "I see a ring," said Bernard, "hanging above me. It quivers and hangs in a loop of light."
>
> "I see a slab of pale yellow," said Susan, "spreading away until it meets a purple stripe."[44]

Throughout these sections, Woolf uses the word "now" to ferry the stasis of the present tense along, but she also uses it to convey a whole range of temporal effects, including simultaneity: "*Now* we draw near the centre of the civilised world," says Neville, going to London on a train while thinking that "Percival is *now* almost in Scotland";[45] the rhythm of creativity: "*Now* I am getting the hang of it," says Bernard, "*Now* I am getting his beat into my brain … *Now*, without pausing I will begin, on

[42]Woolf, *To the Lighthouse*, 201.
[43]Ibid., 202.
[44]Virginia Woolf, *The Waves* (San Diego, New York and London: Harcourt Brace Jovanovich, 1959), 9. Emphases added throughout.
[45]Ibid., 71.

the very lilt of the stroke";[46] the urgency of desire, as when Percival appears in the restaurant;[47] and the horror of loss, as when Percival leaves: "*Now* the agony begins; *now* the horror has seized me with its fangs … *Now* the cab comes; *now* Percival goes.… *Now* Percival is gone."[48]

Jacob's Room is similarly preoccupied with the photographic present, made overt by the refusal of syntactical connection between moments. The effect is to distance the reader from Jacob, a distance sustained toward the novel's end by the narrator's apparently random recitation of present moments: "*Now* the agitation of the air uncovered a racing star. *Now* it was dark. *Now* one after another lights were extinguished. *Now* great towns—Paris—Constantinople—London—were black as strewn rocks."[49] What seem like disconnected observations in the famous last pages of that novel turn out to be connected to the text through their echo of earlier passages ("The eighteenth century has its distinction"; "Listless is the air in an empty room"),[50] and they produce the effect of a world in which all phrases, like all images, have already been uttered or seen. Bonamy's final cry at the window of "Jacob! Jacob!" revisits the novel's beginning, when a small Jacob is called for on the beach, while Woolf's readers may find an echo of that cry in Clarissa Dalloway's "Richard! Richard!" at another window in a later novel.

There is something strikingly frugal, even parsimonious, in this intertextual echoing, cross-hatching, and revisiting of specific moments, concepts, and words that occur not just in but also across Woolf's postwar novels. In four of the five experimental works of the 1920s, she returns almost obsessively to specific ideas and moments to rework them (the fifth, *Orlando* [1928], arguably offers its own dream version of some of those moments). Such moments are to be found, rather strikingly, in Woolf's own biography; they are, in fact, memories. There is the sensation of infant happiness by the sea, and the sun rising as a gold ring in the sky (*Mrs. Dalloway*, *To the Lighthouse*, and *The Waves*); there are the colors of postimpressionism, purple and lemon yellow, applied to waves and fruit (*Jacob's Room* and *To the Lighthouse*); there are lighthouses and yacht masts that prove to be more than one thing when viewed close-up, or to wobble through tears (*Jacob's Room* and *To the Lighthouse*); there are artists on the periphery recording the scene (*Jacob's Room* and *To the Lighthouse*); there are social gatherings which affirm the multiple viewpoints that constitute shared reality (*Jacob's Room*, *Mrs. Dalloway*, *To the Lighthouse*, and *The Waves*). To read Woolf's novels of the 1920s is to experience a variety of thematic variations that don't illuminate the

[46]Ibid., 79.
[47]Ibid., 122–24.
[48]Ibid., 145.
[49]Woolf, *Jacob's Room*, 160; all emphases added.
[50]Ibid., 176.

slender confines of her interests as much as they explore the infinite permutations of her memories.[51]

These variations are textually framed not once but many times by their repetition and revision. Across time—the real time a reader actually spends with Woolf's work—they constitute the peculiar sense that one has already experienced an emotion or event, and thus, like Woolf, one is in some ways *remembering* it; the reader's sense of significance or aesthetic intensity accumulates over the time spent reading all the novels (which is a good argument for reading those works together). The sense of time passing, therefore, is largely the consequence of revisiting specific objects and even words. Working against but also *out of* the photographer's insistence on "now," which is the present that must be captured, is the ongoing and kinetic sense of generalized time that Woolf renders with paradoxical specificity. In *Jacob's Room*, for example, a sense of the passage as well as the duration of time is produced by the ordinary occurrences of multiple days: "About half-past nine Jacob left the house, his door slamming, other doors slamming, burying his paper, mounting his omnibus, or, weather permitting, walking his road as other people do." It isn't until the "or, weather permitting," that the reader understands that this is no one specific moment that Jacob leaves the house, but it represents instead a series or even potential lifetime of such departures and their variations. The passage continues:

> Head bent down, a desk, a telephone, books bound in green leather, electric light … "Fresh coals, sir?" … "Your tea, sir." … Talk about football, the Hotspurs, the Harlequins; six-thirty *Star* brought in by the office boy; the rooks of Gray's Inn passing overhead; branches in the fog thin and brittle; and through the roar of traffic now and again a voice shouting: "Verdict—verdict—winner—winner," while letters accumulate in a basket, Jacob signs them, and each evening finds him, as he takes his coat down, with some muscle of the brain new stretched.[52]

The shift to the pictorial present tense, like that of *David Copperfield*, brings the habitual before us as a collection of images. Time acquires material substance through the repetitive acts of daily life; it develops, in all its infinite but subtle variations, into a type of a day, a type of a life.

In this kind of writing, as in Dickens's, a tension is generated between the stasis of the images and the movement that their perusal helps us to imagine, as though we ourselves as readers create a forward motion in our repetitive encounter with small moments. Thus, on the hunt for Jacob, the narrator leafs through life as a series of thumbnail sketches:

[51]For a thorough and delicate sourcing of those memories, see Hermione Lee's biography, *Virginia Woolf* (New York: Vintage, 1999).
[52]Woolf, *Jacob's Room*, 90.

Shawled women carry babies with purple eyelids; boys stand at street corners; girls look across the road—rude illustrations, pictures in a book whose pages we turn over and over as if we should at last find what we look for. Every face, every shop, bedroom window, public-house, and dark square is a picture feverishly turned—in search of what?[53]

"THE ACHE OF DEPARTURE"

Modernism's Victorian Childhood

Woolf's question—"in search of what?"—is neither specific nor wholly general. It emerges from the Victorian and post-Victorian experience of the world's coming-into-being through a turning "over and over" of pictures—pictures in albums, magazines, illustrated books, catalogs. The turning of pages, of course, was learnt in childhood, and middle-class Victorian children were, as no other children before them had been, the beneficiaries of a thriving market for picture books. In the nineteenth century, learning to read was a matter of images as well as words.[54] Childhood was not only a time of learning the language that summoned the world into being, but it was also marked by the effort to connect word with image. As Bernard says in his final soliloquy in *The Waves*, "let us turn over these scenes as children turn over the pages of a picture-book and the nurse says, pointing, 'That's a cow. That's a boat.'"[55] The past that so preoccupied writers of the early twentieth century was a past in which their own picture-focused readership had emerged.

From its famous first words, conveying the texture of repetition and duration in which Woolf herself was so interested ("For a long time I used to …"), *À La Recherche du Temps Perdu* (1913–27) offers a multitude of entryways into the past, some of which arise out of a stimulus over which the remembering subject has no control. The colors of a magic lantern, the taste of a madeleine, produce the same process of involuntary memory that we find in *Mrs. Dalloway*, in which the past expands out of

Few authors were more interested in visualizing the past than Proust. It's often noted that Woolf was reading Proust while she was writing *To the Lighthouse*, and it's possible to make a case for some overlap where their shared interest in visual imagery is concerned. But where photography's influence on Woolf may be broadly felt in those stylistic tropes of repetition, simultaneity, collage, and fluid temporality, in Proust's work photography appears more overtly as a series of techniques to recall the past, techniques whose utility or lack thereof is continually evaluated by Marcel, and discussion of which becomes part of the work's aesthetic.

[53]Ibid., 97.
[54]Textual illustration remained for some nursery fare: Wordsworth's irritable sonnet of 1846, "Illustrated Books and Newspapers," laments the supposed infantilization of the reader in the image-rich culture of the mid-nineteenth century. *Collected Works of William Wordsworth* (London: Wordsworth Editions, 1998), 583.
[55]Woolf, *The Waves*, 239.

a random external event or occurrence, such as a squeaking door, a paper flower, or (as in the less benign variation of involuntary memory that is shell shock) the sounds of traffic. As Howard Moss argues, involuntary memory in Proust is "a re-living of the past *as the present*";[56] as in those temporally ambiguous moments in Woolf, there is no distinction made between past and present because no meaningful distinction exists.

Proust also represents moments of voluntary, or conscious memory, the kind of memory on which we deliberately embark when we sit down to peruse a photograph album or converse with friends about time past. (The title of his work itself alerts us to such a process.) One might reasonably assume, in fact, that Proust's primary use of photography would be in scenes of voluntary memory, given that photographs are obvious metaphors for a conscious rereading of the past. Samuel Beckett writes that, in Proust, voluntary memory "can be relied on to reproduce for our gratified inspection those impressions of the past that were consciously and intelligently formed … It presents the past in monochrome."[57] Elena Gualtieri's slightly more nuanced view is that "photography works in the *Search* as a way of figuring the model of linear time that the text sets out to undo."[58] Both see photography in Proust as operating within the service of realism, a realism that he critiques (according to Beckett) and ultimately dismantles (Gualtieri). Áine Larkin, meanwhile, makes a more subversive case for the ambiguity of photography in Proust, its "power to represent people and things as they may never actually have been." Far from being symbols of realism or sources of consciously controlled memories, photographs in Proust, Larkin argues, "represent a past whose existence is confined solely to the realms of the viewer's imagination."[59] Frank Wegner's study similarly concludes: "The function of photography in Proust renounces a practice of naïve realism … [it] exposes—in a sense makes visible—that there can be no reliable experience of reality. It shows that there is nothing permanent and stable to be seen."[60] Indeed, photography as metaphor in Proust frequently draws on the instability of the developing process, as well as on the slow, private experience that is a coming-into-focus of changing human opinion—photography, in other words, as metaphor for the internal life that modernist works are most interested in documenting.

[56]Howard Moss, *The Magic Lantern of Marcel Proust: A Critical Study of Remembrance of Things Past* (Boston: David Godine, 1963), 108.

[57]Beckett, qtd. in Áine Larkin, *Proust Writing Photography: Fixing the Fugitive in À la Recherche du Temps Perdu* (London: Legenda, 2011), 65.

[58]Elena Gualtieri, "The Grammar of Time: Photography, Modernism and History," in *Literature and Visual Technologies: Writing after Cinema*, eds. Julian Murphet and Lydia Rainford (New York: Palgrave, 2003), 155–74, 166.

[59]Larkin, *Proust Writing Photography*, 12.

[60]Frank Wegner, *Photography in Proust's À la Récherche du Temps Perdu* (Unpublished doctoral thesis, University of Cambridge, 2004), 110; Larkin, *Proust Writing Photography*, 111.

Walter Benjamin had also been reading Proust when, in the early thirties, he began work on his own memoir, *A Berlin Childhood*, a work shaped, as Howard Eiland notes, by what is essentially a photographic aesthetic:

> the presentation of Benjamin's Berlin childhood involves a method of superimposition or composite imagery that reflects the palimpsest character of memory.... A good example of this use of overlays is found in the vignette "Boys' Books," which assembles images of the child reading … at different stages of his young life and in different places: in the school library, by the table that was much too high, at the window in a snow-storm, and in the 'weather corner' of a cabinet of books in a dream. Each of the moments evoked communicates with and subtly overlaps with the others, as multiply exposed images in a film bleed into one another in a composite transparency.[61]

What Eiland notices in Benjamin is, interestingly, the same randomly sequenced display of images that we saw in *David Copperfield*, while the "composite transparency" is arguably the same thing one finds in Proust and Woolf, whose writings produce the multivalence consistent with the "palimpsest character of memory." As Peter Szondi puts it, "Benjamin's tense is not the perfect, but the future perfect in the fullness of its paradox: being future and past at the same time."[62] Szondi's conclusion—that "Proust listens attentively for the echo of the past" while "Benjamin listens for the first notes of a future which has meanwhile become the past"—obscures the fact that both writers seek a new temporal space in which the past may be creatively engaged. Philosophically as well as figuratively enabled by photography, that space belongs to "future and past at the same time." Szondi's phrase, in other words, describes the work of Proust and Woolf as effectively as it does that of Benjamin.

Berlin Childhood around 1900 is composed of individual pieces with short titles: *Loggias, Imperial Panorama, Victory Column, The Telephone*, and so on. Mostly nouns and proper names that reference objects and places, Benjamin's titles serve as captions or signs that release their author from the obligation of making objects and places connect to each other. This seems to have been deliberate. In "A Berlin Chronicle" he writes that "remembrance must not proceed in the manner of a narrative or still less that of a report, but must, in the strictest epic and rhapsodic manner, assay its spade in ever-new places, and in the old ones delve to ever-deeper layers." In other words, providing connections between views, and narrative in order to create a semblance of wholeness, would run counter to the project, which is in part about the "fruitless searching" that is part of recollection.[63] But absence of connective tissue among the

[61]Howard Eiland, "Translator's Foreword," in Walter Benjamin, *Berlin Childhood around 1900*, translated by Howard Eiland and edited by Peter Szondi (Cambridge, MA: Belknap Press, 2006), xii–xiii.
[62]Peter Szondi, "Hope in the Past: On Walter Benjamin," in Benjamin, *Berlin Childhood around 1900*, 9.
[63]Benjamin, "A Berlin Chronicle," *Reflections*, 26.

different sections also leads, as in *Jacob's Room*, to their visual emphasis. Benjamin acknowledges the effect that is produced by his different views, explaining that he has "made an effort to get hold of the *images* in which the experience of the big city is precipitated in a child of the middle class."[64] His memoirs refuse chronology and offer instead a collage of possibilities, and the resulting effect is that of reading an album or, indeed, of perusing a number of the picture postcards that Benjamin recalls with affection: "I believe that I should gain numerous insights into my later life from my collection of picture postcards, if I were able to leaf through it again today."[65]

It is not the potential for insight that moves Benjamin, however, but the recollection of spectatorship itself, just as it is not the images of the Imperial Panorama that signify but rather the memory of himself as a child in thrall to those images. Recalling his early fondness for this clanking nineteenth-century contraption—a large round machine with multiple viewpoints, at one of which each viewer would be seated for the show of sequenced stereographs—Benjamin does not remember the pictures he saw as much as what it felt like to be one of the Panorama's last patrons:

> One of the great attractions of the travel scenes found in the Imperial Panorama was that it did not matter where you began the cycle. Because the viewing screen, with places to sit before it, was circular, each picture would pass through all the stations; from these you looked, each time, through a double window into the faintly tinted depths of the image. There was always a seat available. And especially toward the end of my childhood, when fashion was already turning its back on the Imperial Panorama, one got used to taking the tour in a half-empty room.[66]

By 1900, the Kaiser Panorama was a quintessentially nineteenth-century experience of virtual travel that, like the author's childhood, was coming to an end. Benjamin's recollection of himself as a small boy taking the tour "in a half-empty room" is a melancholy one that moves us not only because of the innocence of the child's enthusiasm for an unsophisticated pleasure but also because we share Benjamin's burden of hindsight. Writing during the darkening days of the 1930s, and as though to mark the shared passing of boyhood, machine, and century, Benjamin recalls one "small, genuinely disturbing effect" of the panorama:

> the ringing of a little bell that sounded a few seconds before each picture moved off with a jolt, in order to make way first for an empty space and then for the next image. And every time it rang, the mountains with their humble foothills, the cities with their

[64]Benjamin, *Berlin Childhood around 1900*, 38.
[65]Benjamin, "A Berlin Chronicle," 40.
[66]Benjamin, *Berlin Childhood around 1900*, 42–43.

mirror-bright windows, the railroad stations with their clouds of dirty yellow smoke, the vineyards down to the smallest leaf, were suffused with the ache of departure.[67]

As creatures of the twenty-first century, we are very familiar with that ache, which critics have repeatedly described in terms of belatedness and detachment. It is the ache of modernism, the self-conscious recognition of time's passage and our uneasy relationship to it. The ache of modernism is what Ursula feels on her train journey across Europe, and what we feel when Mrs. Ramsay turns back in the doorway. Its point of reference, if it has a point of reference, is something already seen, and we learned how to see it from photographs.

[67]Ibid., 43.

CHAPTER SIX

At Home in
the Nineteenth Century

In the last decades of the twentieth century, Victorian photography began to achieve a new kind of visibility. For literary scholars, academic interest was driven in part by a heightened attention to the representational complexities of nineteenth-century realism. George Levine's *The Realistic Imagination* (1981) argued for considering Victorians, no less than modernists, as formal innovators struggling to represent their particular historical experience, and Levine's work helped open the way for a Victorian cultural studies practice interested both in the history of ideas as well as the material realities with which literature of the period engaged. The resulting shift toward mapping a variety of realisms was defined by intensified engagement with issues of perception, performance, and subjectivity, all of which made self-consciously pictorial photographs of particular interest. Lewis Carroll's barefoot beggar-maid Alice, Robinson's pseudo-consumptive fourteen-year-old, and Cameron's tousled cherubs began to come into focus not just as reactionary or self-indulgent nostalgia exercises but, more interestingly, as theatrical experiments engaging in weird and fascinating ways with a culture in which realism was continually being redefined. There was, moreover, something literary about these pictures that students trained in rhetoric could get their teeth into; not only were Victorian pictorial photographs often overtly textual in origin; they were, like much pre-Raphaelite art, generally interested in narrative, a fact that scholars such as Carol Mavor and Lindsay Smith explored in distinctively different but equally productive and groundbreaking ways.

Around the same time, there was a general classificatory shift of the "found" photograph, one that might be discovered in a drawer, or an estate sale, or among other odds and ends at a thrift store. A found photograph is one that has become untethered from the original circumstances of its production; in content and purpose it is probably as unlike a photograph by Robinson or Cameron as it could possibly be.

Found photographs are attached to no particular biography or history, and besides a spectacular few, such as Ken and Jenny Jacobson's auction discovery of a cache of daguerreotypes made by Ruskin,[1] they are usually images with minimal artistic intentions. Yet the fact of their existence attests to their hidden personal significance; they have mattered in ways in which they do not matter now.

The category to which most photographs now belong—snapshots—has not featured much in accounts of photography, despite the fact that snapshots constitute the vast majority of photographs. As Geoffrey Batchen points out, the history of photography has largely addressed itself to images, such as the pictorial works mentioned above, that do not represent the field. Most photographs are, as he says, more easily defined by what they are *not*: not art, not generalizable, not even, according to Batchen, interesting.[2] But found photographs from the nineteenth century are less likely to be snapshots: produced in the years before Kodak made the practice of photography a personal matter of "snapping," they include laboriously produced daguerreotypes and prints carefully pasted by their commercial photographers on card; they are studio portraits, photographs made for historical surveys, wayside pictures of property, civic events, and farming practices.[3] What these photographs share with snapshots is not just the difficulty of meaningful categorization, but the fact that someone somewhere has found it impossible to part with them—at least until the 1970s, when, along with everything else more or less Victorian, their commercial value began to rise. No longer perceived as fragments, or bits of things (junk), old photographs became icons, or parts of things (antique,) and moved into a new kind of circulation.

What did old photographs offer in the late-twentieth century that in earlier decades went unremarked? It was not just, presumably, what they showed, but rather what as objects they represented or conveyed: some relationship to the past, some connection to a human being, something real, and something *authentic*. Desire for all of those things sustained a new market for old photographs that serviced its customers' nostalgia in the manner of photography itself: with the promise of access, with the solace of retrieval, and with the pleasures of loss. The nineteenth century, or something that looked like it, offered a path to authenticity and identity. Cut loose from its historical context, the view from old photographs became itself the object of nostalgic desire.[4]

In this book I have taken as a given Richard Terdiman's assertion that "how a culture performs and sustains [its recollection of the past] is distinctive and diagnostic."[5] Our

[1] See Jacobson, *Carrying off the Palaces*, 2015.
[2] Most of them, he says, are "boring." Geoffrey Batchen, "Snapshots: Art History and the Ethnographic Turn," *Photographies* 1.2 (September 2008), 121–42, 121.
[3] Kodak's first box camera went on the market in 1888; its Brownie Box camera, in 1900.
[4] It was, of course, only a matter of time before that view was skimmed off and turned into an app. As I noted at the beginning of this book, the title of one such view was *1977*—a name that located the resting place for postmodern nostalgia not in the nineteenth century but rather at the moment when the commercial market for old photographs took off.
[5] Terdiman, Present Past, 3.

relentless memorialization of the Victorians will provide an extraordinary amount of material to future historians, not least because what we popularly define as Victorian now ends neither with the life of its monarch nor even with the beginning and end of her century, but designates instead an aesthetic rather than precisely historical concept. Contemporary cultural allusions to the Victorians sweep generously if inaccurately from the late eighteenth and early nineteenth century, right up to the outbreak of the Great War. The "long nineteenth century," a phrase long-divorced from the historian Eric Hobsbawm, who coined it to indicate a period he felt was bookmarked by the French Revolution and the First World War, has become a handy but imprecise concept, reflecting a growing sense that the borders of our interests require ever-widening circumference. As a term with once specific purpose, the "long nineteenth century" now serves in literary studies as permission to be generally vague; it frequently suggests nothing other than a general assent to what "nineteenth century" means, and that what it means is not effectively represented by its dates. The *long* nineteenth century, in other words, is what the *real* nineteenth century was about—more or less.

For many years the past has maintained some cultural authority that supports the activity of reproducing and purchasing objects past their prime and, commercially at least, the shape of that authoritative past has in recent decades been defined by a nineteenth century that is very long indeed. Past is past, the 1800s really no more so than the 1950s and no less than the 1660s, yet something vaguely Victorian is what advertisers often seem to mean when they say (equally vaguely) "yesteryear," "olde world," or even "olden times." We re-create the past in response to popular demand—that much seems clear; less apparent are the reasons why such a generalized demand exists to be satisfied with a *Victorian* product. Or, to put it another way, why, when we want to reinvent and revisit the past, do we so frequently choose the nineteenth century as the place to get off the train?[6]

THE VISIBLE NINETEENTH CENTURY

The answer to that question is both obvious and subtle: we can see the Victorians. Not just imaginatively, but really—or as really as we see anyone in photographs. No matter how much we may agree in theory with John Tagg that "the causative link between the pre-photographic referent and the sign … can guarantee nothing at the level of meaning,"[7] the Victorians have a documentary assertiveness unavailable before the age of photography, and our view of the nineteenth century has been inflected by it.

[6]The nineteenth century has a great many places to alight: thanks to the movies, one can make quite specific stops in nineteenth-century America from Hawthorne to Henry James; in England, the track reliably stretches between Jane Austen and Thomas Hardy, with the popular further destination of E. M. Forster. Here I make little or no distinction between what are clearly very different destinations, because my subject—the creation of a past that is only generally "Victorian"—presupposes a lack of precision.
[7]John Tagg, *The Burden of Representation: Essays on Photographies and Histories* (Amherst: University of Massachusetts Press, 1988), 1, 3.

Further, while those living in the nineteenth century may appear in photographs in their hoops, top hats, and whiskers, and as much as those photographs affirm their otherness, they also emphasize the shared ordinariness of their human subjects: Victorians only by historical accident. They exist in the absolute and paradoxical present of the photograph, always there yet gone forever, both in and out of history. Markers of presence and of absence, of the coming-into-being of the world as well as its having been and its fading away, their photographs are Benjamin's pointers toward "that invisible stranger, the future,"[8] while they are also and always, in Woolf's words, "already the past."[9]

But although much has been made, here and elsewhere, about the distinctively Victorian characteristics of photography itself, and how it so perfectly embodies the obsessions of the period, there is also a postmodern quality to the frustrations of our relationship with it. No effort, however extraordinary, will ever yield access to a photograph and permit us, Alice-like, to climb through its frame into another world. Apart from the irony contingent on our every encounter with the paradox of the photograph, and at odds with photography's promise of interiority and penetration, is the hard surface of images that will not melt into air. Nonetheless, we have found the Victorians accessible thanks to their appearance in photographs, and that sense of access has been enabled by the cultural invisibility of the photograph *as* photograph. In re-presenting the nineteenth century to us, Victorian photographs are for the most part inseparable as objects from our way of reading them. Our own interpretive fingerprints are on the plate. And just as other historical artifacts affirm a connection with human beings from earlier generations, so old photographs, their negatives (and subjects) long gone, now assume the aura of originals, not merely in terms of their economic value but as points of reference or departure.

Those departure points, the sites and sources of authenticity, are located with the human rather than the object world. Searches for authenticity are searches for signs of agency, the indices of other human beings—axe marks in a beam, thumb prints in pottery, hair caught in oil paint on a canvas, light on glass that once glanced off a human face. When I look back to photography's earliest days, it is not Daguerre's fossils or Talbot's mistier calotypes of Lacock Abbey that most fascinate me, stunning as these images are for their detail and achievement. Instead, it is by that accidental sign of an unknown human being that I am fixated, entranced by the anonymous subject who appears unwittingly before us by virtue of having stopped to get his boots cleaned on a Paris street—stopped, as noted at the outset of this book, long enough to have his presence recorded on a daguerreotype and thus to be taken into a new kind of history, while the rest of the people crowding the street that day simply disappeared into the old one.

[8]Benjamin, "A Berlin Chronicle," 59.
[9]Woolf, *To the Lighthouse*, 111.

It's true, of course, that our preoccupation with indexicality obscures the simplest of truths regarding photography, which is that photographs are constructions, made not begotten. And it is also true that as readers we accept the realism of any given photograph not just because a photograph is so astonishingly like the thing it depicts, but also despite, in Joel Snyder's words, "its failure to substitute for a visual experience."[10] But this is precisely the point. Whether we believe that the world "delivers itself"[11] to photography or whether we don't, the chances are, as Robin Kelsey argues, that the delivery is not quite as expected.[12] In the case of *Boulevard du Temple*, the image showed something Daguerre could not have anticipated: someone else's decision to stop and get his boots cleaned. The thing that set this image on its storied course through history was the collision of that human mind with the photographic process, a mind beyond Daguerre's that hadn't been invited into the process, or into the history of photography, but, while it thought about boots, found its way in regardless. What kept this particular daguerreotype on course to its current place in the canon, however, was not the mind of that accidental subject, nor indeed that of the accidental photographer, but rather the minds of its many viewers, engaged, over decades and centuries, in the imaginative work of history.

In the next couple of pages, I will consider some of the other nineteenth-century photographs we have valued, and I will ask what kind of past it is that we're remembering when we use them to remember the past. While the question arguably demystifies the relation between a photograph and its referent, it will be obvious by now that for me it does not fully eradicate, or even seriously trouble, photography's indexical, sentimental, and historical appeal. My interest in the social production of photographic meaning and my response to the iconic assertiveness of a given image exist in a tolerable suspension. Much as I am aware of the many organizing principles at work in reading photographs, my fascination with the bootblack and his customer on the Parisian boulevard is undeniably inflected by desire that "the thing of the past, by its immediate radiations (its luminances) has really touched the surface which in its turn my gaze will touch."[13]

A PHOTOGRAPHIC CANON

The following brief list constitutes a sort of contemporary top twenty (or so) of nineteenth-century British photographs, compiled simply by cross-referencing popular books of the coffee-table variety, including exhibition catalogs, that in recent decades have professed to deliver the history of photography. A similar list could,

[10]Joel Snyder "Picturing Vision," in *The Language of Images*, ed. W. J. T. Mitchell (Chicago and London: University of Chicago Press, 1980), 228.
[11]Ibid., 224.
[12]See Snyder, "Picturing Vision"; Tagg, *The Burden of Representation*, 1988; Kelsey, *Photography and the Art of Chance*, 2015.
[13]Barthes, *Camera Lucida*, 81.

with different consequences, be made of American photographs. I am not concerned here with the aesthetic or technological merits of these pictures, but only with what we might conclude about our particular historical moment from the results of a brief unofficial poll on postmodern taste. My questions are simple: Of what kind of nineteenth century are we fondest? How do we like to remember it? What images— whose images—have been our preferred sightings of the persons who lived there? Answers to those questions may suggest some reasons we are predisposed to value certain images over others, reasons that have little to do with Victorian photography but have shaped how we have written its history.

My list of canonical Victorian photographs includes the following: Thomas Annan's pictures of Scottish closes; just about anything by Julia Margaret Cameron, but particularly *Whisper of the Muse (George F. Watts)* (1864–65); her photographs of Mary Hillier; and the portraits, especially *Thomas Carlyle* (1867), *Mrs. Herbert Duckworth* (1867), and *Sir John Herschel* (1867); Lewis Carroll's *Alice as a Beggar Maid* (1859) as well as a select few others of Carroll's child friends; the Cottingley fairy photographs (revisited in movie version as a "true story"); Emerson's pictures of the Norfolk Broads, especially *Poling the Marsh Hay* (1886), *Gathering Water-Lilies* (1886), and *Osier-Peeling* (1888); Hugh Diamond's portraits of his insane female patients; Frederick Evans's French and English cathedrals, notably *The Sea of Steps— Wells Cathedral* (1903); Roger Fenton's English landscapes, but also the Crimean *Valley of Death* (1856); Francis Frith's photographs of Egypt; Clementina Hawarden's pictures of her daughters in the studio at Prince's Gardens; David Octavius Hill and Roger Adamson's collaborative work representing middle-class Edinburgh, such as *The McCandlish Children* (1845), but also their documentation of the fisherfolk of Newhaven; John Edwin Mayall's pictures of Queen Victoria; Rejlander's composite morality tableaux, especially *Hard Times* (1860) and *The Two Ways of Life* (Figure 6.1, 1857); Robinson's *Fading Away* (1858) and *The Lady of Shalott* (1861), as well as the pastorals, including *Bringing Home the May* (Figure 6.2, 1862); Talbot's early calotypes of Lacock Abbey, including many of the images in *The Pencil of Nature* reproduced in this book (1843–44); Frank Sutcliffe's naked *Natives* (1895); and John Thomson's *The Crawlers* (1877–78).

It is worth considering what kind of world these frequently reproduced photographs depict, for, as Foucault has noted, a "period only lets some things be seen and not others."[14] There is an imbalance in the list in favor of the pastoral (Emerson, Fenton, Robinson) over the urban (Annan, Thomson): Victorian England in popularly reproduced photographs tends to be rural and southern. And there is a similar emphasis on the mid-century at the expense of the late, which might explain the overrepresentation of the upper classes that could afford, in the 1850s and 1860s,

[14]Michel Foucault, *Discipline and Punish: The Birth of the Prison*, trans. Alan Sheridan (New York: Vintage Books, 1979), 217.

FIGURE 6.1 Oscar Rejlander, *Two Ways of Life*, 1857. Royal Photographic Society/Science & Society Picture Library.

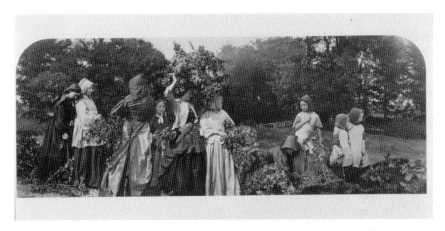

FIGURE 6.2 Henry Peach Robinson, *Bringing Home the May*, 1862. Royal Photographic Society/Science & Society Picture Library.

the expensive equipment and leisure time necessary. To note that Victorian England in our favorite photographs is predominantly pastoral, southern, and mid-century is in fact to note what is really the common denominator of the photographs listed above: the perspective afforded by class. Pictures of the outdoors, garden or countryside, tend to reflect the elevated viewpoints of the landed gentry at home (Talbot, Fenton) or the colonial traveler abroad (Fenton, Frith). Moreover, and perhaps too obvious to need noting, these photographs have been inserted into a history associated with art

rather than, say, communications, or science, or commerce. Collectively they have been considered important as pictures, photographs that in a sense already existed before they were made; replicating work previously undertaken in paintings, they do not tax their viewers' capabilities or challenge their assumptions as much as they affirm them. What social difference they represent is sentimentalized (Robinson, Rejlander) or of anthropological and inherently nostalgic interest (fishwives by Hill and Adamson; Norfolk farmworkers by Emerson). The working classes tend to be obscured: portraits of the poor are sometimes fabrications with middle- or upper-class sitters as models (Carroll, Robinson), or, if real, the laborers are sufficiently distanced to permit abstraction and mythologizing (Emerson). Only Thomson's famous image of a beggar woman with a baby disrupts the apparent harmony.

The list also, and dramatically, overrepresents fine art photography, especially images theatrically conceived and designed to illustrate a particular moral theme or narrative. Indeed, the photographs of Victorians that have had the greatest exhibition value of the late twentieth and early twenty-first centuries seem to be those that represent them pretending to be something other than themselves: dressed as figures from history or poetry, as dairy maids or mythical characters, frequently looking as though they are in paintings and not photographs at all. Few of the pictures hint at social unrest or inequity, and what social documentary there is, with the notable exception of Thomson, presents itself as picturesque. Almost all of the photographs are elegiac in their invitation to look back, and in that, their relationship with the past is consistent with the way they are used today.

The 1980s in particular witnessed a good deal of celebrating of these images, while shows focused on the work of single photographers inevitably contributed to a photographic history structurally analogous to that of a literary survey—a history, that is, attentive to authors, rather than readers or themes. Exhibitions celebrating milestones and years contributed to an understanding of photographic history as defined by dates rather than technological innovation. One popular exhibition of 1984 demarcated the period 1839–1900 as "The Golden Age of British Photography," years that closely approximated the tenure of Victoria and added a convenient twist to the catalog's insistence on the Victorian-ness of photography itself. With its identification of the age both *as* age and as "golden," the title invited a nostalgic perspective (after the golden age, after all, we became simply but less glamorously "modern"). It was a view of the past that spoke, as canons do, of the age that produced it.

NOSTALGIA, AUTHENTICITY, HOME FURNISHING

By the end of the twentieth century, taste and desire for antiquity in the guise of the Victorian had expression far beyond the formal presentation of photographs in exhibitions and books. Wendy Wheeler suggests that, because "it is modernity that troubles us, what comes 'after' modernity is to be found written upon the features of our contemporary cultural life as the return of those things which are excluded,

lost or repressed as a condition of modernity and of the subjectivity it produces."[15] Increased interest in all kinds of Victoriana, coupled with a heightened nostalgia for the "authentic," suggested that the past, loosely packaged as "Victorian," was where authenticity might be retrieved. Thanks to the services of mail-order catalogs such as *Exposures*—now digitalized, but at the end of the last century still a book-like object that arrived in the mail—you could indulge the desire for a connection with the past by transforming "family photos into heirloom originals," itself a curious simultaneity of forward and backward planning. Pictures supplied by you could be reproduced on "cotton muslin in old-fashioned sepia tones, then combined with trinkets, buttons and vintage postcard reproductions in an evocative 36" square Family Photo Quilt."[16] What exactly was to be evoked by the quilt was irrelevant; to be evocative in this case was to be only vaguely suggestive of an imprecise past commercially identified as "yesteryear." In nostalgia, specifics are unimportant, even a hindrance; as noted earlier, one can be nostalgic for something one has never experienced, or of which one has only the vaguest impression or sketchiest memory. The word *vintage*, once meaning a particular and special year, now gestures loosely in the direction of a world in which we probably were not alive, or that we remember only from the perspective of childhood, and makes no claim to fact or specificity in its reference to the past.

The same catalog that brought us the quilt also offered a "personalized wedding certificate" to bring "old world romance to modern couples." Once again, it was not the thing itself that was old, because, like the quilt, the certificate would be made to order; here it was the process that endowed the certificate with authenticity because it "dates back to medieval times." By virtue of using that process, the catalog implied, the wedding certificate was elevated to a higher art:

> Now you can have your own hand made testimony. We will send you a kit to include your wedding date and location, as well as signatures of both husband and wife. Each affidavit will be painstakingly rendered on parchment paper by an English artisan. After an individual hand aging process, the parchment paper is gilded, signed by the artist and stamped for authenticity. Your heirloom arrives ensconced in this rich gold frame ready to hang.[17]

Authenticity was assured in the synecdoche of the hand that signed, stamped, and somehow aged the "parchment"; the "artisan" to whom the hand belonged was, significantly, "English." As with the quilt, instant lineage was projected. We might not know our ancestors but we could be them, and we could have the aged heirlooms ready to pass on down to anticipated future generations. It would be picky

[15]Wendy Wheeler, "Nostalgia Isn't Nasty—The Postmodernising of Parliamentary Democracy," in *Altered States: Postmodernism, Politics, Culture*, ed. Mark Perryman (London: Lawrence and Wishart, 1994), 94–107, 96.
[16]*Exposures* Catalog (Winter 1998), 40.
[17]Ibid., 41.

to note that heirlooms are usually new when they are original—that is, before they become heirlooms. These made-to-order heirlooms came instead prematurely aged, a necessary intervention to get them going, so to speak, to give them a leg up on the last hundred or so years of history. But these ones were already the past, already ready to be passed down, because they *looked* as if they were old enough to be worth something, to have memories in tow.[18]

One way of reading desire for these products of prefabricated history would be to see the aesthetic to which the quilt and the certificate appeal as ahistorical, developed out of a past emptied of history whose dialogic noise has been muffled. Certainly it is hard to quarrel with the viewpoint that the commodification of the past necessarily promotes image at the expense of word. The mess that is history is traded in for flat images that elide conflict and contradiction because, as Steven Connor puts it, there is something of an "enshrined belief in the metaphysical priority of images over words, the belief that an image directly shows us the reality which words can only communicate in a fragile and untrustworthy manner."[19] The quilt looks old and that is sufficient, because appearance constitutes reality and history is an expensive irrelevance.[20] Indeed, at the beginning of the twenty-first century it would have come as no surprise to learn that producers of the postmodern had rid themselves of history and thus ended it, given the multitude of voices that proclaimed the end of art, the death of the author, the end of literature.[21]

But history, it turns out, cannot be done away with because, like the photographic subject, it *adheres*; the structures of thought and memory that permit the essentializing of the Victorians are, as I've suggested in this book, themselves inherited from the nineteenth century. The fudging of the past and the vague inaccuracies in the service of style represented by the wedding certificate and the newly minted heirloom quilt, like their more recent and slightly more upmarket expressions (see Restoration Hardware and Pottery Barn), do not constitute a refusal to encounter the realities

[18]The elements of marketing nostalgia remain unchanged: Restoration Hardware's current online catalog offers sheets "inspired by vintage bedding from a bridal trousseau," while the "collection evokes the look of heirloom linens ... The bedding and its feathery-soft frayed edges are finished by hand at one of Russia's oldest linen mills" (August 2016).
[19]Steven Connor, *Postmodernist Culture: An Introduction to Theories of the Contemporary* (Oxford and Cambridge: Basil Blackwell, 1991), 97. The most theoretically inclined of photography's critics do not share this view. See, for example, the work of Victor Burgin, which is driven by an understanding of photography's immanent textuality: "the intelligibility of the photograph is no simple thing; photographs are texts inscribed in terms of what we may call 'photographic discourse,'" in *Thinking Photography*, ed. Victor Burgin (London: Macmillan, 1988), 144; see also Alan Sekula in Burgin ed., *Thinking Photography*; Snyder, "Picturing Vision"; Tagg, *The Burden of Representation*; and, more recently, Eduardo Cadava, *Words of Light: Theses on the Photography of History* (Princeton: Princeton University Press, 1997).
[20]See Carol Mavor for discussion of our "tradition of infantilizing history" by remaking the Victorians "into lost, innocent children" in a past "free from wear and tear." *Pleasures Taken*, 3.
[21]Fredric Jameson finds the widespread sense "of the end of this or that" (which he rather suggestively terms "inverted millenarianism") to be, indeed, a defining element of postmodernism. "Postmodernism, or the Cultural Logic of Capital," *New Left Review* 146 (1984), 53.

of the past so much as they suggest a vague but widely felt longing for a communion with it, even if it means having to make it first. The existence of the fake quilt does not mean that other quilts are not also crafted that people sleep under, keep for years, and pass down the family. The significance of the postmodern simulacrum lies not in its substitution for the real, but rather in its *self-consciousness* about that substitution; self-consciousness and a desire to "do" history that no more eradicates history than thinking about literature does away with it. As Linda Hutcheon argues, "We are not witnessing a degeneration into the hyperreal without origin or reality, but a questioning of what 'real' can mean and how we can *know* it."[22] The re-creation of the past in various forms marks neither the end of history nor an erasure of history from consciousness, but rather a rethinking of what history itself is even (and perhaps especially) in the experience of a commodified desire to visit it.

In this light, our ongoing appetite for vaguely defined Victoriana may be understood as symptomatic of what Frederic Jameson hails as "an omnipresent, omnivorous and well-nigh libidinal historicism."[23] The desire to purchase or re-create the past in order to revisit it does not inevitably signify the dissolution of a real, fact-based history, but perhaps marks its reassertion. Attending to the commercialization of history may push us into a new and vigorous consideration of all that the production of history entails, a task enabled by the play of the postmodern that highlights, in Hutcheon's words, "the modes of historiography we had come to consider 'natural': continuous narrative, inevitable development, universal … patterns of action."[24] The magnetic field or "cultural dominant" that is postmodernism may finally even be understood as forcing discussion of the limits and uses of historical knowledge, through its continual and obsessive play between the authentic and the inauthentic.[25]

AT HOME IN THE NINETEENTH CENTURY

The postmodern desire for authenticity is inherently nostalgic. Its commercial expression, like its daily airings on a variety of social media platforms, reveals a desire for a past in which we will find ourselves, and it is frequently expressed as a longing for home. Roger Rouse sees in contemporary society a sort of metaphorical mass dislocation, resulting from the fact that in modernity "we have all moved irrevocably to a new kind of social space," the "social space of postmodernism."[26] Perhaps it is this perceived dislocation that gives peculiar intensity to our current nostalgia. Angelika Bammer argues that the old paradigms within which we used to situate ourselves are no longer operative, with the result that we have created the idea of home as the "imaginary point where here and there—where we are and where we come from—

[22]Linda Hutcheon, *A Poetics of Postmodernism: History, Theory, Fiction* (London: Routledge, 1988), 223.

[23]Jameson, "Postmodernism, or the Cultural Logic of Capital," 66.

[24]Hutcheon, *A Poetics of Postmodernism*, 225.

[25]Jameson, "Postmodernism, or the Cultural Logic of Capital," 56.

[26]Rouse, quoted in Angelika Bammer, "Editorial," *New Formations 17*, ed. Angelika Bammer (Summer 1992), viii.

are momentarily grounded."[27] Recent critical discussion constructs home as a place where the self is initially defined, a place you cannot go back to but keep trying to revisit. It is a place of safety, "the last frontier," as Marianna Torgovnik calls it, one that can never be reached.[28]

The longing for home also has its darker side, however. In the postcolonial period, it has been perceived as symptomatic of an elegiac mode of cultural vision complicit with domination, what Renato Rosaldo calls "imperialist nostalgia."[29] Indeed, the concept of home has recently been in full play in the political rhetoric of both the United States and Britain, lending substance to Bammer's claim that home may be the "locus of regressive nostalgia … [a] rallying ground for reactionary nationalisms … linked from the very beginning to the particular pathology of violence and loss that marked the colonialist venture."[30]

The contemporary identification of home with notions of what is real has not been fully explored, although a cursory glance at home furnishing and real estate sites suggests there is a healthy market for a generic past still identified as "Victorian."[31] But by locating authenticity in the past, we set ourselves at a remove from life. What is inauthentic is the present, defined by default as fake, a replica or simulacrum of a more absolute past. "If we are to build places for ourselves, we need to know who we are," writes David Kolb in his study of postmodern architecture.[32] But Kolb has it backward; it is the places we build for ourselves that tell us who we are. Desire for identity, rather than identity itself, fuels the further desire that there *be* a place where we can be at home—where we can be like, if we cannot be, ourselves; and as Susan Stewart observes, "it is in [the] gap between resemblance and identity that nostalgic desire arises."[33] It is not just because of who we are but also out of desire for what we believe we once were that the inhabitants of the Disney-built town of Celebration, Florida, are driven to perform their civic identity in a purposeful re-creation of lost small-town America,[34] just as it is nostalgic desire—more self-consciously ironic, perhaps, but no less performative—that unites the mock audience of the mock band Spinal Tap as it plays at being an audience. *This is Spinal Tap*, the infamous mockumentary

[27]Bammer, *New Formations*, ix.

[28]Marianna Torgovnik, "Slasher Stories," in Bammer, ed. *New Formations* 17, 145.

[29]Renato Rosaldo, *Culture and Truth: The Remaking of Social Analysis* (Boston: Beacon Press, 1989), 69–70.

[30]Bammer, *New Formations*, x–xi.

[31]"*Victoria*, a bimonthly women's lifestyle magazine, is designed to nourish the feminine soul. Created for all who love heritage linens, charming homes, gracious gardens, unique decorative touches, traveling the world, and all that is beautiful in life, *Victoria* promises a return to loveliness" (victoriamag.com).

[32]David Kolb, *Postmodern Sophistications: Philosophy, Architecture and Tradition* (Chicago and London: University of Chicago Press, 1990), 159.

[33] Stewart, *On Longing*, 145.

[34]In the case of Celebration, the nostalgic ideal is "community," which itself is turning out to be something of a buzzword in the twenty-first century. See Celebration's website marking its twentieth anniversary.

of 1984, has proven to have more staying power as a cult than its creator, Rob Reiner, could possibly have imagined. While Spinal Tap's first "performance" as a band was in 1979, as recently as 2009 they performed at Glastonbury, providing a whole new generation the opportunity to be the mock audience of the mock band of their parents' generation, a mirroring of parody all the way back to the 1970s, the decade that seems to have emerged as the source of retro for the twenty-first century.[35] Today's social media practices reveal a continuation of the same desire for authenticity determined by communal consent.

Academic treatments of nostalgia have tended to dismiss it as reactionary and politically suspect, a combination of poor history and narcissistic imaginings,[36] but nostalgia is not merely a symptom of massively retrogressive fantasies; nor, despite its association with the conservatism of the picturesque, is it inevitably an expression of hatred for social change. Nostalgia does not essentialize history as much as it seeks its own; as Wheeler notes, in its construction of the past, nostalgia "offers no barriers to our understanding because it does not appeal in the first place to critical understanding but to experience and affect."[37] This is part of the danger as much as it is the appeal of commercial nostalgia: its artifacts—the heirloom quilt, the wedding certificate, the house stuffed with authenticity, the lost small-town America town, the mock rock concert—*look* authentic, just as they appear to reference an authentic lived experience. The absent original becomes ever more fetishized, for its authority must be distinguished from subsequent imitations.

It is the sense of dislocation from primary experience figured in such remakes of history that Victorian photography embodies and simultaneously promises to heal. If, as Susan Sontag once claimed, "everything exists to end in a photograph," then everything may also be said to begin its afterlife at that point—to achieve authenticity through photography in a post-real representational world.[38] Nineteenth-century photographs have come to signify a kind of last resort, a final frontier, the resting place of the truly authentic; and although they cannot cure our *nostos algos*, our sickness for home, they give us both a place and a time for it.

[35]"We get to go on stage and pretend that we're Spinal Tap. And the fans get to play too, because they get to pretend that they're real Spinal Tap fans." Identity as it is performed in the social space of the mock concert depends on the self-consciousness of parodic remove, in that the audience is united by its mass identification of what is not real—all of which raises a question voiced by Rob Reiner: "So what are the criteria for what is a real band?" (*Washington Post*, March 15, 1992, GII).

[36]One notable exception is Helen Groth's *Victorian Photography and Literary Nostalgia* (2003), a work that explores Victorian nostalgic engagement with photography as well as its legitimation through strategic association with a literary tradition.

[37]Wheeler, 98.

[38]Susan Sontag, *On Photography* (New York: Doubleday, 1977), 24.

BIBLIOGRAPHY

Ansell-Pearson, Keith. "Bergson on Memory," in Radstone and Schwartz, 61–66.

Arago, Dominique François. "Report." July 3, 1839. In Trachtenberg, 15–25.

Archer, Frederick Scott. "The Use of Collodion in Photography." 1851. In Newhall, *Photography: Essays and Images,* 51–2.

Aristotle, *De Sensu and De Memoria.* 1906. Translated by G. T. Ross. New York: Arno, 1973.

Armstrong, Nancy. *Fiction in the Age of Photography: The Legacy of British Realism.* Cambridge and London: Harvard University Press, 1999.

Arnold, Matthew. "Dover Beach." 1867. *The Norton Anthology of English Literature.* 7th edition, vol. 2, edited by M. H. Abrams and Stephen Greenblatt, 1492. New York and London: W.W. Norton, 2000.

Austen, Jane. *Pride and Prejudice.* 1813. New York and London: Penguin Classics, 1996.

Bammer, Angelika, ed. "A Question of Home." *New Formations* 17 (Summer 1992).

Barthes, Roland. *Camera Lucida: Reflections on Photography.* Translated by Richard Howard. New York: Hill and Wang, 1981.

Bartholeyns, Gil. "The Instant Past: Nostalgia and Digital Retro Photography." In *Media and Nostalgia: Yearning for the Past, Present and Future,* edited by Katharina Niemeyer, 51–69. London and New York: Palgrave Macmillan, 2014.

Batchen, Geoffrey. *Burning with Desire: The Conception of Photography.* Boston: MIT Press, 1999.

Batchen, Geoffrey. *Forget Me Not: Photography and Remembrance.* Van Gogh Museum, Amsterdam: Princeton Architectural Press, New York, 2004.

Batchen, Geoffrey, "Snapshots: Art History and the Ethnographic Turn," *Photographies* 1.2 (2008), 121–42.

Baudelaire, Charles. "Salon of 1859." Extracted in Goldberg, 123–126.

Baudrillard, Jean. *Simulacra and Simulation.* Translated by Sheila Faria Glaser. Ann Arbor, MI: University of Michigan Press, 1994.

Beer, Gillian. "Origins and Oblivion in Victorian Narrative." In *Sex, Politics, and Science in the Nineteenth-Century Novel,* edited by Ruth Bernard Yeazell, 63–87. Baltimore: Johns Hopkins University Press, 1986.

Beer, Gillian. *Arguing with the Past: Essays in Narrative from Woolf to Sidney.* New York and London: Routledge, 1989.

Belknap, Geoffrey. *From a Photograph: Authenticity, Science and the Periodical Press, 1870–1890* (London: Bloomsbury, 2016).

Bell, Clive. *Art*. London: Chatto & Windus, 1914.

Benjamin, Walter. "A Berlin Chronicle." In *Reflections: Essays, Aphorisms, Autobiographical Writings*. Edited by Peter Demetz. Translated by Edmund Jephcott. New York: Schocken Books, 2007, 3–60.

Benjamin, Walter. *Berlin Childhood around 1900*. Edited by Peter Szondi. Translated by Howard Eiland. Cambridge, MA: Belknap Press, 2006.

Bennett, Arnold. *Anna of the Five Towns*. Oxford and New York: Oxford University Press, 1995.

Berger, John. "Understanding a Photograph." In Trachtenberg, 291–94.

Bergson, Henri. *Matter and Memory*. 1908. Translated by Nancy Margaret Paul and W. Scott Palmer. Digireads.com, 2010.

Bermingham, Ann. *Landscape and Ideology: The English Rustic Tradition 1740–1860*. Berkeley, Los Angeles and London: University of California Press, 1986.

Birch Suzanne Pilaar. "Google doodle celebrates the missing woman of geology." *Guardian* online, August 21, 2013. Accessed October 15, 2015. http://www.theguardian.com/science/the-h -word/2013/aug/21/photograph-mary-anning-women-history-geology

Bisbee, A. *The History and Practice of Daguerreotyping*. 1853. New York: Arno, 1973.

Brimley, George. Unsigned Review, *Spectator*. (September 24, 1854): 923–25, in Collins, 284.

Brittain, Vera. 1933. *Testament of Youth*. New York: Penguin, 2004.

Brontë, Charlotte. *The Letters of Charlotte Brontë*, vol. 2, 1848–1851, edited by Margaret Smith. Oxford, Clarendon Press, 2000.

Brontë, Charlotte. *Jane Eyre*. 1847. New York and London: Penguin Classics, 2006.

Brown, Bill. "Thing Theory." *Critical Inquiry* 28 (Autumn 2001): 1–19.

Buckley, Jerome. *The Triumph of Time: A Study of the Victorian Concepts of Time, History, Progress, and Decadence*. Cambridge, MA: Harvard University Press, 1966.

Burgin, Victor, ed. *Thinking Photography*. London: Macmillan, 1988.

Burns, Karen. "Topographies of Tourism: 'Documentary' Photography and *The Stones of Venice*." *Assemblage* 32 (April 1997): 22–44.

Butler, Samuel. *Unconscious Memory*. 1880. New York: AMS Press, 1968. 1924 edition.

Byrn, M. Lafayette. *How to Live a Hundred Years*. New York: 1876.

Cadava, Eduardo. *Words of Light: Theses on the Photography of History*. Princeton: Princeton University Press, 1997.

Casey, Edward S. *Remembering: A Phenomenological Study*. Bloomington: Indiana University Press, 1987.

Caws, Maryann. *The Eye in the Text*. Princeton: Princeton University Press, 1981.

Caws, Maryann. *Reading Frames in Modern Fiction*. Princeton: Princeton University Press, 1985.

Claudet, A. "The Progress and Present State of the Daguerreotype Art." *Journal of the Franklin Institute* 10 (1845): 113.

Clayton, Owen. *Literature and Photography in Transition, 1850–1915*. London and New York: Palgrave Macmillan, 2015.

Cleghorn, Thomas. "Writings of Charles Dickens." *North British Review*, May 1845, in Collins, 186–91.

Collins, Philip, ed. *Dickens: The Critical Heritage*. London: Routledge, 1971.

Conan Doyle, Arthur. *Sherlock Holmes: The Major Stories with Contemporary Critical Essays*, edited by John Hodgson. Boston and New York: Bedford Books, 1994.

Connerton, Paul. *How Societies Remember*. Wiltshire: Cambridge University Press, 1989.

Connor, Steven. *Postmodernist Culture: An Introduction to Theories of the Contemporary*. Oxford and Cambridge: Basil Blackwell, 1991.

Conrad, Joseph. *Heart of Darkness*. 1899. New York: Dover, 1990.

Copner, James. *Hints on Memory*. London: 1891.

Crary, Jonathan. *Techniques of the Observer: On Vision and Modernity in the Nineteenth Century*. Boston, MA: MIT Books, 1992.

"Critical Notices." *Photographic News* (October 1, 1858): 40, in Harker, 27.

Daguerre, Louis Jacques Mandé. "Daguerreotype," in Helmut Gernsheim and Alison Gernsheim, 81.

Daguerre, Louis Jacques Mandé. "Preface." *History and Practice of Photogenic Drawing, with the New Method of Dioramic Painting*. Translated by J. S. Memes. 3rd edition. London: Smith, Elder & Edinburgh: Adam Black, 1839.

"The Daguerre Secret." *Literary Gazette* (July 13, 1839): 538–39.

"Daguerrotype." [*sic*] Editorial. *Literary Gazette* 1173 (July 13, 1839): 444.

"La Daguerreotype." *The Court Magazine* (October 1839): 436–39.

"Daguerreotypes of the Moon." *The Schoolmate*, (January 1854): 75. Accessed October 15, 2015. http://www.merrycoz.org/smate/MOON.xhtml

Dames, Nicholas. *Amnesiac Selves: Nostalgia, Forgetting, and British Fiction, 1810–1870*. New York and Oxford: Oxford University Press, 2001.

Debord, Guy. *The Society of the Spectacle*. Translated by Donald Nicholson-Smith. New York: Zone books, 1994.

Di Bello, Patrizia. *Women's Albums and Photography in Victorian England: Ladies, Mothers and Flirts*. Hampshire: Ashgate, 2007.

Dickens, Charles. *Bleak House*. 1853. New York: Bantam, 1985.

Dickens, Charles. *David Copperfield*. 1851. New York and London: Norton, 1990.

Dickens, Charles. *Great Expectations*. 1861. New York and London: Penguin Classics, 1996.

Dinius, Marcy. *The Camera and the Press: American Visual and Print Culture in the Age of the Daguerreotype*. Philadelphia, PA: University of Pennsylvania Press, 2012.

Domanska, Ewa. "The Material Presence of the Past." *History and Theory* 45 (October 2006): 337–48.

D'Or, Sel. "Exhibition Review." *Journal of the Photographic Society* (January 1, 1859):n.p.

Draaisma, Douwe. *Metaphors of Memory: A History of Ideas about the Mind*. Translated by Paul Vincent. Cambridge: Cambridge University Press, 1995.

Duffy, Enda. *The Speed Handbook: Velocity, Pleasure, Modernism*. Durham, NC: Duke University Press, 2009.

Eastlake, Elizabeth. "Photography." *London Quarterly Review*. April 1857, 442–68. Extracted in Goldberg, 88–99.

Ebbinghaus, Herman. *Memory: A Contribution to Experimental Psychology*. 1885. Translated by Henry Ruger and Clara Bussenius. New York: Dover, 1964.

Edinburgh Review. January 1843. In Goldberg, 49–69.

Edridge-Green, Frederick W. *Memory: Its Logical Relations and Cultivation*. London, 1891.

Edwards, Elizabeth. "Commemorating a National Past: The National Photographic Record Association, 1897–1910." *Journal of Victorian Culture* 10.1 (Spring 2005): 123–29.

Edwards, Elizabeth. "Photography and the Material Performance of the Past." *History and Theory* 48 (December 2009): 130–50.

Edwards, Elizabeth. *The Camera as Historian: Amateur Photographers and Historical Imagination, 1885–1918*. Durham, NC: Duke University Press, 2012.

Eksteins, Modris. *Rites of Spring: The Great War and the Birth of the Modern Age*. Boston and New York: Houghton Mifflin, 1989.

Eliot, George. "The Natural History of German Life." 1859. *Selected Essays, Poems and Other Writings*, edited by A. S. Byatt and Nicholas Warren, 107–39. New York and London: Penguin Classics, 1990.

Eliot, George. *Adam Bede*. 1859. New York: Penguin, 1980.

Eliot, George. *Middlemarch*. 1874. New York and London: Penguin, 1994.

Exposures Catalog. Winter 1998. Accessed October 15, 2015. http://www.exposuresonline.com/exposuresonline/

Fish, Stanley. *Surprised by Sin: The Reader in Paradise Lost*. Cambridge, MA: Harvard University Press, 1967.

Fish, Stanley. "Interpreting the Variorum." (1976) In *Is There a Text in This Class? The Authority of Interpretive Communities*, edited by Stanley Fish, 147–74. Cambridge, MA: Harvard University Press, 1980.

Flint, Kate. *The Victorians and the Visual Imagination*. Cambridge: Cambridge University Press, 2000.

Flint, Kate. "Photographic Memory." *Romanticism and Victorianism on the Net*, 53 (February 2009). Accessed October 15, 2015. http://id.erudit.org/iderudit/029898ar

Foer, Joshua. *Moonwalking with Einstein*. New York: Penguin, 2012.

Forster, E. M. "The Early Novels of Virginia Woolf." 1925. In *The Mrs. Dalloway Reader*, edited by Francine Prose, 108–18. New York: Harcourt, 2003.

Foucault, Michel. *Discipline and Punish: The Birth of the Prison*. Translated by Alan Sheridan. New York: Vintage Books, 1979.

Foucault, Michel. *The Foucault Reader*, edited by Paul Rabinow. Harmondsworth: Peregrine/Penguin, 1986.

Fowler, O. S. *Fowler on Memory*. New York: 1872.

"French Discovery—Pencil of Nature." *Literary Gazette* (February 2, 1839): 74.

Friese-Greene, William. "Fox Talbot—His Early Experiments," *The Convention Papers. Supplement to Photography* 1.36 (1889), 6.

Fussell, Paul. *The Great War and Modern Memory*. Oxford, New York and London: Oxford University Press, 1975.

Gaucharaud, Hippolyte. "The Daguerotype" [*sic*]. *Gazette de France* (January 6, 1839). Translated and republished by London's *Literary Gazette* (January 12, 1839): 26.

Gernsheim, Helmut and Alison Gernsheim. *L. J. M. Daguerre: The History of the Diorama and the Daguerreotype*. New York: Dover Publications, 1968.

Gillespie, Diane F. "'Her Kodak Pointed at His Head': Virginia Woolf and Photography." In *The Multiple Muses of Virginia Woolf*, edited by Diane F. Gillespie, 113–47. Columbia and London: University of Missouri Press, 1993.

Gilpin, William. *Three Essays*. London: 1792.

Goldberg, Vicki, ed. *Photography in Print: Writings from 1816 to the Present*. Albuquerque: University of New Mexico Press, 1988.

Gould, Jay Stephen. *Time's Arrow, Time's Cycle: Myth and Metaphor in the Discovery of Geological Time*. Cambridge, MA: Harvard University Press, 1987.

Green-Lewis, Jennifer. *Framing the Victorians: Photography and the Culture of Realism*. Ithaca, NY: Cornell University Press, 1996.

Groth, Helen. *Victorian Photography and Literary Nostalgia*. Oxford and New York: Oxford University Press, 2003.

Gualtieri, Elena. "The Grammar of Time: Photography, Modernism and History." In *Literature and Visual Technologies: Writing after Cinema*, edited by Julian Murphet and Lydia Rainford, 155–74. New York: Palgrave, 2003.

Habermas, Jürgen. *Legitimation Crisis*. Translated by Thomas McCarthey. London: Heinemann, 1975.

Halbwachs, Maurice. *On Collective Memory*. Translated by Lewis Coser. Chicago: University of Chicago Press, 1992.

Handy, Ellen. *Pictorial Effect, Naturalistic Vision: The Photographs and Theories of Henry Peach Robinson and Peter Henry Emerson*. Norfolk, VA: Chrysler Museum, 1994.

Hardy, Thomas. "An Imaginative Woman." *Pall Mall Magazine*, 2.12 (April 1894): 951–69.

Hardy, Thomas. *Desperate Remedies*. 1871. New York and London: Penguin Classics, 1998.

Hardy, Thomas. *The Woodlanders*. 1887. New York and London: Penguin Classics, 1998.

Hardy, Thomas. *Jude the Obscure*. 1895. New York and London: Penguin Classics, 2003.

Hardy, Thomas. *A Pair of Blue Eyes*. 1872. Oxford and New York: Oxford University Press, 2005.

Hardy, Thomas. *Tess of the D'Urbevilles*. 1891. New York and London: Penguin Classics, 2009.

Harker, Margaret F. *Henry Peach Robinson, Master of Photographic Art, 1830–1901*. Oxford: Blackwell, 1988.

Harrison, William Jerome. *A History of Photography Written as a Practical Guide and an Introduction to Its Latest Developments*. New York: 1887.

Haworth-Booth, Mark, ed. *The Golden Age of British Photography 1839–1900*. New York: Aperture, 1984.

Hering, Ewald Butler. "On Memory as a Universal Function of Organized Matter." Lecture. In Butler, 81.

Herschel, Sir John Frederick. *Results of Astronomical Observations Made during the Years 1834, 5, 6, 7, 8, at the Cape of Good Hope; Being the Completion of a Telescopic Survey of the Whole Surface of the Visible Heavens, Commenced in 1825 …* London: 1847.

Herschel, John Frederick. *Outlines of Astronomy*. London: 1849.

Heyert, Elizabeth. *The Glass House Years*. New Jersey: Allanheld, 1979.

"History and Practice of Photogenic Drawing, with the new Method of Dioramic Painting. By the Inventor L. J. M. Daguerre." Translated by J. S. Memes. *The Monthly Review* 3.3 (November 1839): 321–30.

Holmes, Oliver Wendell. "The Stereoscope and the Stereograph." 1859. In *Soundings from the Atlantic*, 124–65. Boston: Ticknor & Fields, 1864.

Holmes, Oliver Wendell. "Sun-Painting and Sun-Sculpture." 1861. In *Soundings from the Atlantic*, 166–227.

Holmes, Oliver Wendell. "Doings of the Sunbeam." 1863. In *Soundings from the Atlantic*, 228–81.

Holmes, Oliver Wendell. "The Last Reader." In *Holmes's Early Poems*, 49–51. New York and Boston: 1899.

Howitt, William. *Ruined Abbeys and Castles of Great Britain*. London: 1862.

Howitt, William. *Ruined Abbeys and Castles of Great Britain and Ireland*. London: 1864.

Hulick, Diana Emery. "The Transcendental Machine? A Comparison of Digital Photography and Nineteenth-Century Modes of Photographic Representation." *Leonardo* 23.4 (1990): 419–25.

Humm, Maggie. *Modernist Women and Visual Cultures: Virginia Woolf, Vanessa Bell, Photography and Cinema*. New Brunswick, NJ: Rutgers University Press, 2003.

Hutcheon, Linda. *A Poetics of Postmodernism: History, Theory, Fiction*. London: Routledge, 1988.

Hutton, James. *System of the Earth*, 1785, edited by George W. White. New York: Hafner, 1970.

Isherwood, Christopher. *Goodbye to Berlin*. New York: New Directions, 2012.

Jacobson, Ken and Jenny. *Carrying off the Palaces: John Ruskin's Lost Daguerreotypes* Kendal, Cumbria: Quaritch, 2015.

James, Henry. *Portrait of a Lady*. 1881. New York: Penguin, 1983.

James, Henry. "The Art of Fiction." 1884. In *Essays on the Novel by Henry James*, edited by Leon Edel, 23–45. London: Rupert Hart-Davis, 1957.

James, William. *Principles of Psychology*, 1890. Philadelphia: Franklin Library, 1985.

Jameson, Fredric. "Postmodernism, or the Cultural Logic of Capital." *New Left Review* 146 (1984): 53–92.

Jolly, Martyn. "Has the Digital Revolution Changed Documentary Photography?" *State Library of New South Wales Magazine*, May 2013. https://martynjolly.com/2013/05/10/has-the-digital-revolutionchanged-documentary-photography. Accessed July 10, 2016.

Jones, David. *In Parenthesis*. 1937. New York: NYRB Classics, 2003.

Joyce, James. "The Dead." 1914. Edited by Daniel Schwartz. Boston and New York: St. Martin's Press, 1994.

Joyce, James. *Ulysses*. 1922. New York: Vintage, 1990.

Kelsey, Robin. *Photography and the Art of Chance* Cambridge, MA: The Belknap Press of Harvard University Press, 2015.

Kern, Stephen. *The Culture of Time and Space, 1880–1918*. Cambridge, MA: Harvard University Press, 2003.

Kolb, David. *Postmodern Sophistications: Philosophy, Architecture and Tradition*. Chicago and London: University of Chicago Press, 1990.

Kracauer, Siegfried. "Photography." Translated by Thomas Levin. 1927. *Critical Inquiry* 19.3 (Spring 1993): 421–36.

Kracauer, Siegfried. "Photography." 1960. In Trachtenberg, 248–68.

Kreilkamp, Ivan. "One More Picture: Robert Browning's Optical Unconscious." *ELH* 73 (2006): 409–34.

Larkin, Áine. *Proust Writing Photography: Fixing the Fugitive in À la Recherche du Temps Perdu*. London: Legenda, 2011.

Lawrence, D. H. *Women in Love*. 1920. New York: Penguin, 1976.

Lee, Hermione. *Virginia Woolf*. New York: Vintage, 1999.

Lerebours, N. P. *A Treatise on Photography*. Translated by J. Egerton 1843, 4th edition. New York: Arno, 1973.

Leslie, Esther. "Siegfriend Kracauer and Walter Benjamin." In Radstone and Schwartz, eds., 123–35.

Levine, George. *The Realistic Imagination: English Fiction from Frankenstein to Lady Chatterley*. Chicago and London: University of Chicago Press.

Levy, Amy. *The Romance of a Shop*. 1888, edited by Susan David Bernstein. Ontario, Canada: Broadview, 2006.

"Librorum Impressorum." *Quarterly Review* 72 (1842): 1–25.

Locke, John. *Essay Concerning Human Understanding*, 1689. Chapter 10, section 2. Ed. Kenneth P. Winkler. Indianapolis: Hackett, 1966.

Lohrli, Anne. *Household Words: A Weekly Journal 1850–1859*. Toronto: University of Toronto Press, 1973.

Lover, Samuel. "The Happiest Time Is Now." *Literary Gazette* (April 13, 1839): 225.

Lowenthal, David. "Nostalgia tells it like it wasn't." In *The Imagined Past: History and Nostalgia*, edited by Malcolm Chase and Christopher Shaw, 18–32. Manchester and New York: Manchester University Press, 1989.

Lyell, Charles. *Principles of Geology*. 1830, vol. 1. Chicago: University of Chicago Press, 1990.

Lyons, Claire L., John K. Papadopolous, Lindsey S. Stewart, and Andrew Szegedy-Maszak, eds. *Antiquity and Photography: Early Views of Ancient Mediterranean Sites*. Los Angeles: J. Paul Getty Trust, 2005.

Malcolm, Norman. *Memory and Mind*. Ithaca, NY: Cornell University Press, 1977.

Mannan, Ilona. "Early Modernist Vision: Emile Zola and Photography." *Ecloga: Journal of Literature and the Arts*. "New Work in Modernist Studies." Special Edition, 2014, edited by Andrew Campbell. Accessed October 31, 2015. www.strath.ac.uk/ecloga/

Marsh, Joss. "Spectacle." In *A Companion to Victorian Literature and Culture*, edited by Herbert Tucker, 276–88. Malden, MA and Oxford: Blackwell, 1999.

Mavor, Carol. *Pleasures Taken: Performances of Sexuality and Loss in Victorian Photographs*. Durham, NC: Duke University Press, 1995.

Maynard, Patrick. *The Engine of Visualization: Thinking through Photography*. Ithaca, NY: Cornell University Press, 1997.

Miller, Andrew D. *Poetry, Photography, Ekphrasis*. Liverpool: Liverpool University Press, 2015.

Miller, Daniel. *Material Cultures: Why Some Things Matter*. London: University College London Press, 1998.

Mitchell, W. J. T. "Romanticism and the Life of Things: Fossils, Totems, and Images." *Critical Inquiry* 28.1 (Autumn 2001): 167–84.

Moss, Howard. *The Magic Lantern of Marcel Proust: A Critical Study of Remembrance of Things Past*. Boston: David Godine, 1963.

Mundy, Laura, to W. H. Fox Talbot. December 12, 1834. *Correspondence*. Doc. 3017. Collection British Library, London—Fox Talbot Collection. Accessed November 16, 2016. http://foxtalbot .dmu.ac.uk/index.html

"Murchison's Silurian System." *Quarterly Review* 64 (1839): 102–20.

Newhall, Beaumont, ed. *Photography: Essays and Images: Readings in the History of Photography*. New York: Museum of Modern Art, 1980.

Newhall, Beaumont, ed. *The History of Photography*. New York: Museum of Modern Art, 1982.

Newman, Charles. *The Post-Modern Aura: The Act of Fiction in an Age of Inflation* Evanston: Northwestern University Press, 1985.

Nickel, Douglas R. *Francis Frith in Egypt and Palestine: A Victorian Photographer Abroad*. Princeton and Oxford: Princeton University Press, 2004.

North, Michael. *Camera Works: Photography and the Twentieth-century Word*. Oxford and New York: Oxford University Press, 2005.

Nora, Pierre. "General Introduction: Between Memory and History." In *Realms of Memory: The Construction of the French Past*, edited by Lawrence Kritzman and Pierre Nora. Translated by Arthur Goldhammer. New York: Columbia University Press, 1996.

Novak, Daniel. *Realism, Photography, and Nineteenth-Century Fiction*. Cambridge: Cambridge University Press, 2008.

Olin, Margaret. *Touching Photographs*. Chicago and London: University of Chicago Press, 2012.

Olson, Liesl. *Modernism and the Ordinary*. Oxford and New York: Oxford University Press, 2009.

Pasternak, Gil. "Taking Snapshots, Living the Picture: The Kodak Company's Making of Photographic Biography." *Life Writing* 12.4 (2015): 431–46.

Pater, Walter. *Studies in the History of the Renaissance*. London: Macmillan, 1873.

Perryman, Mark. ed., *Altered States: Postmodernism, Politics, Culture*. London: Lawrence and Wishart, 1994.

Phillips, Christopher. "A Mnemonic Art? Calotype Aesthetics at Princeton." *October* 26 (Autumn 1983): 34–62.

"Physical Geography." *Quarterly Review* 85 (1848): 305–40.

Poe, Edgar Allan. "The Daguerreotype." *Alexander's Weekly Messenger* (January 15, 1840), 2. In Trachtenberg, 38.

Pointon, Marcia. "The Representation of Time in Painting: A Study of William Dyce's *Pegwell Bay: A Recollection of October 5th, 1858*," *Art History* 1.1 (March 1978): 99–103.

Price, Uvedale. *Essay on the Picturesque*. London: 1794.

Proust, Marcel. *Remembrance of Things Past*. Translated by C. K. Scott Moncrieff. 7 vols. 1913–27. New York: Vintage, 1982.

Radstone, Susannah, and Bill Schwarz, eds., *Memory: Histories, Theories, Debates*. New York: Fordham University Press, 2010.

Reid, Thomas. *Works*. Edited by W. Hamilton, 2 vols. Edinburgh: 1872.

Remarque, Erich Maria. 1928. *All Quiet on the Western Front*. Translated by A. W.Wheen. New York: Fawcett Crest, 1958.

Rigby, Elizabeth. "*Vanity Fair*–and *Jane Eyre*." *Quarterly Review* 84.167 (December 1848): 153–85.

Ritchin, Fred. *After Photography*. New York: Norton, 2009.

Robinson, H. P. "Composition NOT Patchwork." *The British Journal of Photography* 7.121 (July 2, 1860): 190.

Robinson, H. P. *The Elements of a Pictorial Photograph*. 1896. New York: Arno, 1973.

Rosaldo, Renato. *Culture and Truth: The Remaking of Social Analysis*. Boston: Beacon Press, 1989.

"Royal Society." *Literary Gazette* (February 2, 1839): 75.

Ruskin, John. "The Nature of Gothic." 1851–53. *The Stones of Venice*, vol 2, chapter 6. Ed. J. G. Links. New York: Da Capo, 2003, 157–90.

Russell, Lee. "The Geology of Pegwell Bay." Accessed October 15, 2015. http://russellweb.org.uk/WriteHanded/Documents/Geology/The_Geology_of_Pegwell_Bay_V8.pdf

Samuel, Raphael. *Theatres of Memory*. London: Verso, 1994.

Scarry, Elaine. "Work and the Body in Hardy and other Nineteenth-Century Novelists." *Representations* 3 (Summer 1983): 90–123.

Scarry, Elaine. *Reading by the Book*. Princeton: Princeton University Press, 2001.

Schorr, Naomi. *Reading in Detail: Aesthetics and the Feminine*. New York and London: Methuen, 1987.

Sheehan, Tanya and Andrés Mario Zervigón, eds. *Photography and Its Origins*. New York: Routledge, 2015.

Silverman, Kaja. *The Miracle of Analogy, or the History of Photography, Part 1*. Stanford: Stanford University Press, 2015.

"Sir John Herschel's *Astronomical Observations at the Cape of Good Hope*." *Quarterly Review* 85 (1847): 1–31.

Smith, Graham. "Time and Memory in William Henry Fox Talbot's Calotypes of Oxford and David Octavius Hill and Robert Adamson's of St Andrews." In *Time and Photography*, edited by Jan Baetens, Alexander Streitberger, and Hilde Van Gelder, 67–84. Leuven: Leuven University Press, 2010.

Smith, Lindsay. *Victorian Photography, Painting, and Poetry: The Enigma of Visibility in Ruskin, Morris, and the Pre-Raphaelites*. Cambridge: Cambridge University Press, 1995.

Smith, Lindsay. *Lewis Carroll: Photography on the Move*. London: Reaktion Books, 2015.

Snyder, Joel. "Picturing Vision." In *The Language of Images*, edited by W. J. T. Mitchell, 219–46. Chicago and London: University of Chicago Press, 1980.

Sontag, Susan. *On Photography*. New York: Doubleday, 1977.

Spear, Jeffrey. "The Other Arts: Victorian Visual Culture." In *A Companion to the Victorian Novel*, edited by Patrick Brantlinger and William B. Thessing, 189–206. Malden, MA: Blackwell, 2002.

Stendhal. *De L'Amour*. 1822. Paris: Gallimard, 1980.

Stevens, Wallace. "A Postcard from the Volcano." In *Collected Poems*. New York: Vintage, 1990, 158.

Stewart, Susan. *On Longing: Narratives of the Miniature, the Gigantic, the Souvenir, the Collection*. Durham, NC: Duke University Press, 1993.

Stokes, William. *Memory*. 5th edition. London: 1865.

Szondi, Peter. "Hope in the Past: On Walter Benjamin." In Benjamin, *Berlin Childhood around 1900*, 1–33.

Tagg, John. *The Burden of Representation: Essays on Photographies and Histories*. Amherst: University of Massachusetts Press, 1988.

Talbot, Christopher Rice Mansel. Letter to W. H. Fox Talbot, March 30, 1839; document number 2528. British Library, London. Fox Talbot Collection. *The Correspondence of William Henry Fox Talbot*. Accessed November 15, 2016. http://foxtalbot.dmu.ac.uk/index.html

Talbot, W. H. Fox. Letter to Sir Charles Fellows, April 11, 1843; document number 4799. Copy owned by Harold White. *The Correspondence of William Henry Fox Talbot*. Accessed November 15, 2016. http://foxtalbot.dmu.ac.uk/index.html

Talbot, W. H. Fox. Letter from Talbot to Fellows, April 26, 1843; document number 4808. Getty Research Institute, Los Angeles. Special Collections. *The Correspondence of William Henry Fox Talbot*. Accessed November 15, 2016. http://foxtalbot.dmu.ac.uk/index.html

Talbot, W. H. Fox. Letter from Fellows to Talbot, August 1, 1843; document number 6436. Original
 letters and papers. Collection: British Museum, London. *The Correspondence of William Henry
 Fox Talbot*. Accessed November 15, 2016. http://foxtalbot.dmu.ac.uk/index.html

Talbot, W. H. Fox. Letter to John Herschel, Tuesday, January 29, 1839; document # 3779. Collection
 # HS 17: 279. *The Correspondence of William Henry Fox Talbot*. Accessed November 15, 2016.
 http://foxtalbot.dmu.ac.uk/index.html

Talbot, W. H. Fox. Letter to Rear Admiral Charles Feilding, June 7, 1836. British Library, London.
 Fox Talbot Collection. LA 36–32. *The Correspondence of William Henry Fox Talbot*. Accessed
 November 15, 2016. http://foxtalbot.dmu.ac.uk/index.html

Talbot, W. H. Fox. Letter. "Photogenic Drawing." *Literary Gazette* 1150 (February 2, 1839): 73.

Talbot, W. H. Fox. *The Pencil of Nature*. London: 1844; reprint New York: Da Capo Press, 1969.

Talbot, W. H. Fox. "Some Account of the Art of Photogenic Drawing." 1839. Reprinted in Newhall,
 Photography: Essays & Images, 23–31.

Terdiman, Richard. *Present Past: Modernity and the Memory Crisis*. Ithaca, NY: Cornell University
 Press, 1993.

Thackeray, William Makepeace. *Vanity Fair*. 1847. Oxford: Oxford University Press, 2008.

Thomas, Alan. *The Expanding Eye; Photography and the Nineteenth-Century Mind*. London: Croom
 Helm, 1978.

Thomas, Julia. *Pictorial Victorians: The Inscription of Values in Word and Image* Athens, OH: Ohio
 University Press, 2004.

Thomas, Ronald. "Making Darkness Visible: Capturing the Criminal and Observing the Law in
 Victorian Photography and Detective Fiction." In *Victorian Literature and the Victorian Visual
 Imagination*, edited by Carol Christ and John O. Jordan, 134–68. Berkeley: University of
 California Press, 1995.

Torgovnik, Marianna. "Slasher Stories." In Bammer, 133–45.

Trachtenberg, Alan, ed., *Classic Essays on Photography*. New Haven, CT: Leete's Island Books, 1980.

Townsend, George Alfred. Interview with Mathew Brady. *The New York World*. April 12, 1891. In
 Goldberg, 199–206.

Unsigned review. *Illustrated London News*. (September 24, 1853): 247, in Collins, ed., 282.

Van House, Nancy. "Personal Photography, Digital Technologies and the Uses of the Visual," *Visual
 Studies* 26. 2 (June 2011), 125–34.

"Varieties." *Literary Gazette* (September 28, 1839): 621–22.

Wegner, Frank. *Photography in Proust's À la Récherche du Temps Perdu*. Unpublished doctoral
 thesis, University of Cambridge, 2004.

Weintraub, Stanley. *Victoria*. New York: Truman Talley, 1992.

Weiss, Marta. "The Page as Stage." In *Playing with Pictures: The Art of Victorian Photocollage*. Ed.
 Elizabeth Siegel, with essays by Patrizia Di Bello and Marta Weiss, 37–48. Chicago: Art Institute
 of Chicago and Yale University Press, 2010.

Wells, H. G. *Tono-Bungay*. 1909. New York and London: Penguin Classics, 2005.

West, Nancy Martha. "Her Finger on the Button: Kodak Girls, Snapshot Nostalgia, and the Age of
 Unripening." *Genre* 29 (1996): 63–92.

West, Nancy Martha, *Kodak and the Lens of Nostalgia*. Charlottesville: University Press of Virginia,
 2000.

Wheeler, Wendy. "Nostalgia Isn't Nasty—The Postmodernising of Parliamentary Democracy." In
 Altered States: Postmodernism, Politics, Culture, ed. Mark Perryman. 94–107. London: Lawrence
 and Wishart, 1994.

Wilkinson, Lynn R. "*Le Cousin Pons* and the Invention of Ideology." *PMLA* 107.2 (1992): 274–89.

Woolf, Virginia. *Between the Acts*. 1941. San Diego, New York and London: Harcourt Brace
 Jovanovich, 1969.

Woolf, Virginia. *The Diary of Virginia Woolf*, vol. 1, 1915–1919, edited by Anne Olivier Bell. San Diego, New York and London: Harcourt Brace Jovanovich, 1977.

Woolf, Virginia. "Gold and Iron." In *Essays of Virginia Woolf*. Vol. 3, 1919–1924, edited by Andrew McNeillie, 139–41. San Diego, New York and London: Harcourt Brace Jovanovich, 1988.

Woolf, Virginia. *Jacob's Room*. 1922. San Diego, New York and London: Harcourt Brace Jovanovich, 1950.

Woolf, Virginia. *Mrs. Dalloway*. 1925. San Diego, New York and London: Harcourt Brace Jovanovich, 1981.

Woolf, Virginia. *To the Lighthouse*. 1927. San Diego, New York and London: Harcourt Brace Jovanovich, 1981.

Woolf, Virginia. *The Waves*. 1931. San Diego, New York and London: Harcourt Brace Jovanovich, 1959.

Woolf, Virginia. *The Years*. 1937. San Diego, New York and London: Harcourt Brace Jovanovich, 1965.

Wordsworth, William. 1846. "Illustrated Books and Newspapers." In *Collected Works of William Wordsworth*, 583. London: Wordsworth Editions, 1998.

Yeazell, Ruth Bernard. *Art of the Everyday: Dutch Painting and the Realist Novel*. Princeton: Princeton University Press, 2008.

Zemka, Sue. *Time and the Moment in Victorian Literature and Society*. Cambridge: Cambridge University Press, 2012.

INDEX